KU-332-120

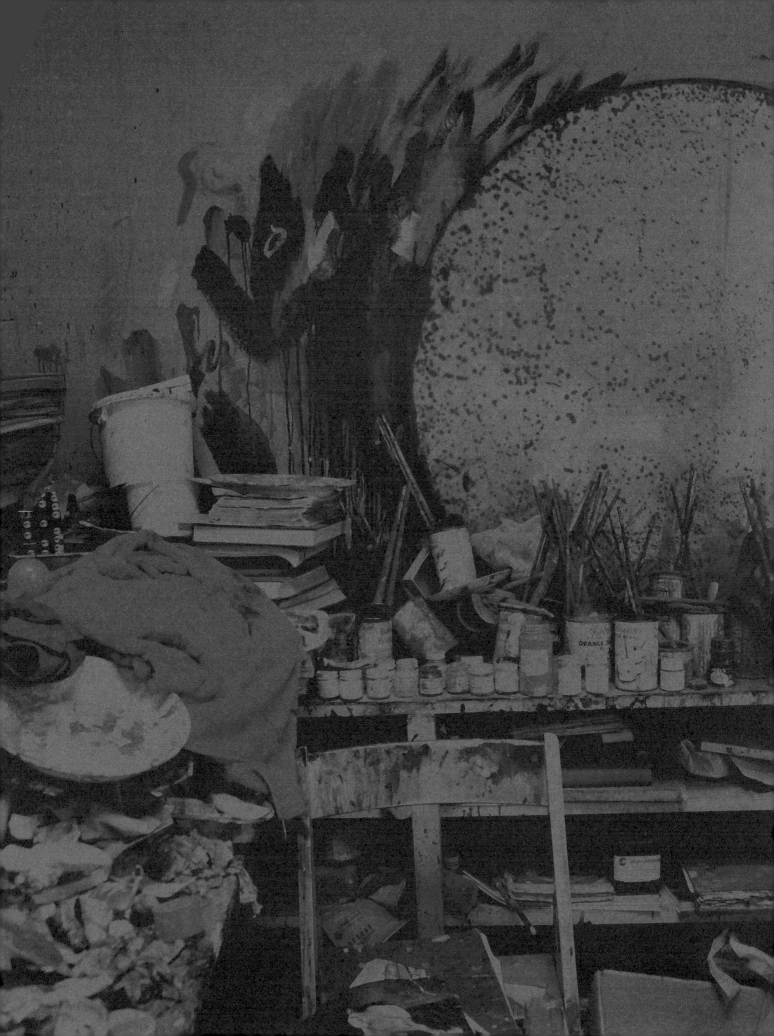

I ALWAYS THINK
OF MYSELF
NOT SO MUCH
AS A PAINTER
BUT AS A MEDIUM
FOR ACCIDENT
AND CHANCE.

FRANCIS BACON

FRANCIS BACON

FIVE DECADES

Edited by Anthony Bond

with essays by

Anthony Bond
Martin Harrison and Rebecca Daniels
Margarita Cappock
Ernst van Alphen

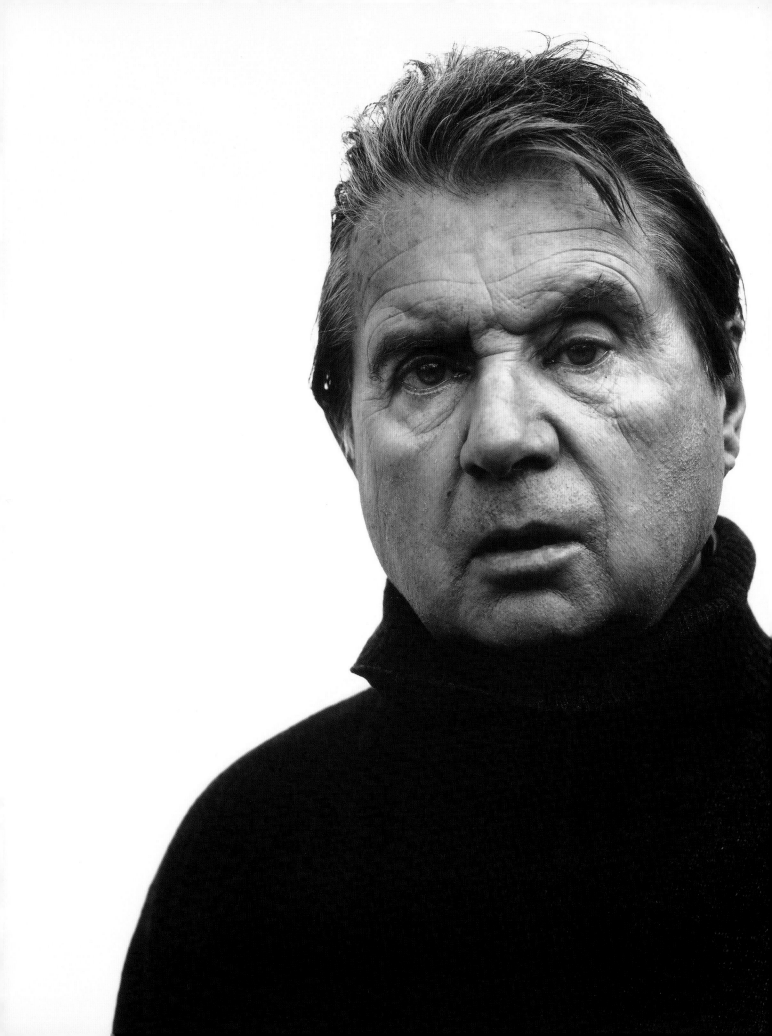

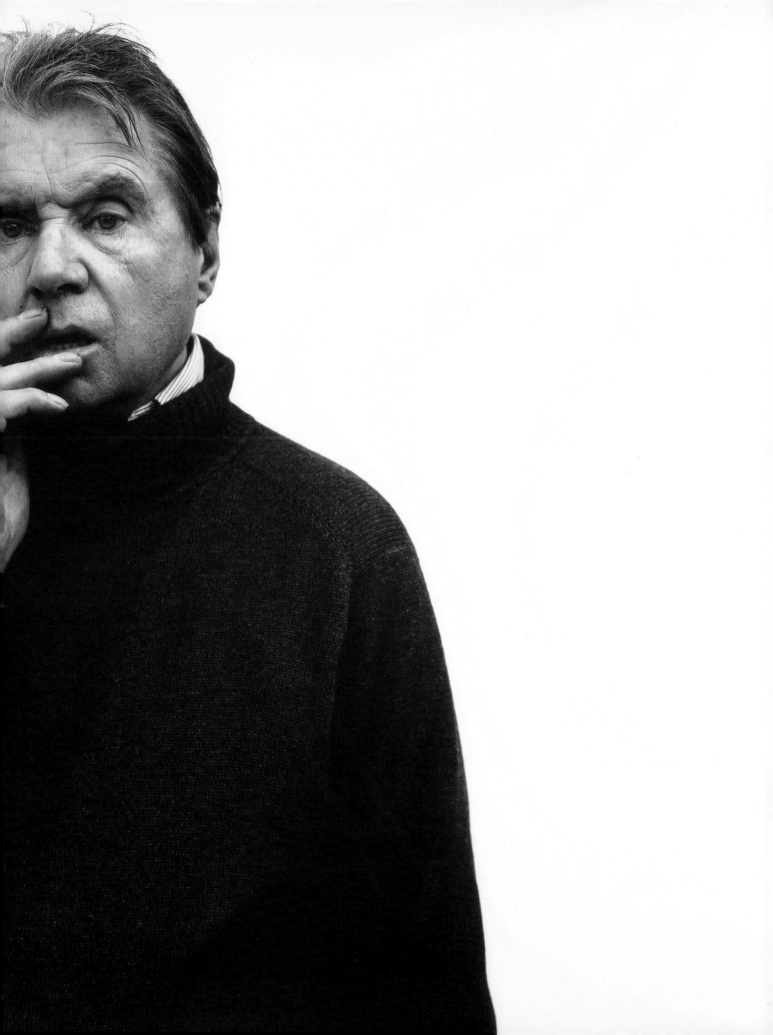

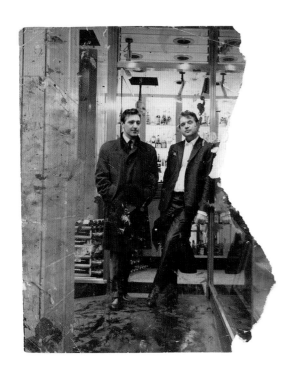

George Dyer and Francis Bacon in front
of a delicatessen in Soho, London, c1966.
photographed by John Deakin

Dublin City Gallery The Hugh Lane RM98F149:82

previous pages:

Richard Avedon
Francis Bacon, artiste, Paris, 11 April 1979

Premier's message

The NSW Government, through Destination NSW, is proud to support *Francis Bacon: five decades*, the first major exhibition in Australia of rare works by the master of postwar British art as part of the 2012–13 Sydney International Art Series, a signature event on the NSW Events Calendar.

Following the great successes of *The first emperor: China's entombed warriors* in 2010–11 and *Picasso: Masterpieces from the Musée National Picasso, Paris* in 2011–12, *Francis Bacon: five decades* is the third Art Gallery of New South Wales exhibition in the Sydney International Arts Series.

Curated by the Art Gallery of New South Wales, *Francis Bacon: five decades* has been three years in the making, with works drawn from more than 30 private collections and Australian and international institutions such as the Museum of Modern Art and Metropolitan Museum of Art in New York, Tate Britain in London, Pompidou Centre in Paris, and the Francis Bacon Estate.

Bringing the world's most outstanding exhibitions to Sydney further strengthens our global city's reputation as Australia's cultural tourism hub. *Francis Bacon: five decades* is a compelling retrospective that provides Sydney residents and our visitors with a unique opportunity to view significant works from one of the world's most important painters, spanning the entirety of his full and celebrated career.

On the twentieth anniversary of this great artist's passing, this important cultural event provides a timely showcase of his outstanding work. Welcome to *Francis Bacon: five decades*.

The Hon Barry O'Farrell MP
Premier of New South Wales

Sponsor's message

Ernst & Young is proud to be the principal sponsor of the *Francis Bacon: five decades* exhibition at the Art Gallery of New South Wales.

At Ernst & Young we are passionate about the arts. Our long history of supporting the arts, both nationally and globally, demonstrates our commitment to bringing significant collections to a wider audience than would otherwise see them. It is one of the ways we inspire our people, clients and communities to reach their potential.

Francis Bacon: five decades marks the twentieth anniversary of Bacon's death and, as the first major exhibition of his work to be shown in Australia, it provides a unique opportunity to view a collection of pieces from throughout his lifetime. As a long-term sponsor of the Art Gallery of New South Wales, Ernst & Young is delighted to help bring this exhibition to Sydney.

Rob McLeod
Chief Executive Officer
Ernst & Young Oceania

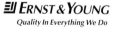

Quality In Everything We Do

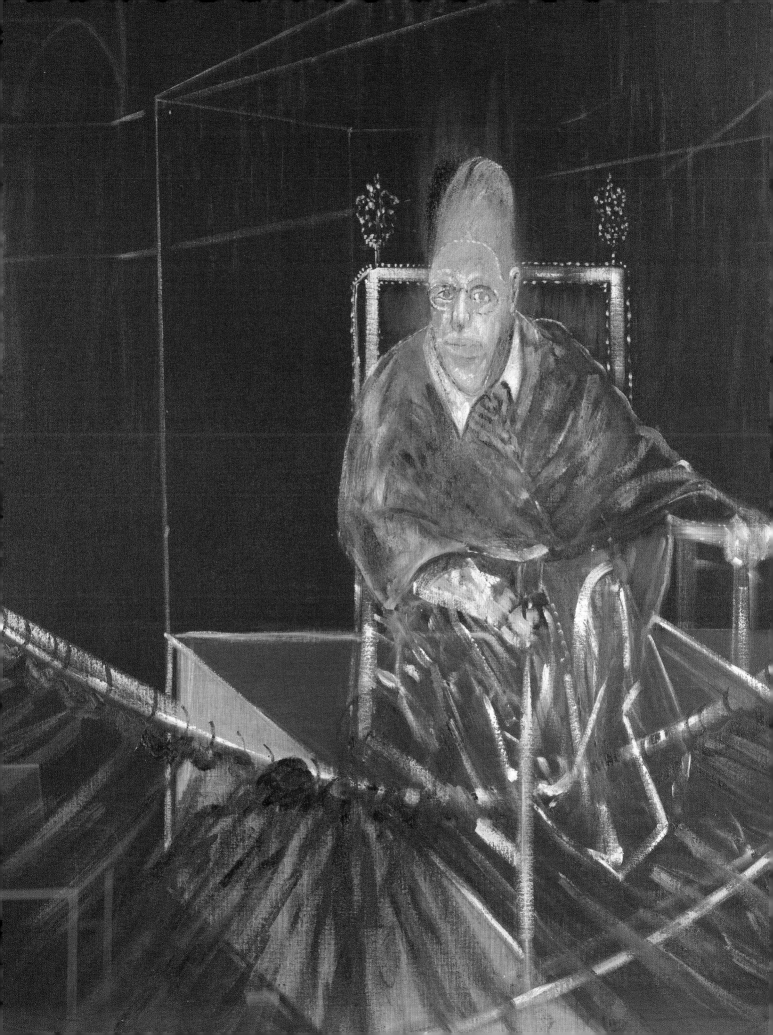

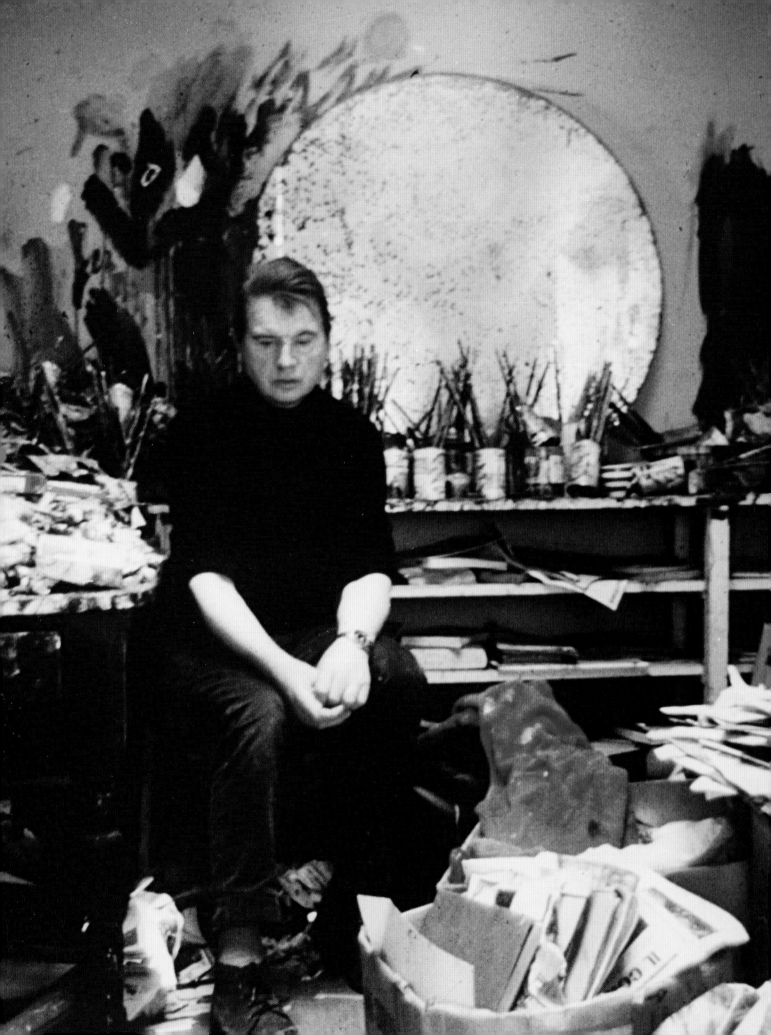

FOREWORD

Francis Bacon: five decades is the third exhibition in the Sydney International Art Series and follows *Picasso: masterpieces from the Musée National Picasso, Paris* (2011–12) and *The First Emperor: China's entombed warriors* (2010–11). The Art Gallery of New South Wales is proud of its program of self-generated exhibitions and we acknowledge the support it has received from the NSW Government through Destination NSW, as a strategic partner.

Francis Bacon is recognised as one of the most outstanding figurative painters of the twentieth century. Until now, however, there has never been an exhibition of his work in Australia. *Francis Bacon: five decades* marks the twentieth anniversary of Bacon's death in 1992. This survey and publication have benefited from substantial new research that has enabled us to rethink aspects of Bacon's artistic achievement. Bacon's significant Australian connections, for example, are discussed in this book in an essay by Martin Harrison and Rebecca Daniels. Bacon's father was born in Adelaide and it was the Australian painter Roy de Maistre who in 1930 suggested that Bacon, then working as a furniture designer, take up painting. The Australian artist Brett Whiteley was also greatly influenced by Bacon and visited him in his London studio in the 1970s where he made portraits of the artist, one of which is included in this exhibition and book.

Francis Bacon: five decades brings together more than 50 iconic paintings. Four are held in Australian public collections and we are grateful to the Art Gallery of South Australia, National Gallery of Australia and National Gallery of Victoria for lending their works to the exhibition. We are also delighted to be able to show our own Bacon painting, *Study for self-portrait* 1976, in the context of this significant survey. The show could not have been assembled without the generosity of many international museums, The Francis Bacon Estate and a number of private collectors. Tate in London, who loaned five masterpieces to this exhibition, was the first museum to strongly support the project, giving us the confidence to press ahead with the challenge of securing so many valuable works of art.

There have been a number of previous Bacon retrospectives and surveys: at the Tate in 1962; the Grand Palais in Paris in 1971; the Tate again in 1985; in Moscow in 1988; at the Hirshhorn Museum and Sculpture Garden at the Smithsonian Institution in Washington DC in 1989; and a third exhibition at the Tate in 2008. We have structured the Art Gallery of New South Wales exhibition around the five main decades of Bacon's career, which enables the distinctive developments in his subject matter and technique to be shown in a broadly chronological sequence of rooms in the exhibition and in the chapters in this book.

We are grateful to all the lenders to the exhibition who have agreed to share their works with our audience in Australia (a list of lenders to the exhibition is on page 233), to those who have supported the curator's research, and to the authors of this publication. Our gratitude also goes to our principal sponsor, Ernst & Young; our official airline, Qantas, and official hotel, Sofitel; our media partners, ABC 702 Sydney, JCDecaux and *The Sydney Morning Herald*; our supporters, the Art Gallery of New South Wales President's Council and City of Sydney; and our cultural partner, the British Council.

Finally, I would like to thank the curator of the exhibition and editor of this publication, Anthony Bond, for his vision, his insight and the dedication with which he worked on behalf of both the Art Gallery of New South Wales and our audience, and to all our staff who made this project possible.

Michael Brand
Director, Art Gallery of New South Wales

previous page:

Francis Bacon
Pope I – study after Pope Innocent X by Velázquez 1951 (detail)
see p 114

opposite:

Bacon in his studio at 7 Reece Mews, South Kensington, photographed by Michael Pergolani, May 1970 (detail).
Dublin City Gallery The Hugh Lane LG3

page 13:

Francis Bacon
Three studies of the male back, triptych 1970 (detail)
see pp 172–75

MY PAINTINGS ARE NOT ILLUSTRATIONS OF REALITY BUT ... A CONCENTRATION OF REALITY AND A SHORTHAND OF SENSATION.

FRANCIS BACON

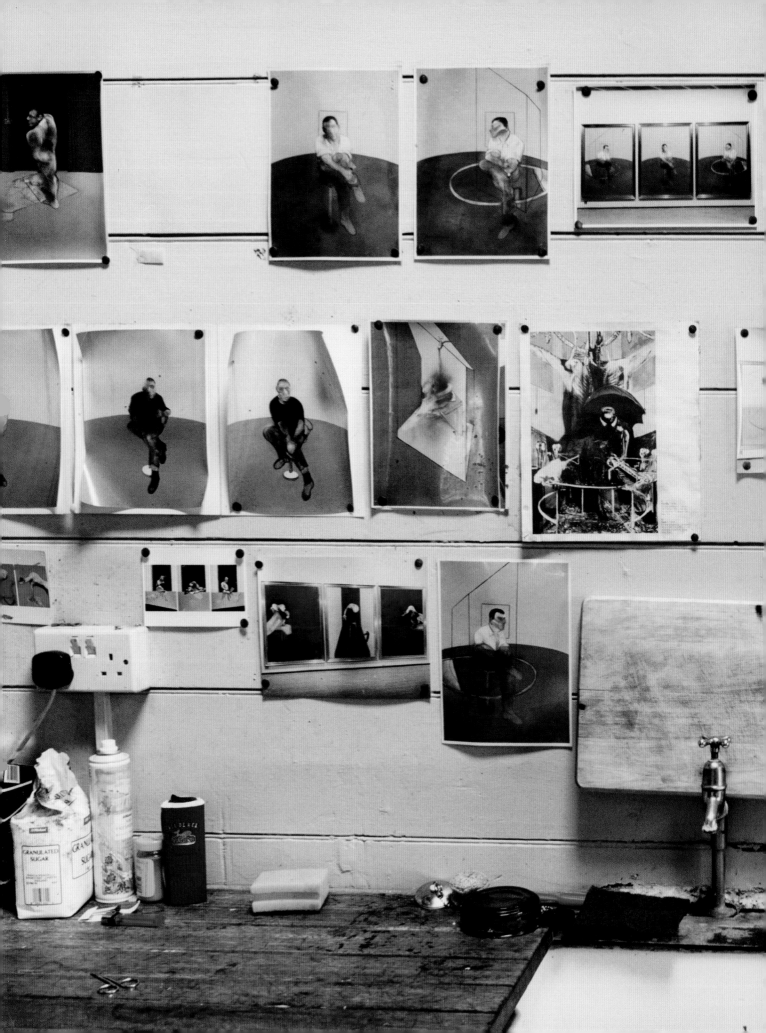

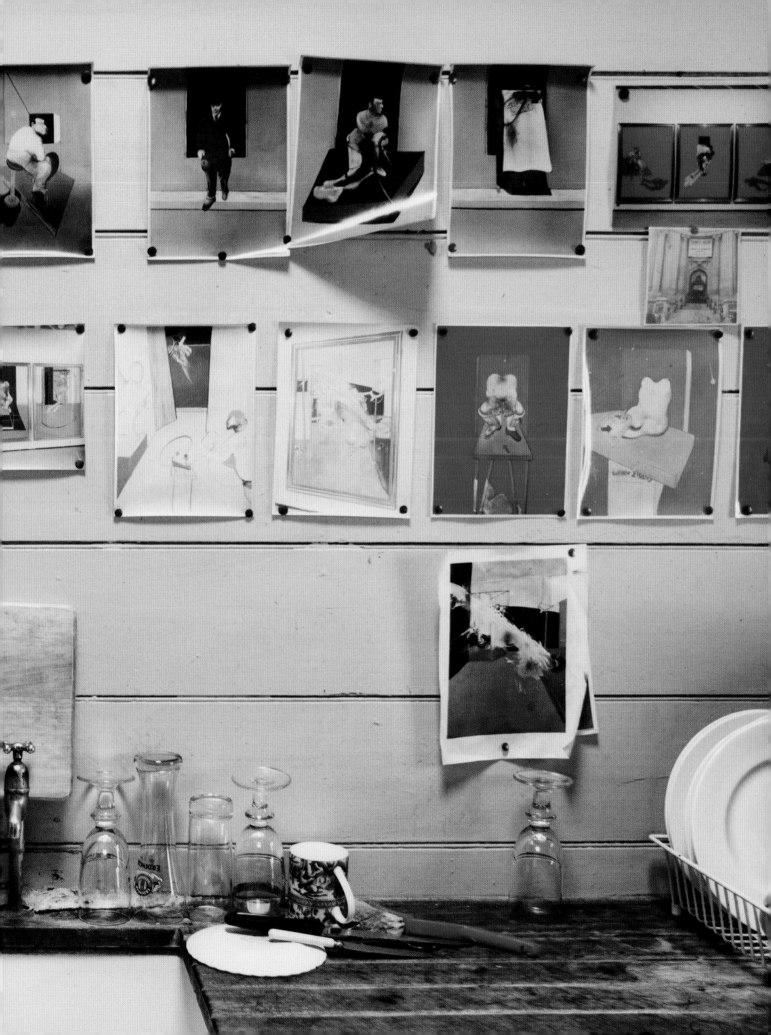

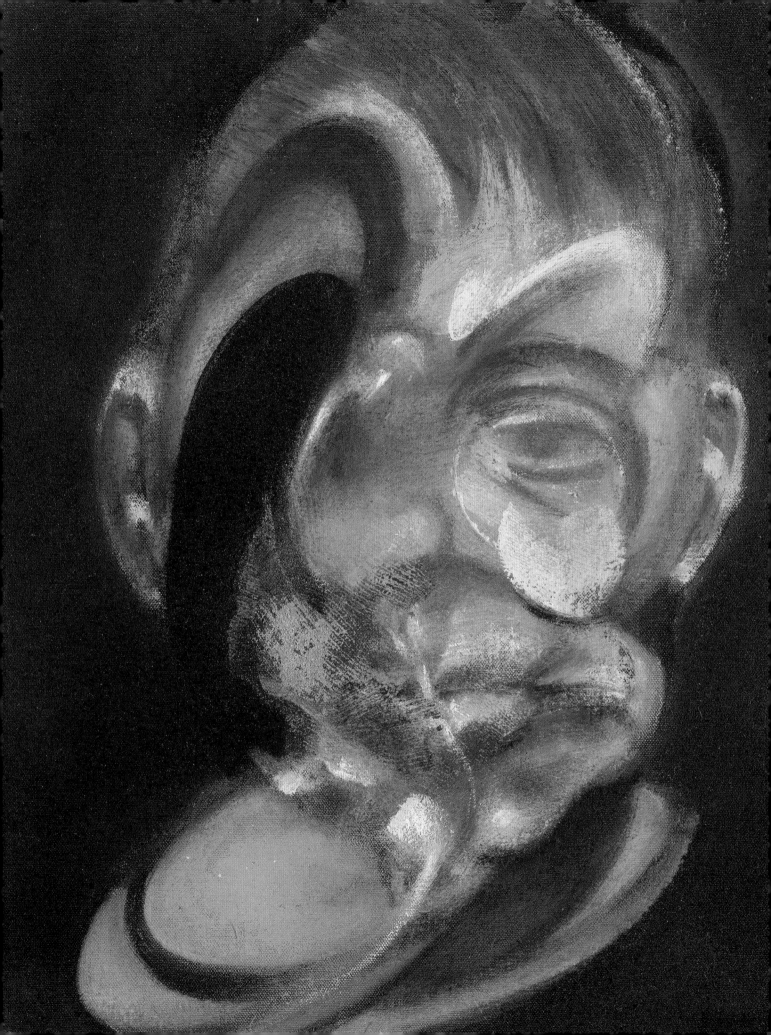

FRANCIS BACON
FIVE DECADES

Anthony Bond

This book, published with the first survey exhibition in Australia of Francis Bacon's painting, covers five decades of the artist's work from the 1940s to the 1980s. The paintings encapsulate the developments in Bacon's technique and subject matter over this period. While aiming to avoid overstating biographical and psychoanalytical narratives, there is a strong connection between the imagery in Bacon's work and the circumstances of his life, including the influence of his close friends and five long-term lovers. This essay provides an overview of Bacon's painting and places it in an art-historical context. Each decade covered in the book is introduced by a concise summary of key events in Bacon's life and the friends who appear in his paintings.

BEYOND THE LEGEND

In 2012, 20 years after Bacon's death, our understanding of this exceptional artist's contribution to the history of art has benefited from new research that provides a more complex picture than was possible in his lifetime. Bacon was very particular about how his work should be interpreted and with the help of his interviewers, most notably the English art historian David Sylvester, he created a compelling legend around the convulsive nature of his creativity. Bacon changed his story from time to time and while there is a consistent thread, selective quotes can be misleading and contradictory. The legend perpetuated by Sylvester informed the French philosopher Gilles Deleuze's 1981 book *Francis Bacon: logique de la sensation* (*The logic of sensation*), thereby locking it more firmly into our collective imagination. The convulsive act is certainly represented in Bacon's paintings but in some ways it is just that: a representation of an act. This is what he wanted us to experience but he knew exactly how to create this sense of spontaneity. However, this knowledge certainly did not remove the element of chance that Bacon prized and sought to introduce into his method. He was, after all, an inveterate gambler, often risking everything on an outside bet at the casino, as well as in his art.

Constructing the sensation of accidents in his work was only part of the language that Bacon evolved which continues to challenge conventional views of representation. The Dutch cultural theorist Ernst van Alphen, for example, has suggested contrivances within the structure of Bacon's images that take representation as their underlying subject.[1] This reading is perhaps akin to the American art historian Michael Fried's analysis of Gustave Courbet's self-portraits as representations of the act of painting. It is difficult to believe that Bacon did not know exactly what he was

opposite:

Francis Bacon
Self portrait 1973 (detail)
see p 185

previous pages:

The kitchen-cum-bathroom at
7 Reece Mews, South Kensington.
photographed by Perry Ogden, 1998
Dublin City Gallery The Hugh Lane 1964.05

doing with these devices, although this implies that a prodigious intellect was driving his work, in contrast to what was always presented as an unconscious, almost drunken, leap into the dark. I for one am happy to hold these apparently contradictory versions as equally true. After all, a good drunk, like a cat, knows exactly how to land.

BODIES IN PAINT

Bacon's paintings tend to be large, but not overly so, and scaled to the body. The mark of the artist's hand plays back to us when we stand in his place in front of the canvas. Bacon's brushwork always rewards close scrutiny; he was a master in applying paint to convey a range of sensations. From the early 1960s his colours became incredibly vibrant, often isolating and foregrounding the central motif, usually a figure, in flat fields of pure colour. Much has been said about the violent nature of his imagery, although Bacon claimed to be not particularly interested in representing violent events: 'I never look for violence. There is an element of realism in my pictures which might perhaps give that impression, but life is so violent; so much more violent than anything I can do!'[2]

In fact, very few of Bacon's works depict scenes of violence, much less so than the paintings of his idol Pablo Picasso. While his paint is often violently applied, he always did this to break through the comfort of appearances and to ensure that the viewer experienced the raw sensation of the subject directly 'on their nervous system'.[3] As Bacon put it, this was 'So that the artist may be able to open up or rather, should I say, unlock the valves of feeling and therefore return the onlooker to life more violently'.[4]

What is real in Bacon's art is never the appearance of things but always the dramatic encounter of each viewer with the fact of paint and the sensations it conveys. Bacon's images are nearly always beautiful in spite of, or indeed because of, the violence he did to appearances in the process of transforming flesh into paint and paint into flesh.[5] It is my hope that in looking closely at the works in this exhibition viewers can experience a physiological and personal response to the paint whereby their subjectivity overrides any conscious attempt to interpret what Bacon was thinking or feeling. This is what Bacon wanted and is what he makes possible in the way he constructed his paintings.

Painting for Bacon was definitely not intended to be narrative or illustrative, or psychoanalytical or autobiographical, even though his work traces his close observation of twentieth-century images and events. Although he was clear about his dislike of psychoanalytical interpretations of art he pointed out that: 'In the end, painting is the result of the interaction of those accidents [chance in the process of applying paint] and the will of the artist or, if you prefer, the interaction of the unconscious and the conscious.'[6]

Before considering the significance of these ideas it is important to acknowledge the obvious fact that, whether narrative or not, the subject of Bacon's paintings was invariably the human body and we cannot help but have empathy for the represented body of another and thus to speculate about its condition. Much has been said about the fragmentation and distortion of the body in Bacon's work. He claimed that this was always to avoid illustration and to somehow bring back the sensation of the thing more directly. The forms of individual bodies are often hard to fix upon as one

body collapses into another and the paint that convinces us it is flesh fails to keep the body parts intact. Boundaries between the inside and the outside of the body become unstable; the colours and textures often suggest mucous membranes rather than skin.[7] Bacon's friend, the French writer Michel Leiris, was quoted by the English art critic John Russell as having described some of the artist's portraits from the 1960s as reminiscent of the mythological Irish figure Cuchulain, who in the heat of battle moved so violently that he seemed to revolve within his own skin.[8]

Bacon spoke about his fascination for the insides of bodies, triggered in part by his experience of working as an air-raid warden during the London Blitz in the Second World War. He collected illustrated medical journals and was fascinated by butcher shops where, as he remarked, he sometimes found it strange that animal carcasses were hanging there rather than his own body.[9] He saw paintings of meat by Rembrandt and the Russian artist Chaim Soutine (figs 1 & 2) at an impressionable age, and meat appears in a number of his crucifixion works. The colours and textures of intestines and the glossy sheathing on muscles are indeed beautiful to look at, except that for most of us the context of injury or death makes them abhorrent. Bacon claimed to have been able to see such things as beautiful without necessarily finding them disturbing.

The language of sexual attraction often suggests intimacy with interiors; the expression 'every part of you', for example, does not sound like it stops at the epidermis any more than 'dreaming of being inside you' does. However, what works in poetry or love letters does not easily translate into the visual, even if the sexual imagination might allow for it. Bacon's self-confessed sexual masochism may have made this boundary more porous in his imagination, but this was not the purpose or subject of his work.

In an interview with David Sylvester in 1962 Bacon said that love was never complete, that you could cut yourself open and try to merge with the loved one but that, ultimately, such a desire was impossible. The zip of white paint he often threw at the canvas at the end of the painting process was, he said, a way of introducing an element of chance that might or might not bring the work to fruition. This practice has also been invariably read as ejaculatory. As a gesture, this may well have been how Bacon felt about it as the culmination of the creative process but, again, it is not the literal story he wanted to tell. The notion of artistic creation and procreation being entwined, as in Dionysian models of creativity, dates back at least to the seventeenth century, especially in self-portraiture.[10]

Bodies sometimes seem to liquefy in Bacon's paintings. The shapes at the feet of each figure, which might be understood as shadows, are not necessarily dark or related to the direction of light. In fact, very often these shapes seem to more closely resemble fluid seeping from the body. On rare occasions this is associated with actual violence – as in Bacon's memorials to his lover George Dyer, whose messy death by suicide literally saw his body give up its fluids from every orifice. None of these associations are of themselves definitive ways of looking at the paintings, which are principally about bringing the experience of paint and, by analogy, flesh as directly as possible onto the nervous system of the viewer.[11]

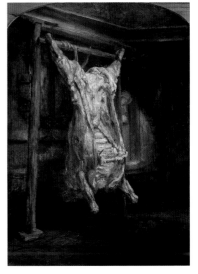

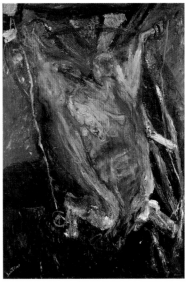

fig 1 Rembrandt van Rijn
The slaughtered ox 1655
oil on canvas, 94 x 68 cm
Louvre, Paris

fig 2 Chaim Soutine
The side of beef 1925
oil on canvas, 115 x 66 cm
Stedelijk Museum, Amsterdam

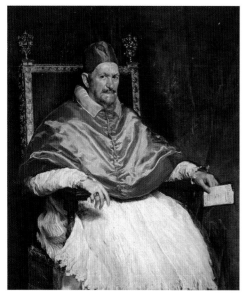 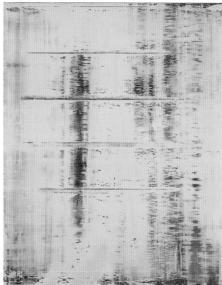 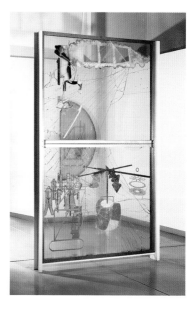

fig 3 Diego Velázquez
Portrait of Pope Innocent X c1650
oil on canvas, 140 x 120 cm
Galleria Doria Pamphilj, Rome

fig 4 Gerhard Richter
Abstract painting (812) 1994
oil on canvas, 250 x 200 cm
Art Gallery of New South Wales
Foundation Purchase 1999
© Gerhard Richter

fig 5 Marcel Duchamp
*The bride stripped bare by her bachelors,
even (The large glass)* 1915–23
oil, varnish, lead foil, lead wire and dust
on two glass panels, 277.5 x 177.8 x 8.6 cm
Philadelphia Museum of Art.
Bequest of Katherine S Dreier, 1952
© Estate of Marcel Duchamp. ADAGP/Licensed by Viscopy

RAW EMOTIONAL ENCOUNTERS WITH PAINT

By looking very closely at the surfaces of Bacon's works one can detect his extra-ordinary experiments with paint. Sometimes at least half-a-dozen different ways of handling paint can be seen within a small area, such as on a figure's head. Bacon enjoyed the accommodation of chance that came with the movement of paint. As he explained: '… moving – even unconsciously moving – the brush one way rather than the other will completely alter the implications of the image … It's really a continuous question of the fight between accident and criticism.'[12]

Bacon's energetic emphasis on material overrides the demands of appearance. In this his technique is reminiscent of the detailed and often violent flicks and twists of paint that the seventeenth-century Spanish baroque painter Diego Velázquez used for apparently insignificant areas of his compositions. Both Velázquez and Bacon deliberately animated the paint surface to stimulate movement in the eye of the beholder. I do not mention Velázquez lightly; he is a touchstone for many contemporary painters, including the German artist Gerhard Richter who is also committed to moving the viewer's body before the painted surface. Bacon kept any number of reproductions of paintings by Velázquez in his studio and created a series of works based on the artist's *Portrait of Pope Innocent X* c1650 (fig 3). Creating images of movement and requiring the movement of the viewer's body to try to resolve the image in the paint are two constant features of Bacon's painting. In addition to causing the viewer's body to move, the incompleteness or blurring of boundaries in paintings by Bacon and Richter (fig 4), and even Velázquez, encourages the observer to complete the image in their imagination, thereby making the work their own.

Bacon always had his paintings glazed and framed, which notoriously makes viewing the paint more difficult and requires our movement to see beyond the reflective surface to the image behind. It may not be coincidental that this idea of glass as a surface, mirror and transparent membrane was first exploited by the French dada artist Marcel Duchamp in his major installation *The bride stripped bare by her bachelors, even (The large glass)* 1915–23 (fig 5).[13] For Duchamp, this difficulty

of seeing, including the reflection of the viewer in the glass, ensured the physiological participation of the audience in the work, transferring the construction of feeling from author to viewer. It is likely that Bacon embraced these effects as part of his interest in movement although he made little of it in his interviews.[14]

Bacon obsessively experimented with the sense of motion caused by the different ways that paint leaves the brush or the piece of cloth he often used in place of a brush. Thick strokes of paint sometimes cut through a face, partly making the shape of a cheekbone, partly severing the face like a cubist conceit. Next to or on top of this the firm slash of the brush is countered with paint applied by means of pressing and smearing it with textured fabric, such as corduroy or towelling. Large areas are left unpainted so that the raw linen acts as both colour and texture. These vital details of Bacon's painting are not readily visible in reproduction, hence the importance of this exhibition for a first-time audience. Bacon used different kinds of paint in the same composition, such as oils, acrylics and spray paint, as well as found materials. Sometimes this seems to have had direct indexical relevance to the subject – for example, applying dust or fluff to the paint to describe the fabric of a coat. Speaking of *Figure in a landscape* 1945 (p 90), based on a photograph of his lover Eric Hall wearing a grey flannel coat, Bacon said:

> … that early painting in the Tate Gallery of Eric Hall in which his suit looks immaculate is painted with dust … there is no paint at all on the suit apart from a very thin grey wash on which I put the dust from the floor … dust is the perfect colour for a grey suit … how can I make that slightly furry quality of a flannel suit? And then suddenly I thought: well I'll get some dust.[15]

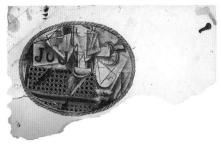

He also worked dust into the painting *Sand dune* 1983 and sand into the paint describing a bullring in *Study for bullfight no 2* 1969.

This use of applied material hints again at Bacon's interest in Marcel Duchamp, who in around 1915 instigated a visual and tactile language of materials and objects that implied things rather than making pictures of them. Bacon's other hero, Picasso, also used found objects as early as 1912 in *Still life with chair caning* (fig 6). This is an extraordinary layering of signifiers and referents. For example, Picasso has applied oil cloth, commonly used on tables in Paris, with a pattern of chair caning. The elliptical canvas represents a tabletop in perspective. The frame is a sailor's rope noose – a rope was often used to hold table cloths in place at that time, and rope motifs were commonly carved around the edge of wooden tables, including one in Picasso's studio.

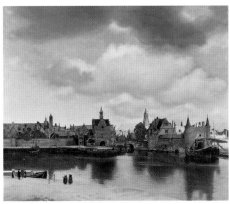

fig 6 Page from Bacon's studio illustrating Pablo Picasso's *Still life with chair caning* 1912 from William Rubin (ed), *Pablo Picasso: a retrospective*, Museum of Modern Art New York, Thames & Hudson, London, 1980.
Dublin City Gallery The Hugh Lane F16:90
© Succession Pablo Picasso. ADAGP/Licensed by Viscopy

fig 7 Johannes Vermeer *View of Delft* c1660–61
oil on canvas, 96.5 x 115.7 cm
Royal Cabinet of Paintings Mauritshuis, The Hague

This desire to include traces of the real is not only a modern tendency; seeking equivalents between materials and the subject to be portrayed has long been a preoccupation of certain realist artists. The seventeenth-century Dutch artist Johannes Vermeer, for example, in his work *View of Delft* 1660–61 (fig 7), conveyed the roughness of brick by mixing coarse grains of pigment into the paint, producing a rough, uneven surface. The reflection in the water is thinly painted in brown-grey and grey-blue, the transitions softened with a brush.

Including material as a trace or index of the thing itself crosses the line between reality and representation, exposing the viewer to multisensory experience and reducing the protective distance offered by the conventions of representation. There is a connection between this indexical aspect of realism in Bacon's work and the avant-garde that I will return to shortly.

BACON'S AVERSION TO ILLUSTRATION AND NARRATIVE

Bacon often spoke of his aversion to narrative in painting, which he saw as leading away from the fact of the paint. As he said:

> In the complicated stage in which painting is now, the moment there are several figures – at any rate several figures on the same canvas – the story begins to be elaborated. And the moment the story is elaborated, the boredom sets in; the story talks louder than the paint.[16]

In *The logic of sensation* Deleuze follows his colleague, the French philosopher Jean-Francois Lyotard, in distinguishing between figuration and the figural.[17] Figuration, like illustration, tends to tell a story or describe a sequence of events. Bacon does not do figuration; rather, he makes figures where the body is a material fact, rather than a character in a story. The body represented by Bacon aspires to be the sensorial equivalent of the body of paint. Bacon said that he wanted to represent a number of figures in his work but to avoid the logical development of a sequence or story. To block any possibility of the figures forming a sequence he isolated them on different canvases, as in the triptychs. Figures are also isolated in space, locked off from any interaction with other figures by linear frames, boxes, curved rails, curtains and other devices. Each figure is effectively entwined in a one-on-one encounter with the viewer, rather than with other figures in the composition. The narrative now becomes about the encounter with the viewer and not about relationships within the painting.

Figures often seem trapped in the canvas, or in the convoluted representations of space within it. Invariably, the spaces Bacon creates are logically impossible, the perspective irrational or contradictory. Openings represented as doors or windows through which we see a figure can equally be read as mirrors, or sometimes as paintings-within-a-painting, a kind of *mise en abyme* in which the identity of the figure is further fragmented or lost.[18] Linear frames that seem to contain the figure may also bisect it, fragmenting the body not only on the pictorial plane but also in space, by seeming to appear in front of and simultaneously behind the frame. In this way the figure is woven into the fabric of the canvas.

Bacon kept a magazine reproduction of Duchamp's sculpture *Door, 11 rue Larrey* 1927 (see fig 47, p 52). This door was set in a corner of Duchamp's studio so that to open it one way meant closing it in another. It too is a paradoxical model for creating optional and contradictory passages in space. One of the reasons Bacon respected Duchamp so much might well have been because his mysterious works defy any single interpretation. Indeed, there has been more scholarly speculation about the hidden meanings in Duchamp's work, especially *The large glass*, than that of any other artist.

All of these devices used by Bacon draw attention to the conventions of representation that he studiously deconstructed while ensuring that the viewer was constantly brought back to the figure and its equivalence in paint. If there is a narrative here it is about the viewer coming face to face with this process of looking at and interpreting painted surfaces. This sensation can be described as, the 'consciousness of perceiving or seeming to perceive some state or condition of one's body or its parts or senses or of one's mind or its emotions'.[19]

Parallels can also be drawn between Bacon's work and similar convolutions of sightlines and space in the paintings of Velázquez. In *Las Meninas* c1656 (fig 8),

for example, one of the most complex paintings about painting in the history of art, Velázquez includes a painting-within-a-painting and a mirror that manipulates the position of the viewer before or even within the composition.

There are conflicting views about what is depicted in *Las Meninas*. Is the reflection in the mirror on the back wall that of the king and queen who once stood exactly where the viewer now stands looking at the painting? Or is it a reflection of the painting-in-the-painting of the king and queen that the artist is working on and which we can only see from the back? There are arguments for both interpretations but it is my belief that Velázquez was being deliberately provocative and playful.[20] Even though the mirror logically shows the painting of the king and queen, rather than their presence before the canvas, the artist is still looking at us as he paints them so either way we are positioned as royalty.

Like Bacon, Velázquez challenges our sense of self and makes us acutely aware of the process of looking at looking and how we read painted surfaces as space. Velázquez and Richter are not the only artists in the western tradition to make art that plays with perception and the conventions of representation. Self-portraiture from the mid sixteenth century onwards is rich with examples, some of which I have written about previously.[21] Picasso in his analytic cubist phase, in the period 1911–13, systematically separated the means of representation – such as perspective, overlap, edge and tonality that artists have traditionally used to depict space – from the subject of the painting. In other words, the tools of representation are exposed by being detached from their usual purpose. To walk through a retrospective of these works as they progressively pull apart representation is an extraordinary and vertiginous exercise. In relation to conceptual art, the Australian artist and writer Ian Burn noted that the enhancement of a viewer's acute attention was demonstrated in Jasper Johns's number paintings from the 1950s and 1960s. In these paintings numbers in a grid suggest a hidden message of some sort and yet nothing is forthcoming except for the fact that you are left looking at the impasto numbers and become aware of your own looking.[22]

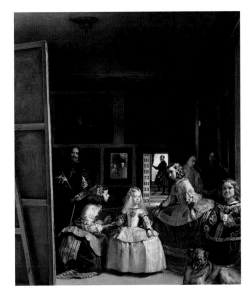

fig 8 Diego Velázquez
Las Meninas or The family of Philip IV c1656

oil on canvas, 316 x 276 cm
Prado, Madrid

BACON'S AVERSION TO EXPRESSIONISM

Bacon rejected the idea that his personal feelings were in any way relevant to our experience of his paintings. This contradicts much of the writing on Bacon that assumes his dramatic biography and extrovert lifestyle have a great deal to do with the meaning of his work.[23] As Bacon explained: 'I'm not sure that experiencing emotion is the most important thing as far as creativity is concerned. Perhaps it is for the person who experiences it, but probably not for the artist himself.'[24]

What has emerged for me in considering Bacon's anti-expressionist, realist position is the sense that he was much more an artist of his time than he is often thought to be. He has been seen as sitting uncomfortably alongside the important abstract movements of the twentieth century and, with the possible exception of Picasso, he seems to stand alone – one of those eccentric British artists like Stanley Spencer, perhaps. However, his vigorous rejection of illustration and his anti-expressionism constitute a position that is at the heart of ideas that permeated the creative thinking of that period and indeed he was ahead, if a bit to one side, of his time.

Bacon's consistent efforts to distance his own emotions from the affect conveyed

by his paintings seems to me very much a part of a growing realist tendency in the second half of the twentieth century that countered the idea of self-expression as epitomised by abstract expressionism. This counter-tendency took many forms and played a key role in defining our understanding of how art operates in the late twentieth and twenty-first centuries. The diversity of these movements and the strategies they adopted was such that although we might take their cumulative effect for granted, we still do not have a satisfactory account of how together they constitute a new aesthetic.[25] By the mid 1950s the creative and critical environment had already become hostile to the claims that had been made for expressionism. The artists Yves Klein and Mark Rothko, for example, both railed against expressionism, which they believed 'spilled the guts' of the artist for our gratification. Klein wrote of abstract expressionism: 'I hate artists who empty themselves into their paintings … they vomit, ejaculate, spew all their horrible rotten infectious complexity into their painting as if to relieve themselves and saddle others.'[26]

Klein and Rothko believed that art should be a vehicle for elevating the viewer's consciousness and could not be about the author's inner feelings. The central goal of these anti-expressionist tendencies was not to eliminate expression but to shift it away from the feelings of the artist and embed it in the object, and the encounter between each viewer with that object. This is exactly what Bacon reiterates in many of his interviews and is what he achieved in his paintings. In conversation with the English broadcaster Melvyn Bragg in 1985, for example, Bacon repeats such phrases as: 'I am not trying to express anything', 'I have no story to tell', 'I simply want to make images of the real world', 'Visual shock is not an expression', 'It is just a visual shock not a story'.[27]

It might seem to be stretching a point to look for parallels with artists who also took this view, particularly when, sooner or later, this line of argument must bring us to the unlikely conclusion that Bacon shared a common cause with American minimalism. Nonetheless, the principal idea of minimalism was to make something real in and of itself, anti-illusion and anti-allusion.[28] The object was always conceived as an encounter between a viewer and a thing, and not a narrative about something else. This description of the art object sits comfortably alongside many of Bacon's statements. And even though Bacon avowedly rejected abstraction, he did privilege the role of the spectator before the work.

Robert Rauschenberg is a less awkward juxtaposition with Bacon. Rauschenberg, particularly in his combines, used familiar domestic objects in ways that create disturbing encounters which, as Bacon would say, are felt directly on the nervous system. Rauschenberg's assemblage *Bed* 1955 (fig 9), for example, consists of a pillow and bedding hung vertically on a wall, supported by a wooden frame. The pillow has been vandalised with scribbled pencil marks and the bedspread is smeared with dribbled paint. What should be a comforting place in which to curl up has become revolting and besmirched, quite possibly the site of extreme or perverse actions. Its spatial orientation, rotated through 90 degrees from the normal horizontal, renders it useless as a bed, turning the thing into its own representation – not unlike Picasso's *Still life with chair caning*. This is very close to Bacon's own subject matter, and his play with materials and impossible spaces. Rauschenberg and Jasper Johns were important precursors to minimalism – not stylistically, although Johns's seriality could be thought of in that light, but because of their direct confrontation with specific objects.

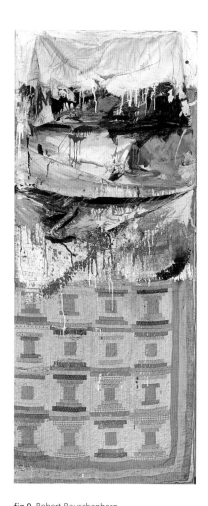

fig 9 Robert Rauschenberg
Bed 1955

oil and pencil on pillow, quilt and sheet
on wood supports, 191.1 x 80 x 20.3 cm
Museum of Modern Art, New York.
Gift of Leo Castelli in honour of Alfred H Barr, Jr
© Robert Rauschenberg. VAGA/Licensed by Viscopy

BACON: THE CHRONICLER OF AN AGE

A view of Bacon as a realist must include the broader historical context. Bacon collected massive amounts of visual information – photographs of friends, pages from magazines such as *Picture Post*, as well as art journals, newspapers and film posters – with which he surrounded himself in his studio. So extensive was his collection that he once talked about using it to make a pictorial book of his times.[29] In many ways the body of work he left behind can be viewed as a trace of the sensations such a collection might have evinced of the troubled twentieth century. He absorbed all this visual information and it erupted in his art, capturing the events of his lifetime and conveying their pain. It is not a literal history any more than it is pictorially illustrative, but it conveys the affect appropriate to each viewer's experience and associations.

Fragments of this visual information emerge in the paintings, in which wildly divergent sources are often conflated in a manner that is reminiscent of the workings of our memory. Are the stripes of paint that fragment so many of the paintings from the mid 1940s through to the 1960s inspired by pictures of the vertical searchlights at a Nuremberg rally (fig 10), or are they a recollection of the tight folds in the curtains Bacon designed in the 1930s when he was a furniture designer? Could a photograph of a figure sheltering under blankets and an umbrella on a Leni Riefenstahl film set have inspired *Figure study II* 1945–46 (pp 94–95), or was it the Magdalene from Giotto's fourteenth-century fresco cycle in the Arena Chapel in Padua, Italy? I would say all of the above and much more.[30]

Bacon's fascination with photographs, which he thought brought moments of the real to life in an extraordinary way, can also be considered in relation to indexical realism. The photograph is never only an image of something; black-and-white photographs, in particular, which Bacon's collection mainly comprised, have something of the quality of the trace about them. The French theorist Roland Barthes powerfully expressed this idea in his 1980 book *Camera lucida: reflections on photography* in which he writes about the shock of finding, after his mother's death, a photograph of her as a child.[31] The photograph had nothing to do with his memories of his mother and yet it was a physical trace of her life before he knew her. This remove

Francis Bacon
Untitled (figure) 1950–51
see p 113

fig 10 Third Reich night parade, Nuremberg, Germany, 1937. Bacon was known to accumulate images such as this of Nazi Germany. The floodlights at the Nuremberg rallies may have informed the striations that marked many of his paintings in the 1950s, including *Untitled (figure)* 1950–51.

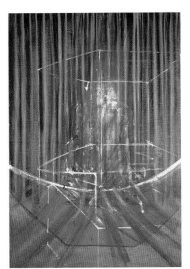
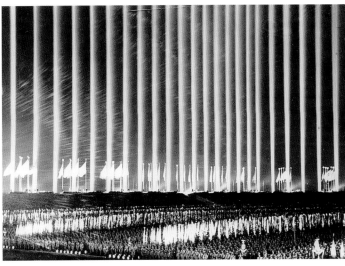

heightened the sense of the object as a trace. Barthes also makes a case for the black-and-white photograph physically fixing the light falling from an object as something like the trace that conveys an absent presence – such as the well-used reference to Man Friday's footprint, which indicates to Robinson Crusoe that he is not alone. Bacon's use of the image as an object – holding, bending and folding it, splattering it with paint, pinning and gluing it down – emphasises this materiality of the photograph as a trace of the real.

Extraordinarily detailed studies have been undertaken of source images relating directly to Bacon's paintings.[32] In 1998 Bacon's sole heir, John Edwards, donated the contents of the artist's studio to Dublin City Gallery The Hugh Lane. Thus began the forensic archaeological process of identifying and recording the precise position of every scrap of paper and abandoned paintbrush so that everything, including the walls, floor and ceiling, could be relocated to The Hugh Lane. Not only was the move brilliantly accomplished, giving us the opportunity to visit Bacon's studio interior just as he left it, but the contents were also scrupulously documented. Some 7500 catalogue entries include more than 1500 photographs collected by Bacon, as well as the tools of his trade, books and pages from journals, and empty boxes that were once full of champagne. A representation of this archive appears in the exhibition courtesy of Dublin City Gallery The Hugh Lane and curator Margarita Cappock has compiled a chapter on this material in this book (p 45).[33]

REALISM AND THE AVANT-GARDE

Bacon's attachment to various aspects of indexical realism, including the photograph as a trace; using materials and objects that are ontologically consistent with the subject, such as dust or sand; and his abhorrence of narrative and illustration, all combine to place him in the company of leading twentieth-century avant-garde artists. Close observation of his works and published statements affirm his commitment to this kind of realism. Superficially, the term 'realism' seems to contradict Bacon's gross distortions of the figure and space. However, it is not a realism of appearances but something much more fundamental to late modernism. Bacon himself noted that it was not illustrative realism, but rather 'a new way to lock reality into something completely arbitrary.'[34] He continued: 'The person who I think got in some ways nearest to it was Marcel Duchamp in *The large glass* which takes to the limit this problem of abstraction and realism'.[35]

Bacon collected many printed references to Duchamp and revealed in interviews that he thought the artist was onto something important. This always seemed strange to me until I thought about it in terms of a realism that shunned illustration and illusion in favour of traces of the real; that is, where the material has an indexical relation to the subject represented. Duchamp's accumulation of dust to represent a series of cone-shaped sieves in the lower half of *The large glass* is a particularly precise example. In order to represent the sieves, Duchamp collected dust which he then fixed to the glass to create the image. He said that he wanted to use materials that in some way partook of the qualities of the subject. Sieves are used to extract particles from a matrix, so he made their likeness by doing just that: collecting dust particles from the air. This is possibly the most convincing use of indexicality in postmodernism and has obvious resonance with Bacon's use of dust. Occasionally,

opposite:

fig 11 Letter from Francis Bacon to Michel Leiris, c1981, see transcript p 29

Appearance can be noticed

Cher Michel

After, the sensation that a state
also but I trust to make enough into the
is of how it worked on me
or perhaps, realism into
of more profound sense
it is always, whenever
when I look at grass
I would at times
a lump of earth and grass
to tear off why and put
it in the frame but of
comes that wouldn't work
and one is forced back into
trying to invent methods
by which the reality of

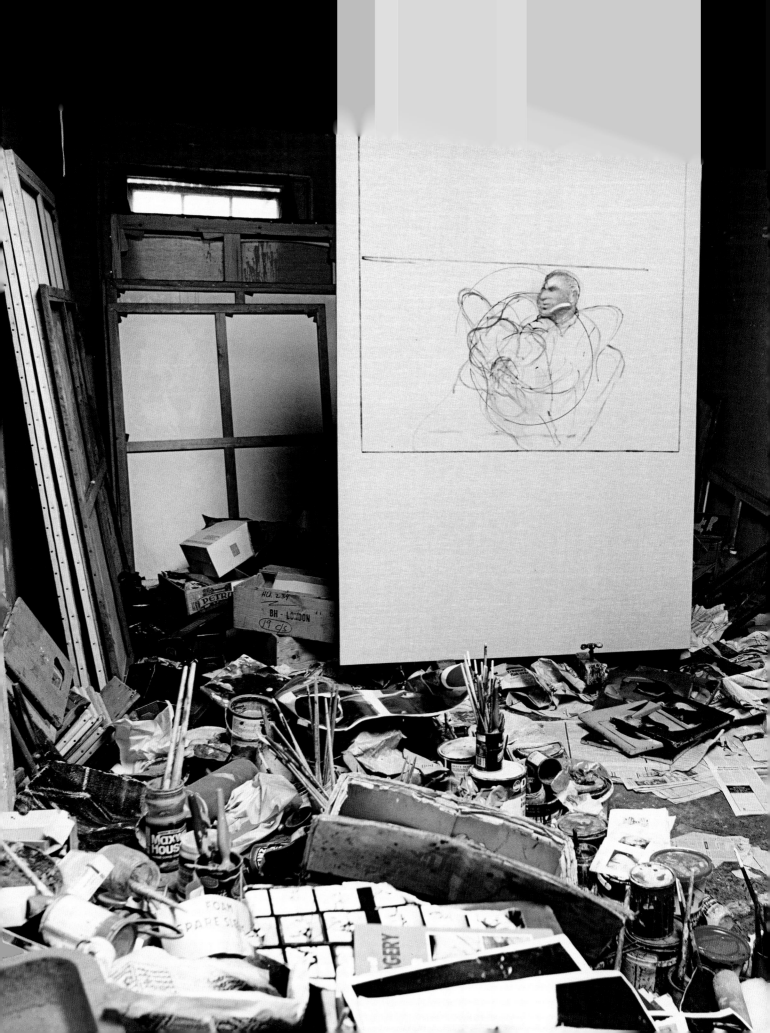

Bacon also used language that suggests an indexical intention. As he explained: 'I would like my pictures to look as if a human being had passed between them, like a snail, leaving a trail of the human presence and memory trace of past events, as the snail leaves its slime.'[36]

Further evidence of Bacon's indexical tendency is revealed in an unpublished letter to Michel Leiris in c1981 (fig 11) in which he wrote:

> For me realism is the attempt to trap appearance with all the sensations that a particular appearance starts up in me … Perhaps realism in its more profound sense is always subjective. When I look at grass I would at times love to tear up a lump of earth and grass and put it in a frame but of course that wouldn't work and one is forced back into trying to invent methods by which the reality can be reimposed on our nervous system.[37]

Another illustration of this interpretation of realism is *nouveau réalisme*, the name of the French avant-garde movement founded in 1960 that took its materials and subjects from the street. Dada after Duchamp and neo-dada similarly harnessed our responses to everyday objects drafted into use as signifiers in a representational regime. This use of found signifiers also had the effect of removing affect associated with the gesture of the artist as a primary meaning of the work.

THE STUDIO AS A CULTURAL BATTERY

When looking at the images of Bacon's studio at Reece Mews, and at the actual materials found there, an even more unexpected association with the avant-garde comes to mind. The floor and tables are piled high with scraps of photographs, pages torn from books and journals, empty boxes often glued together by splattered paint, old paint rollers, coagulated brushes, spray cans, pieces of fabric coated in paint, rubber gloves, and discarded plates once used as palettes. This was a deliberate accumulation of tools and source images for Bacon's paintings and dated back several decades. In an interview with the French art historian Michel Archimbaud, Bacon spoke about his need for chaos: 'The mess here around us is rather like my mind; it may be a good image of what goes on inside me, that's what it's like, my life is like that.'[38]

In his 1985 interview with Melvyn Bragg, Bacon remarked that he could never clean out the mess because the clutter of the studio was his creative source: 'I work much better in chaos … chaos for me breeds images.'[39] This remark suggests a striking similarity between Bacon's productive chaos and the 'fonds' or 'cultural batteries' of the German artist Joseph Beuys (fig 12). For Beuys, a stack of old newspapers was as good as a history book. He also accumulated objects and materials that he found in some way compelling, the best example of which is perhaps *Scene from the stag hunt* 1961, an assemblage of bottles, jars, chemicals, detritus and newspapers now housed in the Hessisches Landesmuseum Darmstadt in Germany.

The shelves that make up this work are piled with relics of ideas, concepts and materials of all kinds, hung with string-tied packages of newspapers that Beuys described as 'batteries' – a store of energy and ideas. A photograph of a section of this assemblage could easily be mistaken for the floor of Bacon's studio. Both served a similar purpose as a kind of reservoir of creative energy, although while Beuys

fig 12 Joseph Beuys
Scene from the stag hunt (*Szene aus der Hirschjagd*) 1961 (detail)
Hessisches Landesmuseum Darmstadt
© Joseph Beuys. VG Bild-Kunst Bonn/Licensed by Viscopy

opposite:
fig 13 Bacon's final unfinished painting on the easel in his studio after his death in 1992.
photographed by Perry Ogden, 1998
Dublin City Gallery The Hugh Lane 1963:15

thought of it as art, Bacon never did. Nonetheless, Bacon's attachment to its charged materiality and the many small traces of things used in his paintings suggests an affinity that must be more than circumstantial.

It is curious that at least one image of Beuys was found in Bacon's studio (fig 14). Presumably torn from a journal, it shows Beuys as a small figure standing at a doorway at the end of a long space – not unlike the figure in the doorway in *Las Meninas* (see fig 8, p 23). In the early 1970s, according to John Russell, the British artist Richard Hamilton arranged a dinner between Beuys and Bacon which it seems was something of a flop. Beuys was keen to connect with Bacon but their worldviews were too different. Bacon was looking for someone who understood painting enough to give him sound criticism, and that person was not Beuys. However, Hamilton's impulse was right: Beuys should have made sense to Bacon.

David Sylvester also repeatedly tried to get Bacon to talk about the reasons why Duchamp was so important to him. Bacon always confirmed his admiration but never explained why. The hints of a shared indexical realism that I have traced above might only be indicative of a significant thread, but I would be surprised if new evidence and scholarship do not one day make more of this.

BACON'S LEGACY

When all the analysis and connections to sources are done, Bacon will remain as a giant among artists, his life's work never able to be explained away. I suspect that like Duchamp's legacy, Bacon's imagery will continue to be re-interpreted and discoveries made and contradicted for generations to come – not just because of the strange ambiguities woven into every canvas but simply because his talent exceeds even his own ambition. Bacon said that he wanted to be able to hang alongside the Old Masters in the National Gallery in London – or why bother to make art at all? The remarkable 2011 exhibition, *Caravaggio Bacon*, at the Galleria Borghese in Rome, would have pleased him immensely.

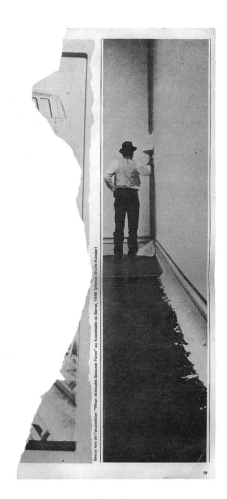

fig 14 Fragment from *Chroniques de l'Art Vivant*, no 48, 1974, in Bacon's studio, with photograph of Joseph Beuys captioned: Beuys lors de l'exposition (When attitudes become form), Kunsthalle de Berne, c1969 (photo: Shunk–Kender).
Dublin City Gallery The Hugh Lane F16:295B

opposite:

Francis Bacon
Study of a nude 1952–53 (detail)
see p 123

30

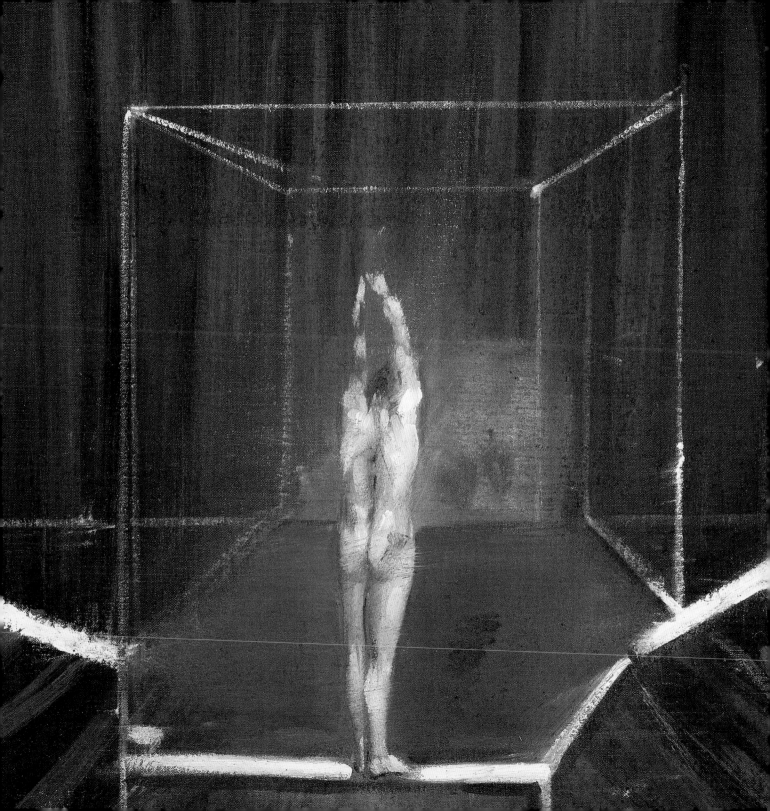

KODAK SAFETY FILM 5063 KODAK SAFE

→2A →3 →3A →

FILM 5063 KODAK SAFETY FILM 5063

→8A →9 →9A →10

FILM 5063 KODAK SAFETY FILM 5063

AUSTRALIAN CONNECTIONS

Martin Harrison and
Rebecca Daniels

Francis Bacon never quite made it to Australian shores: an attempted trip in the 1980s was cancelled due to ill health. Yet Australia and Australians played a significant part in his life. His father, Anthony Edward Mortimer Bacon, was born in Adelaide, the grandson of Major General Anthony and Lady Charlotte Bacon. Lady Charlotte had been immortalised as 'Ianthe' by Lord Byron and this, coupled with her vigorous interest in South Australian affairs, made her something of a celebrity during her 12 years' residency in Walkerville, Adelaide.[1] This chapter explores Bacon's artistic connections with Australia, principally his debt to Roy de Maistre who, according to art historian John Richardson, 'was crucial to Bacon';[2] it also proposes reciprocities with two of Bacon's foremost Australian artist-contemporaries, Sidney Nolan and Brett Whiteley.

BACON AND ROY DE MAISTRE

Notwithstanding his persistent claims that he had been a 'late starter', Francis Bacon had set up an interior design studio in London in 1929 at the age of 19. During 1928 and 1929, and possibly earlier, he stayed for prolonged periods in France and Germany. According to Bacon it was a Picasso exhibition at Galerie Paul Rosenberg, Paris in 1927 that inspired him to try to become a painter, in which case he was referring to *Cent dessins par Picasso* (*One hundred drawings by Picasso*) shown in the spring of that year. On other occasions he spoke about having once admired some of Picasso's 'very decorative still-lifes', or expressed a strong preference for his Dinard period beach scenes. Yet in one of his last interviews Bacon was unequivocal about the importance of 'an exhibition of paintings of women with those enormous bodies that he painted in Dinard'.[3] These apparent contradictions may indicate that he simply misremembered the date of his Picasso epiphany, or conflated discrete events: his familiarity with Picasso reproductions in the magazine *Cahiers d'Art* needs also to be taken into account. Paradoxically, none of Bacon's few extant works made prior to 1933 bear any trace of Picasso's surrealistic 'bone' period, whereas there are indirect references in them to his neoclassicism.

Roy de Maistre emigrated from Australia to London in March 1930. Despite being one of the acknowledged founders of abstract art in Australia, by 1929 de Maistre had been working as an art teacher and interior designer in Sydney. In the same year he organised a successful exhibition of antique and modern interiors at Burdekin House in Macquarie Street (de Maistre had designed some of the contemporary furniture).[4] When de Maistre arrived in London, however, he immediately reverted to painting and

opposite:
Brett Whiteley painting Bacon's portrait at Bacon's studio, 7 Reece Mews, South Kensington, October 1984.
photographed by John Edwards

there is no evidence he ever returned to decoration. Evidently he became acquainted with Bacon soon after his arrival, for in November 1930 he showed a *Portrait of Francis Bacon* in an exhibition in which he, Bacon and Jean Shepeard participated, held in Bacon's studio at 17 Queensberry Mews West, South Kensington. Bacon showed both rugs and paintings: the average price of his five paintings was £35, while that for de Maistre's seven was only £31. This is a surprisingly skewed reflection of their relative status at that time – it was Bacon's first exhibition, while de Maistre, 15 years his senior, brought not only his experience as a painter in Australia, he had also been given a solo show at the Beaux Arts Gallery, London, in July 1930.

There is scant documentation for this period of Bacon's life, but certain passages in his small extant output between 1930 and 1932 are redolent of the French artists Jean Lurçat, Jean Souverbie and Fernand Léger, as well as the English artists Paul Nash and Edward Wadsworth. Since both Bacon and de Maistre were in Paris in the 1920s it is problematical to disentangle the impact on them of the cubists Auguste Herbin and Jean Metzinger, but clearly their example informed the cubistic style that de Maistre adopted from the 1930s onwards. Unfortunately, few of de Maistre's early paintings made in London are securely dated. However, in his large and ambitious *Conflict* 1932 (Art Gallery of New South Wales) (fig 17), which in some respects resembles a more painterly, less geometricised Wadsworth, the resonances of Picasso in the biomorphic form with its triangular 'hand' pre-date Bacon's quotations from the Spaniard. Yet if de Maistre was instrumental at this stage in the range of visual stimuli that Bacon was absorbing, their artistic dialogue appears to have become reciprocal early on, as Bacon's 'extraordinary natural talent'[5] rapidly manifested itself.

The first surviving artworks by Bacon are a watercolour and a gouache of 1929. Although his ambition was to be a painter, he appears to have been unsure of his ability to support himself solely through painting, for he maintained an intermittent involvement with interior decoration until the late 1930s. It is likely that the relationship between Bacon and de Maistre was, briefly at least, sexual (Bacon later denied it, but it is certainly the perception of de Maistre's descendants). According to the painter Joan Bell, wife of the composer Christian Darnton who bought one of Bacon's curved stools in the 1930s, 'Bacon looked like an angel',[6] a description borne out by de Maistre's fond portrait of him. The first painting listed in the catalogue of the exhibition held at 17 Queensberry Mews West is *Portrait of Francis Bacon* by de Maistre (fig 16). There are compelling reasons to suggest that a portrait of Bacon, traditionally assigned to 1935, was in fact the painting exhibited in 1930, not least because Bacon is represented as a shy and slightly apprehensive 20-year-old. Older men, in particular, clearly found Bacon extremely attractive. Eric Hall (1890–1959) was already his lover in 1929, and almost certainly financed Bacon's design studio; his relationship with Bacon outlasted de Maistre's, continuing until about 1949. Hall and John Eric Allden (1886–1949), another older homosexual, along with Gladys MacDermot, Sir Michael Sadler and Bacon's second cousin, Diana Watson, were Bacon's sole patrons up until 1946. De Maistre's admiration for the young artist was manifested in a rather unusual way. In 1930 he made two oil paintings of the interior of Bacon's studio at Queensberry Mews West, the first in a group of paintings on this theme that betokens an obliquely expressed but touching affection that amounted almost to veneration (fig 15).[7]

A shift in the balance of power between the two artists (a paradigm for the trajectory of Bacon's career) was soon apparent, but de Maistre's guidance helped

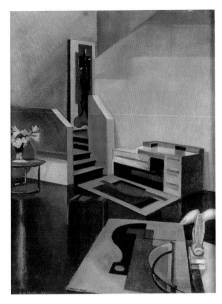
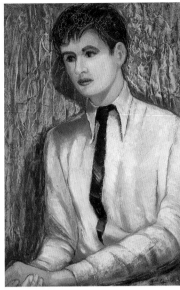
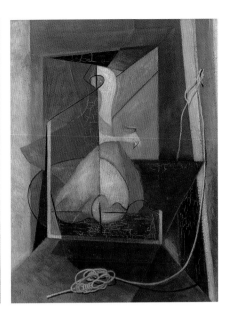

from left:

fig 15 Roy de Maistre
*Francis Bacon's Queensberry Mews
studio* 1930

oil on canvas, 64 x 44.5 cm
The Estate of Francis Bacon
© Caroline de Mestre Walker

fig 16 Roy de Maistre
Portrait of Francis Bacon 1930
(or 1935?)

oil on board, 64.5 x 41.5 cm
Private collection, Melbourne
© Caroline de Mestre Walker

fig 17 Roy de Maistre
Conflict 1932

oil on canvas, 112 x 86.5 cm
Art Gallery of New South Wales
Purchased 1960
© Caroline de Mestre Walker

fill significant gaps in the untrained Bacon's technique. It suited Bacon's later revisions of his history to cast himself as an autodidact, yet irrespective of de Maistre's typically diffident suggestion that he had merely 'shown Bacon a few things',[8] he confided to the English art historian and director of the Tate Gallery John Rothenstein his surprise that Bacon 'knew nothing whatsoever about the technical side of painting and had scarcely drawn at all'.[9] De Maistre probably expanded the younger man's grasp of art history too, directing him, for example, to Roberto Longhi's 1930 monograph on Piero della Francesca, from which source de Maistre quoted, in a cubistic variation, *Three heads (after Piero della Francesca)* 1933 (Art Gallery of New South Wales) and Bacon the dog that appears in the foreground of his painting *Figures in a garden* 1936 (Tate Britain). De Maistre was able to impart knowledge without the strict pedagogy that Bacon would have found uncongenial: in 1934, with the artist Martin Bloch, de Maistre opened the short-lived School of Contemporary Painting and Drawing (close to de Maistre's studio in Ebury Street, London) and significantly their precepts valued self-expression above formal discipline, the final conception above laborious process.

Bacon did acknowledge that de Maistre introduced him to Gladys MacDermot.[10] MacDermot lived in Australia from 1924 to 1929 and had been an important patron of de Maistre in Sydney.[11] In addition to buying his paintings, a room from her house was included in de Maistre's Burdekin House exhibition and her daughter received painting lessons from him.[12] In late 1932 or early 1933 Bacon was commissioned to design and furnish MacDermot's London flat at 98 Ridgmount Gardens, Bloomsbury. The commission was substantial and included a dining table and chairs, a sideboard, and a desk and coffee tables, which continued to be used by the family for decades.[13] MacDermot later bought a pen, ink and wash on paper by Bacon, *Corner of the studio* 1934 (private collection), which explored the theme of the artist's studio, focusing on the floorboards, door and walls in a freer and more abstract style than de Maistre's, and in which the easel could also be interpreted as a biomorph.

Bacon's other important furniture commissions were also due to de Maistre, and all have a link to Australia. Rab Butler and his wife Sydney (née Courtauld) met de Maistre while honeymooning in Sydney in 1927 and remained close friends with him after their return to England.[14] De Maistre introduced them to Bacon, from whom

fig 18 Francis Bacon
Untitled (head) c1949
Private collection

fig 19 X-ray of Francis Bacon's
Untitled (head) c1949 showing a
Roy de Maistre painting underneath.

they commissioned a glass dining table with two thick chrome parallel steel supports and a bubbled frosted glass top, as well as two laminated stools for their house in Smith Square, Westminster.[15] It was undoubtedly through his friendship with the Butlers and de Maistre that Douglas Cooper, also originally from Australia and co-director of the Mayor Gallery in London from 1933 to 1938, commissioned a desk from Bacon. Cooper, infamous for his spiteful attacks on former friends, fell out with Bacon in the 1930s but kept the desk in his house to show guests how bad he thought it looked.[16]

In 1938 the Butlers sold their furniture to Patrick White, who was then renting a flat from de Maistre above his studio at 13 Eccleston Street, Victoria, London. White had decided to decorate in the modern taste, which he could scarcely afford: he was still working on his first novel, *Happy valley*, which was published in the following year and dedicated to de Maistre.[17] Nevertheless, the determined White came up with a solution: 'I think I may be solving that problem by having it designed by a painter I know called Francis Bacon, and made up bit by bit as my pocket allows in some workshop.'[18] Significantly, White described Bacon as a 'painter' whose subject at that time was the obsessive study of false teeth, most works of which he destroyed.[19] This may refer to the works by Bacon in *An exhibition of paintings* at Agnew's in 1937, which received unfavourable reviews.[20] Bacon had not completely abandoned design, since he produced for White 'a magnificent desk with wide, shallow drawers and a red linoleum top'.[21] White auctioned all his furniture when he left England in 1947 and the desk has long since disappeared, although two photographs survive of his dining room and study with Bacon's furniture and de Maistre's paintings.[22]

After Bacon left the Queensberry Mews West studio in 1932 he appears to have occupied a studio in Carlyle Studios, Chelsea, in which building de Maistre also had a studio. If there was an amorous relationship between Bacon and de Maistre it probably did not outlast de Maistre's affair with Robert Wellington, which began in late 1933. They remained close as artists, however, until 1936, after which Bacon virtually ceased to paint for the next eight years. Patrick White, who became de Maistre's lover in 1936, also remembered 'The odd passion of de Maistre and Bacon for newspaper photographs',[23] referring to a shared interest that would have profound repercussions for Bacon's process and iconography. A painting that directly testified to their artistic dialogue reappeared on the art market in 2007, a thickly impastoed head by Bacon, c1949, on a composition board support (fig 18). Two signatures of Roy de Maistre remain visible at the lower corners of the painting and X-rays revealed a composition by de Maistre underneath, possibly a Madonna and child (fig 19). It may indicate that de Maistre was providing Bacon with materials at a time of postwar shortages, or that Bacon overpainted a work he had acquired previously.[24]

As director of the Tate Gallery from 1938 to 1964, (Sir) John Rothenstein played a significant part in both artists' careers. He first heard of Bacon in June 1943, when de Maistre and Graham Sutherland spoke to him with enthusiasm about the 'work of a strange but gifted painter'.[25] Rothenstein's affection for de Maistre is conveyed in his sympathy for this 'deeply civilised man', whose 'fastidious and reticent'[26] manners and benevolent urbanity he doubtless found more congenial, at a social and personal level, than the inebriated 'teddy-boys with exotic haircuts and leather jackets'[27] with whom Bacon associated. Yet in 1962, when Rothenstein oversaw the first major retrospective exhibition devoted to Bacon, an event that sealed the increasingly international dimension of his renown, de Maistre's simultaneous award

of a Commander of the British Empire (CBE) served to underline his acceptance as merely an English establishment figure.[28] Moreover, although the Tate Gallery acquired four of de Maistre's paintings in the 1950s (three of which were gifts), Rothenstein failed to honour him with an exhibition; he did, however, contribute an introduction to the catalogue of the de Maistre retrospective that Bryan Robertson mounted at the Whitechapel Art Gallery in 1960.

From 1949 onwards the three foremost British art critics, Robert Melville, David Sylvester and Lawrence Alloway, avidly took up Bacon and their essays and reviews helped establish his pre-eminence in the British figurative avant-garde. All three writers situated Bacon within the long tradition of European high art, relating him to Rembrandt and Velázquez, as well as Manet, Degas and van Gogh. A few brief quotes from the artist himself concerning his inspirations were published prior to 1962, at which point Sylvester commenced his now-famous series of interviews with Bacon. The sole exception to this was Bacon's text on Matthew Smith, written with the help of Sylvester, for the catalogue of Smith's retrospective at the Tate Gallery in 1953. Thereafter, Bacon was interrogated almost exclusively in the context of the masters of the Grand Manner, or pioneers of modernism such as Picasso and Marcel Duchamp. That he was also coerced into condemning the abstract expressionism of his American contemporaries Jackson Pollock and Mark Rothko was probably a reaction to Sylvester's preoccupations as much as a reflection of Bacon's.

It cannot be overstressed, therefore, that Bacon's perspective on the first half of his career was conveyed (and, since his death, is constantly referred to) either in redacted form or with the memory lapses of hindsight. Either way, Bacon seldom discussed – and may not have been asked about – his English contemporaries, even those who had formerly played a part in his own development. In one of his last interviews he mentioned Graham Sutherland, disingenuously describing him as 'a painter, who is dead now', as though his interlocutor might not have been familiar with his work.[29] Similarly, he never acknowledged de Maistre in interviews, nor indeed Walter Sickert, whose use of photographs and painterly daring had clearly resonated with him. Consequently, it might be inferred that after 1936 he saw little of de Maistre, but this was not the case, for the two men remained on good terms. In October 1960 Bacon made a positive intervention in the matter of paintings by de Maistre intended for the new Roman Catholic Church of the Immaculate Heart of Mary in Hayes, Middlesex. De Maistre, conscious of his failing health, recognised that he could not complete the commission unaided and in conversations with Bacon and William Redgrave it was decided that Redgrave would supply the portrait of *St Mary Anthony Claret* and de Maistre a large, boldly coloured *Crucifixion*. The Italian portrait artist Pietro Annigoni painted the huge reredos of the *Madonna and child*.[30]

Bacon was required to attend church while growing up in Ireland, and in the 1930s he may not have identified so firmly with atheism; he probably had not read Nietzsche at this point, and both Eric Hall and de Maistre were churchgoers. It is plausible that de Maistre's Christian faith, and the turn to religious themes in his paintings at this time, played some part in Bacon's early iconography, notably in the three crucifixions he painted in 1933. Douglas Cooper persuaded the English art critic Herbert Read to include one of these in his 1933 book *Art now*, in which it was reproduced opposite Picasso's *Baigneuse* (*Bather*) 1929 (fig 79, p 86). If all Bacon's paintings before 1944 might be considered tentative or exploratory, *Crucifixion* 1933 (p 87) is the most

resolved and the least overtly derivative, despite the obvious Picasso borrowings in its etiolated forms; it also evinces Bacon's first virtuosic achievement in handling *paint*, a haunting grisaille in which the ghostly figures leave a trace of sfumato blur. Its sinister, disquieting overtones signified, too, Bacon's sharp divergence from de Maistre: if Bacon's program was not fully realised until 1949, partly due to his staccato career, he had signalled that the aspect of de Maistre's art characterised by John Rothenstein as 'aggressive to the point of harshness' would be conveyed with greater intensity in his own work.[31] De Maistre remains under-appreciated in both Australia and England, and his rapid eclipse was starkly symbolised less than a year after his death, when the Tate Gallery contacted de Maistre's descendants to enquire if they owned further paintings of Bacon's studio, stressing that, in their opinion, they were de Maistre's most interesting work.[32]

BACON, NOLAN AND WHITELEY

When Sidney Nolan first visited London in 1950 he was already being promoted by the influential English art historian Kenneth Clark, who had been deeply impressed by his art on a trip to Australia in 1949.[33] The Redfern Gallery, with its antipodean management, held Nolan's first solo show in London, which opened to critical acclaim in January 1951.[34] By the time Nolan made London his permanent home, in 1953, he was holding regular exhibitions and being reviewed by the leading critics, including David Sylvester, Colin MacInnes, Quentin Bell and Robert Melville. In fact, Melville wrote at length on both Nolan and Bacon.[35]

Although no documentation has emerged to confirm that Bacon and Nolan were friendly, certain parallels and coincidences suggest they were probably aware of one another's paintings. Their paths could have crossed many times: Bacon exhibited paintings (although these may have been stock items) at the Redfern Gallery in the 1950s, and they represented their respective countries at the 1954 Venice Biennale. They shared mutual friends, such as the writers Stephen Spender, Colin MacInnes, Patrick White and later the pop sculptor Clive Barker; both could count Sir Colin Anderson as a patron,[36] they were written about by the same critics, and were photographed in their respective studios by Douglas Glass in 1957.[37] Marlborough Fine Art in London represented Bacon from 1958 and Nolan from 1963.

During this period, both Bacon and Nolan were experimenting with the leitmotif of the isolated figure. In May 1955 Nolan held an exhibition at the Redfern Gallery that included new renditions of a subject upon which his reputation was largely based, the Victorian bushranger Ned Kelly. While David Sylvester recognised the 'irresistible charm' of the first series (1946–47), which Nolan saw as 'very angry, violent pictures', he considered the new works, created in London, an important development which had 'acquired breadth and luminousness and complete conviction'.[38] In the majority of his Ned Kelly works, Nolan depicted Kelly in his armour, a black mask with a rectangular cut-out for the eyes, riding off into the Australian wilderness or fixed within the narrative of the Kelly Gang. The reception of the works in England immediately drew parallels with Bacon, and Alleyne Zander, the Australian critic and former manager of the Redfern Gallery, noted that 'the bushranger is monstrous in the Baconian manner'.[39] As recognisable as Bacon's popes, they were, in Robert Melville's words, 'an interplay of spectral apparition and human presence'.[40]

The history and folk-mythology of the Kelly Gang centred on the violent resistance among the Irish-Australian Catholic working class to the oppression of an Anglo-Australian colonial hierarchy.[41] Given both Bacon's and Nolan's close family connections with Ireland, the story would have resonated with them, if for slightly different reasons. Nolan, who himself was of working-class Irish descent, became fascinated with Kelly through the stories his grandfather told him of his days as a policeman hunting the Kelly Gang. Bacon spent much of his childhood in Ireland: he, however, was the scion of a relatively wealthy English Protestant family and his grandmother married the Kildare District Inspector of the Royal Irish Constabulary.[42]

In November 1954 Nolan returned to London from Italy and commenced his second series of Kelly paintings. It seems likely that before he returned to the masked figure on horseback he painted a transitional work, *Death of a poet* 1954 (fig 20) (Walker Art Gallery, Liverpool). In this painting the death mask of Ned Kelly is set against a brilliant blue background, surrounded by foliage that the art historian TG Rosenthal interpreted as a crown of thorns.[43] The move from violence to melancholy may have been influenced by Nolan's focus on religious painting following his trip to Italy. By removing Kelly's helmet, Nolan creates a portrait of great sensitivity that is, as Rosenthal points out, the only true likeness of Kelly that Nolan ever painted.[44] Exhibited at the Redfern Gallery in May 1955 as *Death of an outlaw*, it is possible that Bacon saw the work and that it informed his series *Study for Portrait I–V (after the life mask of William Blake)* (fig 21), which he commenced in the same year.[45]

The precise dates of Bacon's Blake paintings are uncertain: the Tate curator Ronald Alley, co-author of the Bacon catalogue raisonné, stated that the first three in the series were completed at the Imperial Hotel in Henley in January 1955, although this may have included the two works in the series that he destroyed.[46] If Alley was correct the Nolan painting could not have been relevant in this context, unless Bacon had seen it at the Redfern Gallery before the show started, or at Nolan's studio, which is unlikely. Bacon embarked on the series in response to a request from his friend, the composer Gerard Schurmann, to provide a cover illustration for his score of *Nine poems of William Blake*; Schurmann cites the date of his Blake songs as 1956, not 1955. However, Robert Sainsbury, Bacon's patron, believed Bacon had completed the works shortly before they were exhibited at the Hanover Gallery in June and July 1955,[47] in which case Bacon could have seen Nolan's work in May 1955 and borrowed the formal arrangement for his Blake paintings: Bacon typically painted with greater urgency when faced with an impending exhibition deadline.[48]

Some doubt also surrounds the sequence of the Blake paintings. A note in Alley's preliminary papers for his catalogue raisonné of Bacon's work suggests that Schurmann and Caroline Citkowitz (formerly Lady Caroline Blackwood, then owner of *Study for Portrait II [after the life mask of William Blake]*) both thought that *Study for Portrait III* was painted first, followed by *II* and then *I*.[49] If Bacon had been inspired by Nolan's death mask this chronology seems more appropriate. Like Nolan's painting, *Study for Portrait III (after the life mask of William Blake)* is more sculptural, and Bacon includes the prominent circular base of the life-mask that he largely excludes from the other works in the series. Both artists positioned the masks in the same three-quarter pose and they made the unusual decision of floating a sculpture in space (although Nolan's is surrounded by foliage) to further isolate the sitter. While Bacon followed the photographic reproduction quite closely, he reduced the prominence

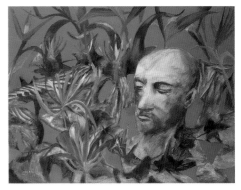

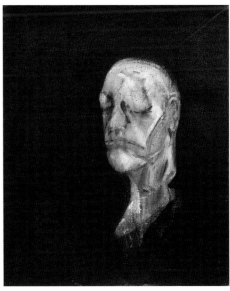

fig 20 Sidney Nolan
Death of a poet 1954
Ripolin enamel on hardboard, 91.5 x 122 cm
Walker Art Gallery, Liverpool
© The Trustees of the Sidney Nolan Trust

fig 21 Francis Bacon
Study for portrait II (after the life mask of William Blake) 1955
oil on canvas, 61 x 50.8 cm
Tate, London. Purchased 1979

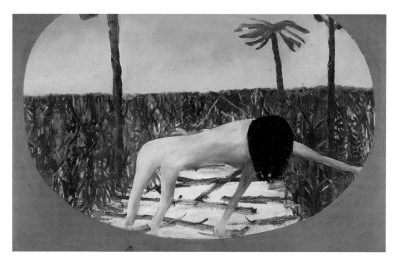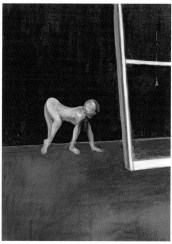

fig 22 Sidney Nolan
Mrs Fraser 1947

Ripolin enamel on hardboard, 66.2 x 107 cm
Queensland Art Gallery
Purchased 1995 with a special allocation
from the Queensland Government.
Celebrating the Queensland Art Gallery's
Centenary 1895–1995
© The Trustees of the Sidney Nolan Trust

fig 23 Francis Bacon
*Paralytic child walking on all fours
(from Muybridge)* 1961

oil on canvas, 197.5 x 140 cm
Haags Gemeentemuseum, The Hague

of the base substantially, so that his work appears less solid and grounded. In the remaining works by Bacon the masks seem to move away from the sculptural to become increasingly human; in *Study for Portrait IV (after the life mask of William Blake)*, for example, they seem to be amalgamated with the features of Bacon's lover Peter Lacy.

William Blake's *Nebuchadnezzar* 1795 (Tate Britain) is a viable prototype for Nolan's powerful and similarly animalistic painting *Mrs Fraser* 1947 (Queensland Art Gallery) (fig 22).[50] Nolan has chosen a literal outsider, as Jane Clark points out, for his subject. Mrs Fraser was shipwrecked with her husband, the captain, and other crew members on Fraser Island off the coast of Queensland. Captain Fraser was subjected to hard labour and then murdered by the natives, while Mrs Fraser was forced into domestic slavery.[51] She eventually escaped to the mainland, helped by Bracewell, himself an escaped convict, for whom she promised to plea to the authorities for a pardon. Mrs Fraser betrayed him but he managed to flee back into the bush.[52]

Nolan portrays Eliza Fraser as naked, desperate, crawling along the mangroves, her hair covering her face to hide her shame;[53] always a thorough researcher, he had travelled to Fraser Island in 1947 to make an intensive study of its topography.[54] The curator Barry Pearce has observed that *Mrs Fraser* bears some similarities to Bacon's *Figure study II* 1945–46 (p 95),[55] and there are links in the crawling figures, their faces directed to confront the viewer. In *Mrs Fraser*, Nolan also appears to have referenced the outer panels of Bacon's *Three studies for figures at the base of a crucifixion* c1944 (fig 24). Although Nolan's figure clearly represents a woman, her body is strangely androgynous, her genitals and breasts absent from his stripped-down portrayal, half-woman, half-animal. Nolan's painting carries echoes of the outstretched biomorph in the right panel of Bacon's groundbreaking work and of the woman's face, largely obscured by hair, from the left panel.

Another possible source for the figure of Mrs Fraser is Eadweard Muybridge's photograph *Infantile paralysis: child walking on hands and feet*, plate 539 in *Animal locomotion* of 1887. The angle of the figure's back legs with the slightly raised hipbone is very close to frame 10 in Muybridge's sequence. Bacon used this Muybridge plate to form the basis of his *Paralytic child walking on all fours (from Muybridge)* 1961 (fig 23). While the title of this work clearly references the Muybridge source, it is possible that Bacon recalled the atmosphere created by Nolan in *Mrs Fraser*. Bacon could have seen the painting in the retrospective of Nolan's work at Whitechapel Art Gallery in 1957.

Both Bacon and Nolan were largely self-taught and relied on reproductions of art – Nolan partly out of necessity due to his distance from Europe while he was training.

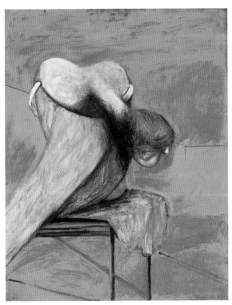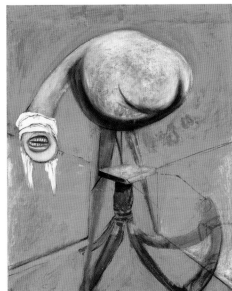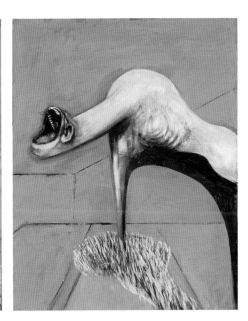

fig 24 Francis Bacon
*Three studies for figures at the
base of a crucifixion* c1944

oil on board, triptych, each 94 x 73.7 cm
Tate, London. Presented by Eric Hall 1953
© Tate, London

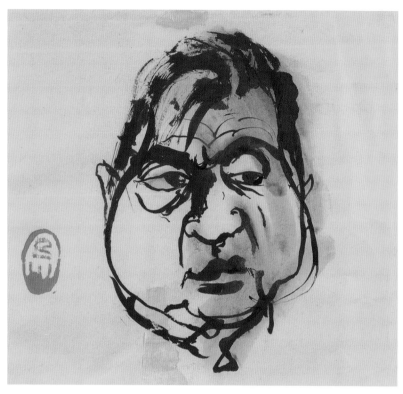

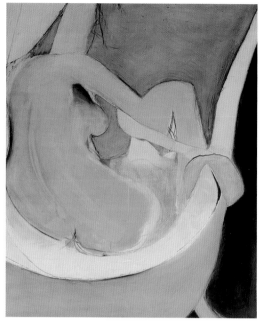

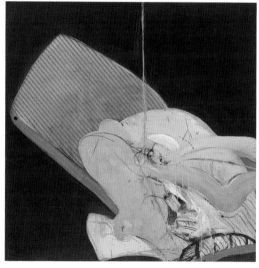

clockwise from above:

Brett Whiteley
Francis Bacon c1984–89

ink drawing on paper, 22.5 x 20.5 cm
Private collection, Sydney
© Wendy Whiteley

fig 25 Brett Whiteley
Woman in a bath 1964

oil, charcoal, tempera, material and
collage on plywood, 146.8 x 120 cm
Private collection, Melbourne
© Wendy Whiteley

Australian artist Brett Whiteley was
deeply influenced by Bacon, as can
be seen in his distortions of the body.

fig 26 Brett Whiteley
Small Christie painting no 1 1965

oil, encaustic and collage of cotton
fabric on plywood, 86.2 x 86.2 cm
National Gallery of Australia, Canberra.
Purchased 1966
© Wendy Whiteley

Mutual influences may be only coincidental, but Bacon and Nolan were, almost contemporaneously, working towards similar solutions in their art: according to his daughter Jinx, Nolan admired one of Bacon's pope paintings and Bacon may have been looking at Nolan's work.[56]

There is no evidence for a comparable dialogue between Bacon and Brett Whiteley. They met, however, at Whiteley's request, at the opening dinner of the exhibition *Recent Australian painting*, held at Whitechapel Art Gallery in 1961.[57] From that time Whiteley's London works are heavily indebted to familiar Bacon motifs, and Bacon had a reproduction of one of Whiteley's bath series in his studio.[58] In Whiteley's bath series the twisted and turning female bodies recall Bacon's turning and reclining nudes of 1960–62, and in *Woman in a bath* 1964 (private collection, Melbourne) (fig 25) the female's back curves sensually, echoing the shape of the bath. Here, and in his *Bathroom drawing* 1963 (private collection, Sydney), Whiteley is revealed as sharing Bacon's lifelong interest in Degas, and in particular Bacon's fascination with Degas's depiction of the spine. It is possible that Bacon discussed this with Whiteley. As Bacon explained to David Sylvester:

> you will find at the very top of the spine that the spine almost comes out of the skin altogether. And this gives it such a grip and a twist that you're more conscious of the vulnerability of the rest of the body than if he had drawn the spine naturally up to the neck. He breaks it so that this thing seems to protrude from the flesh.[59]

In *The artist's eye: Francis Bacon*, an exhibition held at the National Gallery, London, in 1985, Bacon chose Degas's *After the bath: woman drying herself* c1890–95 for the cover of the catalogue. As David Sylvester pointed out, Bacon had borrowed the device of a twisted spine in his *Study from the human body* 1949 (p 103), a painting acquired by the National Gallery of Victoria in 1953.

Whiteley's Christie murder series (fig 26) was immediately compared with the 'horror' of Bacon's work, but Whiteley borrowed the more mundane motif of the bed, with its traditional pattern of mattress ticking, from two works by Bacon from 1963, *Study of Portrait of PL from photographs* (destroyed) and *Lying figure with hypodermic syringe*. Whiteley would have seen Bacon's work at Marlborough Fine Art, where he showed both the bath and Christie series in 1964 and 1965 respectively. Bacon and Whiteley's continuing friendship culminated in a sitting at Bacon's studio in October 1984 for Whiteley's triptych homage, *Francis Bacon at 75*. Photographs of the event, taken by John Edwards, provide a compelling visual insight into Bacon sitting for Whiteley. Back in Sydney at the end of November, Whiteley wrote to Edwards: 'Mate, could you please send me some of the photos you shot that wonderful day as I am full blaze into a portrait of Francis & it would help enormously.'[60] It is possible that Whiteley had taken Bacon a copy of Peter James's book, *Lifesaver* (1983), as a gift for the sitting. Whiteley refers to the lifesavers who were 'rolling them up a bit' when the photographer, 'well-known and gay' appeared and 'it got round that this book was in production'. With characteristic Whiteley wit he inscribed the book 'dear Francis theres [sic] "wonderful" mixture of Muybridge & Michaelangelo & Ucello [sic] in here after seeing "Jet of Water". I am sure theres [sic] some visual triggers in here for you for 1985!' Whiteley returned to London in 1985 and 1989, but any further possibility of meetings between the two artists was abruptly terminated in 1992, the year in which, by a doleful coincidence, the art world lost Bacon, Whiteley and then Nolan.

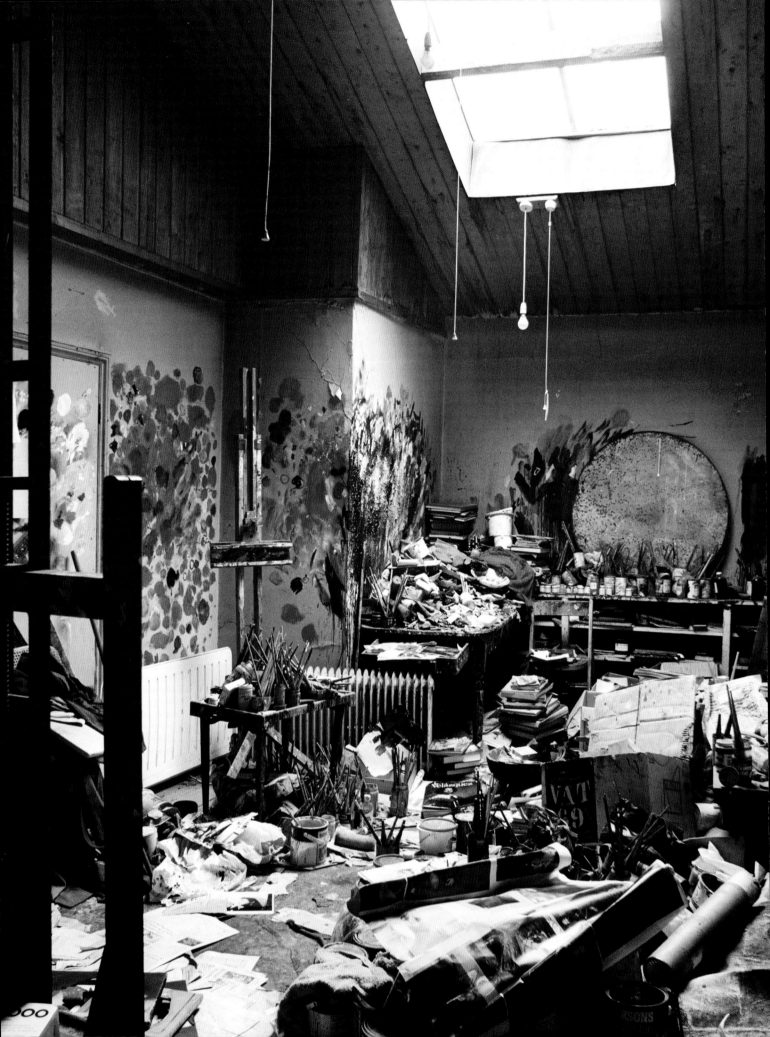

FRANCIS BACON'S STUDIO

Margarita Cappock

In the autumn of 1961 Francis Bacon moved to 7 Reece Mews, a modest three-room dwelling in South Kensington, London, which served as his principal studio and residence until his death in 1992 (fig 27). An inveterate hoarder of pictorial material, Bacon eventually accumulated more than 7500 items in this space, including books, magazines, newspapers, photographs, drawings, handwritten notes, destroyed canvases and artists' materials (figs 28 & 29).

Of this cluttered mess Bacon said: 'I feel at home here in this chaos because chaos suggests images.'[1] This small room was to become the locus for the production of some of the most powerful and uncompromising paintings of the twentieth century. After Bacon's death, the studio remained largely untouched until 1998 when the artist's sole heir, John Edwards, presented it to Dublin City Gallery The Hugh Lane. Thus began the mammoth task of removing this prodigious mess from its original home and transporting it to Dublin where it was faithfully reconstructed and opened to the public in 2001. This process, with its forensic attention to detail, uncovered the full extent of Bacon's visual archive, which was much larger than anticipated. During his life, Bacon had allowed only his closest friends into his Reece Mews studio.

Aside from acknowledging the obvious debts in his work to the British photographer Eadweard Muybridge and artists such as Michelangelo, Velázquez and van Gogh, Bacon was guarded in terms of revealing any other material from his visual archive or his absorption of images. The studio contents provide us with a wide-angle view of Bacon's artistic agenda, thought processes and working methods, and suggest the origins of aspects of individual works of art. The material discovered in the studio has changed the shape and focus of studies on Bacon and provides an astonishingly detailed portrait of the artist and his work practices.

PHOTOGRAPHY

Photography played a central, if often subterranean, role in Bacon's work and the large stockpile of photographs in his studio amply confirms his reliance on the medium. Photographs, of course, made up only one part of a much wider visual store that included illustrated publications such as books, magazines, newspapers and catalogues. As Bacon stated: '99 per cent of the time I find that photographs are very much more interesting than either abstract or figurative painting. I've always been haunted by them.'[2] Bacon's use of photographs developed gradually but pre-dated his arrival in Reece Mews by some 30 years. The relevance of photography to his art

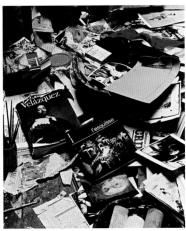

top:

fig 27 Exterior of 7 Reece Mews, South Kensington, London. photographed by Perry Ogden
The Estate of Francis Bacon

opposite and above:

figs 28 & 29 Francis Bacon's studio at Reece Mews, South Kensington. photographed by Perry Ogden, 1998
1963:14, 1963:06

Unless indicated otherwise, all photographs and archival ephemera illustrated in this essay are from the collection of Dublin City Gallery The Hugh Lane.

in the 1930s, however, was insubstantial, and with the exception of two works the few surviving paintings from this period betray no signs of a specific photographic debt.

Bacon's painting *Figure in a landscape* 1945 (p 91) marked a turning point by using as its main reference a photograph of the artist's then lover, Eric Hall, slumped on a chair in London's Hyde Park. Nevertheless, it was some time before Bacon realised the potential of the medium as a visual source. Before 1962 he rarely used photographs – apart from reproductions from books, magazines, catalogues and newspapers – and in the iconic Sam Hunter image taken in Bacon's studio at 7 Cromwell Place, no original photographs can be seen (fig 30).

In Hunter's photograph of the studio we can see the many pages that Bacon tore from books and magazines, including a photograph by Victor Bulla, *Street demonstration on Nevsky Prospekt, Petrograd, July 4, 1917*, from the book *News in our time 1896–1946: Golden Jubilee book of the Daily Mail* (1946), and the French photographer Félix Nadar's portrait of Baudelaire, most likely torn from Peter Quennell's book, *Victorian panorama: a survey of life & fashion from contemporary photographs* (1937). We can also see an illustration of Matthias Grünewald's *Christ bearing the Cross* 1523–25, originally part of the panel of the Tauberbischofsheim altarpiece in the Kunsthalle, torn from Hans Heinrich Naumann's book *Das Grünewald-Problem und das neuentdeckte Selbstbildnis des 20 jährigen Mathis Nithart aus dem Jahre 1475* (1930); photographs of Heinrich Himmler and Joseph Goebbels; an image of a hippopotamus from Marius Maxwell's book *Stalking big game with a camera in equatorial Africa* (1924); a reproduction of Velázquez's *Portrait of Pope Innocent X* c1650; and a man with a bandaged face, possibly a victim of London's 1936 fascist riots, the Battle of Cable Street. Also visible is a page torn from the artist Jack Bilbo's 1948 autobiography showing three images of the painter as a gangster with the caption, 'Man of mystery Al Capone's bodyguard – sorry – never met Al Capone, never been to Chicago, just a pose to please my publishers and public'; and Roger Manvell and Rachel Low's book *The history of the British film: 1896–1906* (1948), with illustrations showing stills from films made by the School of Brighton (British pioneers of cinema) between 1900 and 1903.

While Bacon selected this material from an existing set of images in illustrated publications, original photographs were advantageous in that he could be, and sometimes was, their dictator or author. In other words, the subject and composition of photographs he commissioned or took were to some extent a reflection of his visual preferences, and in many of them his guiding intelligence is discernible. That Bacon himself at times took up a camera is not in question and his photographs often show him placing the subject in a more hieratic way.

From around 1963, and with few exceptions, Bacon used his closest friends as subjects, painting them from photographs and memory rather than from life. The artist felt that while painting friends he was practising an injury on them, something he had no desire to do in their presence. In their absence, however, he could twist their features and inflict his 'injuries' without having to contend with the judgment of the sitter.

Bacon's interest in photographs was not confined simply to what an image contained, he was also keenly receptive to its physical state. He employed recurring pictorial effects in his work and the origins of these can be found in the tears, creases and paint accretions on the photographs littered across the studio floor. While sensitive

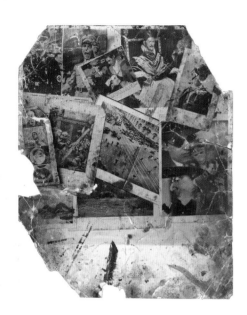

fig 30 Montage of images from art history and popular culture from Bacon's Cromwell Place studio, 1950. arranged and photographed by Sam Hunter F1A:201

fig 31 John Edwards photographed by Francis Bacon at 21–22 Stanhope Gardens, London, c1983. BC23

opposite:

Bacon commissioned John Deakin to take photographs of his friends and lovers to use as source material.
clockwise from top left:
fig 32 Isabel Rawsthorne c1965 F17:63
fig 33 George Dyer c1965 F1A:100
figs 34 & 35 Lucian Freud c1964a F24:65, F24:70

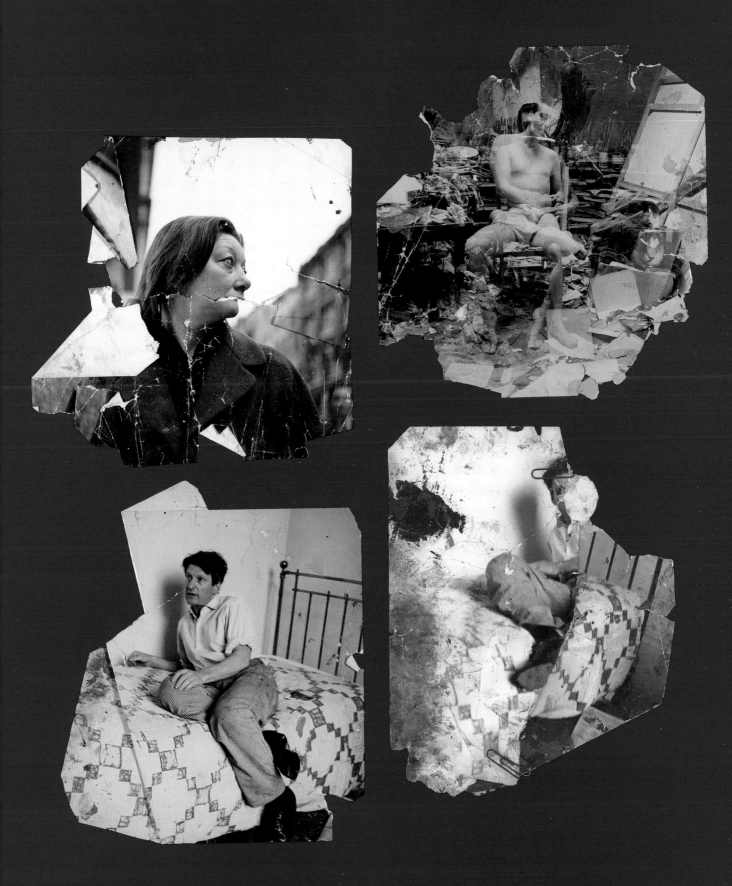

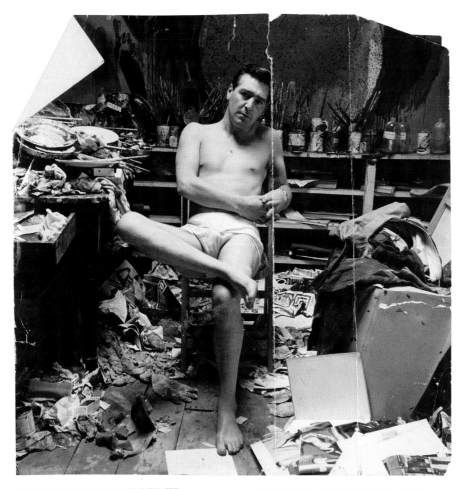

figs 36–39 George Dyer in Bacon's Reece Mews studio, 1965 and in a Soho street (below), c1964.
photographed by John Deakin

Dyer was the subject of many Bacon paintings in the 1960s and 70s and images of him in the studio became an enduring motif.

LG5, F17:30, F17:110, F1A:184

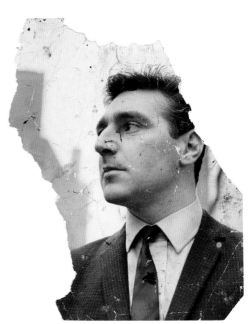

to the way that damage could irrevocably alter an image, Bacon made conscious, deliberate manipulations and modifications to material, with many of his distortions held in place by adhesive tape, safety pins or sewing needles. An example of this is the large vertical fold held in place by three metal paperclips that Bacon made in the centre of a photograph of his friend, the artist Lucian Freud (fig 35).

In around 1960 Bacon commissioned the *Vogue* photographer John Deakin to take several sets of photographs of Lucian Freud (figs 34, 35), Peter Lacy, George Dyer (figs 33, 36–39), Isabel Rawsthorne (fig 32) and Henrietta Moraes. Bacon was either directly or indirectly involved in selecting the sitters' poses, which meant they could be rehearsed and repeated with variations. An unsatisfactory session – as Deakin's first shoot with a nude Henrietta Moraes was thought to be – could be superseded by one closer to the artist's intentions (figs 40, 41).

Deakin's photographs played a crucial role in Bacon's portraiture from the first half of the 1960s onwards, but there are images of Bacon himself taken by Deakin dating to as early as 1952. His attitude to these photographs was not confined to passive study and improvised variation. He could be ruthlessly direct: photographic prints were deliberately folded, cut or mounted on cardboard. More than 300 photographs, fragments and negatives by Deakin were found in Bacon's studio and of these 129 were of George Dyer.

The series from which Bacon improvised most often, and most freely, are the photographs of Dyer in his underpants in the Reece Mews studio, taken in around 1965. Bacon was probably present at this session and chose his lover's poses. The artist's highly distinctive editing comes to the fore in these photographs of Dyer sitting on a chair. Several of the prints were sliced into two or more pieces so that the figure was left in quasi-autonomous halves (figs 37, 38). Bacon then set about isolating and honing the choicest portions. By means of cutting and tearing he continued the photographic process of framing, editing and selection. In essence, destruction became another form of enquiry.

In the years that followed, Bacon co-opted these images for a raft of paintings. In *Triptych – August 1972* 1972 (pp 180–82), for example, Dyer's pose in the left and right panels is derived from the Deakin's photographs. Similarly, in *Three studies of George Dyer* 1969 (pp 162–63), the debt to the photographs is apparent once more. As late as 1988 Bacon turned to the Deakin images of Dyer for his *Portrait of John Edwards* 1988 (p 215), an effortless amalgam of Dyer's lower body and Edwards's head and shoulders as recorded in numerous photographs by, among others, Bacon himself (fig 31, p 46). Photography enabled just this type of superimposition and substitution, a strategy that had added piquancy when the anatomies of a current companion and a former lover were combined.

figs 40 & 41 Henrietta Moraes, c1963

Bacon commissioned John Deakin to take a series of nude photographs of his friend and bon vivant Henrietta Moraes; several of Bacon's paintings use these images. At top, the same photograph has been folded and torn, which informed the figural distortions in Bacon's paintings.

F130:179, F1A:107

The images could also be conflated with other sources, as is evident in *Study of Henrietta Moraes (Laughing)* 1969, in which a clear link has been established with a photographic still of the actress Emmanuelle Riva in Alain Resnais's 1959 film *Hiroshima mon amour*. Bacon's still shows Riva, and the Japanese actor Eiji Okada, in a shower, her face blurred by the movement and effect of the water (fig 42). Bacon manipulated the photograph, folding a vertical crease across Riva's cheek and compressing her mouth by pushing the paper together. This photograph directly relates to *Study of Henrietta Moraes (Laughing)*, and to a lesser extent *Three studies for portrait of Henrietta Moraes* (pp 160–61), providing the starting point for the tilted head and the distorted curve of the ultra-aquiline nose. The reproduction, as retrieved from Bacon's studio, is identical to the painting in its tight cropping of the head and demonstrates Bacon's manipulation of the reference material to conform with his intentions for a painting.[3]

ARTIST AS SUBJECT

Bacon's face attracted the scrutiny of many photographers, both professional and amateur. Over the decades he was photographed by Cecil Beaton, Henri Cartier-Bresson, John Deakin, Peter Stark, Michael Holtz, Jorge Lewinski, Michael Pergolani, Jean-Loup Cornet, Peter Beard, Jane Bown and John Edwards, to count those whose prints were found at Reece Mews. Bacon actively enjoyed these photo sessions, revelling in the process. He became adeptly self-aware before the camera and over time the slew of these photographs in the studio formed the essential compost for his self-portraits which he began to paint in earnest from 1969 onwards, producing more than 40 of them until his death in 1992. Indeed, the unfinished painting on his easel at the time of his death was a self-portrait (fig 45).

Most of the photographs found in the studio were taken either in Reece Mews or in its vicinity, although Bacon was rarely photographed in the act of painting. The most evocative colour photographs of Bacon in the studio were taken in May 1970 by the Italian photographer Michael Pergolani (fig 43). The photographs taken by Michael Holtz (fig 44) offer a true record of the studio's natural light, and on at least two occasions Bacon turned to Holtz's photographs when painting a self-portrait,

fig 42 Studio fragment of a page from Thomas Wiseman, *Cinema* (1964) showing a still from Alain Resnais's 1959 film *Hiroshima, mon amour*, which Bacon greatly admired. Bacon was inspired by cinema, and Resnais's films were a touchstone for him. The fold in this image gave rise to distortions in many of Bacon's portraits, including those of Henrietta Moraes (see pp 160–61). F1A:40

from left:

fig 43 Francis Bacon in front of *Three studies of the male back* 1970 (pp 173–75) at his Reece Mews studio, May 1970. photographed by Michael Pergolani LG2

fig 44 Francis Bacon in his Reece Mews studio, 1974. photographed by Michael Holtz F15:79

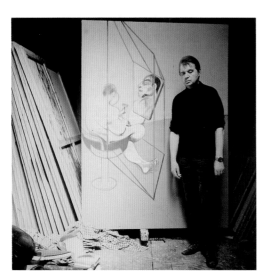

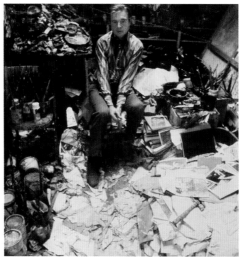

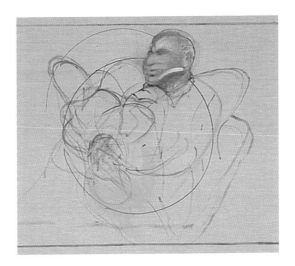

for example *Study for self-portrait* 1981. Holtz's five surviving colour photographs of Bacon reveal the studio to have been in a more anarchic state in 1974 than it was at his death. The disintegrating papers at Bacon's feet indicate that, for all the sources that have survived, a great many must have mouldered away.

Photography, too, could be a solitary activity, even for the living subject. Bacon was a devotee of automatic photo booths, a cheap alternative to the intrusion of a formal photoshoot. The everyday anonymity of the photo booth process was something he turned to his advantage. Within the confines of the booth he chose whatever attitudes and faces he pleased, although he rarely looked directly into the camera and almost never pulled a smile. His headturns and off-frame glances imply an implacable indifference to scrutiny, even to his own gaze (fig 46). When asked where his ideas came from, his reply calls to mind a processed photographic strip as it falls from a dispensing slot: 'images just drop in as if they were handed down to me.'[4] In both *Study for self-portrait* 1976 (p 195) and *Three studies for a self-portrait* 1979–80 (pp 200–01) the twists and elisions of the brush are amplified by his consecutive attempts at a likeness, and each variation supplements the other. The provisional-sounding titles and choice of a triptych format lend a contingent air to these canvases. The humble photo-strip neatly encapsulated the notion that representation could, and even should, be a plural rather than a singular phenomenon.

PRINTED MEDIA: BOOKS, MAGAZINES, NEWSPAPERS

Bacon sought visual matter constantly, accumulating far more material than he could ever hope to use. Such was his absorption in illustrated publications that he felt no inclination to separate them from a wider discussion of photography – although he was unquestionably something of a connoisseur of photography with very particular tastes. He especially admired the photographs of Eugène Atget, whose work transposed photography's function in the nineteenth century of documentation into the realm of art. However, when asked about the role of photographs in his work Bacon's response moved seamlessly from original prints by John Deakin to illustrations in books, magazines and newspapers. When pushed, he would acknowledge the qualitative difference between the two, but it was a distinction that stood for little when he was at his easel, searching for a motif.

Illustrated publications immeasurably expanded Bacon's frame of reference. More than 570 books, and some 1300 loose leaves torn from books, were found in

fig 46 Bacon was a devotee of automatic photo booths, a cheap alternative to a formal photoshoot. Within the confines of the booth he adopted whatever attitudes and faces he pleased, although he rarely smiled or looked directly into the camera. F16:248

above left:
fig 45 Frances Bacon's final unfinished painting, 1991–92 (detail).
oil on canvas, 198 x 147 cm

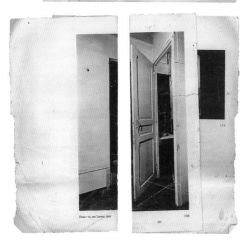

fig 47 Page torn from Arturo Schwarz and Marcel Duchamp, *The complete works of Marcel Duchamp*, Thames & Hudson, London, 1969, p 137.

The page had been folded by Bacon to isolate the celebrated double-opening door in Duchamp's Paris apartment. Bacon used this modified image as the model for the 'doors' in the outer panels of *Triptych – studies from the human body* 1970. Doors recur in Bacon's paintings and, in his later work, seem to open onto voids. F1A:46

the Reece Mews studio. In addition, 200 magazines and leaves from magazines, and 245 newspapers and newspaper fragments, were also uncovered. The subjects range from art, sport, crime, history and cinema to photography, wildlife, medicine and parapsychology – reflecting Bacon's own endless but purposeful curiosity.

While Bacon's approach to imagery was non-hierarchical, within these genres certain categories of subjects, firmly established early in his artistic career, were more likely to stimulate his thoughts, as is evident from the analysis of the studio contents. The diversity of subject matter promoted what might be called an imaginative cross-pollination. Illustrations from formally distinct categories, such as politics and wildlife, could be joined together, overlaid and re-conjugated.

For the purposes of his work, printed images were free agents not at all bound by the texts they illustrated; text might inform an image, but it could never fix it to a single interpretation. Bacon's art was partly motivated by the breaking, or at least the modifying, of given associations. In this way a motif could be made more truly his own or, as he preferred to see it, divested of narrative baggage. Motifs such as umbrellas, daises and carcasses recur, regardless of their original context, and were often mounted on cardboard.

Illustrated publications offered Bacon a remote means of grappling with the work of other artists and proved to be decisive in his development. Two of his major series of paintings were based on reproductions of the work of other artists, namely Velázquez's *Portrait of Pope Innocent X* c1650 (fig 53, p 54) and van Gogh's *The painter on the road to Tarascon* 1888. Bacon's knowledge of both paintings was gained entirely through reproductions, a dependency that, far from limiting his scope, encouraged him to take extravagant license.

Bacon professed his admiration for the work of Michelangelo, Velázquez, Rembrandt, Ingres, van Gogh and Giacometti, but for him the two most innovative artists of the twentieth century were Marcel Duchamp and Picasso. To some degree, the inclusion of Duchamp in Bacon's pantheon of influential artists seems anomalous: all the other artists are painters or sculptors in the more traditional sense, whereas Duchamp refused to be categorised as either. Duchamp's sense of irreverence regarding the work of other artists may well have provoked Bacon, but it would appear that his admiration for Duchamp's work, specifically *The bride stripped bare by her bachelors, even (The large glass)* 1915–23 (fig 5, p 20), was because it was 'so impervious to interpretation',[5] an idea that is in keeping with Bacon's refusal to interpret his own paintings.

A small number of loose pages found in Bacon's studio feature images of Duchamp's work, including *Sculpture for travelling* 1918 and *Nude descending a staircase* 1912. Bacon's use of safety pins in works such as *Study from the human body* 1949 (p 103) has been linked to Duchamp's work *Tu m'* (*You me*) 1918, which plays with the concept of the trompe l'oeil by incorporating three actual safety pins to hold together a tear in the canvas. Other links between Bacon and the work of Duchamp can be made, such as the loose page found in the Reece Mews studio featuring a reproduction of Duchamp's work *Door, 11 rue Larrey* 1927 – a double-opening door Duchamp designed for his Paris apartment. Bacon folded the page to isolate the door and used this modified image as the model for the 'doors' in the outer panels of his painting *Triptych – studies from the human body* 1970.[6] Bacon repeatedly used the door motif to frame the figure and create an ambiguous space.

28 YOU CAN'T MAKE A PICTURE "WITHOUT 'EM

dig those
feet in

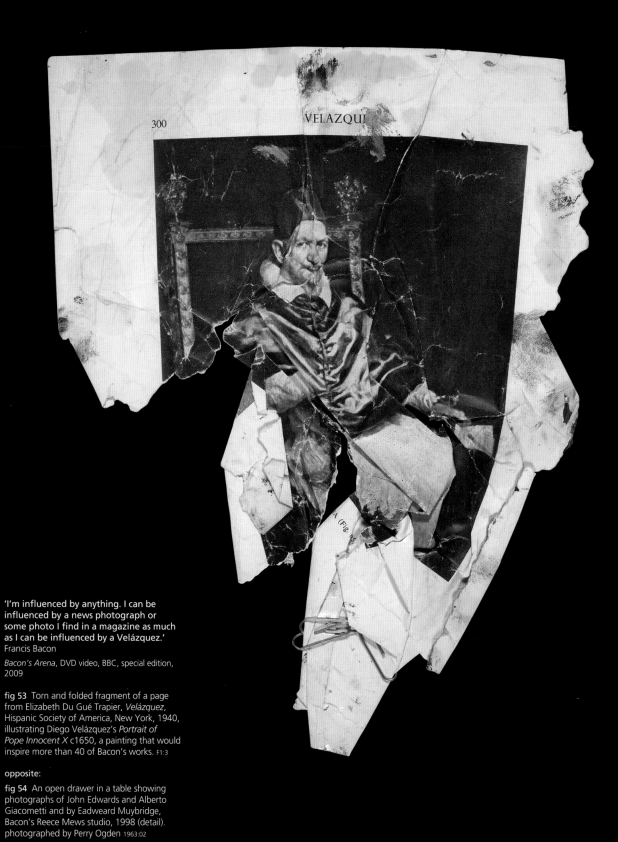

'I'm influenced by anything. I can be influenced by a news photograph or some photo I find in a magazine as much as I can be influenced by a Velázquez.'
Francis Bacon

Bacon's Arena, DVD video, BBC, special edition, 2009

fig 53 Torn and folded fragment of a page from Elizabeth Du Gué Trapier, *Velázquez*, Hispanic Society of America, New York, 1940, illustrating Diego Velázquez's *Portrait of Pope Innocent X* c1650, a painting that would inspire more than 40 of Bacon's works. F1:3

opposite:

fig 54 An open drawer in a table showing photographs of John Edwards and Alberto Giacometti and by Eadweard Muybridge, Bacon's Reece Mews studio, 1998 (detail). photographed by Perry Ogden 1963:02

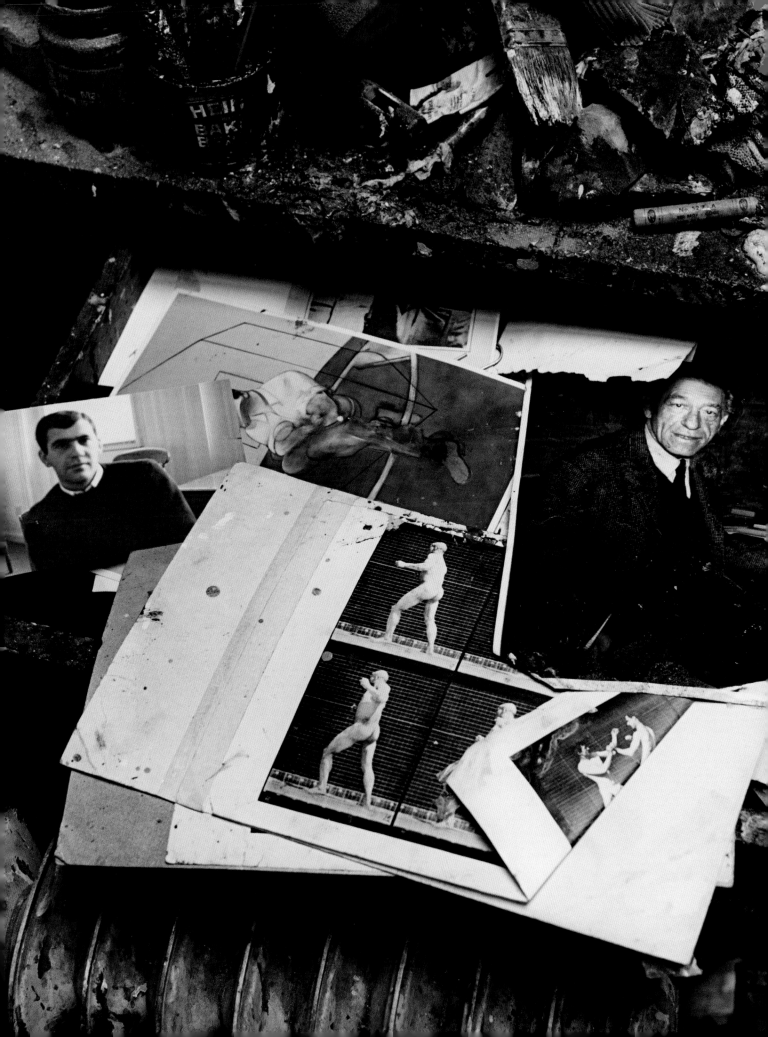

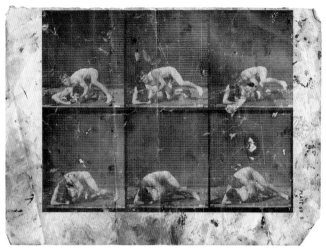
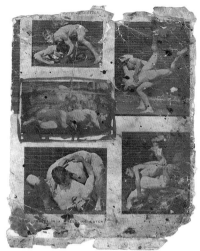

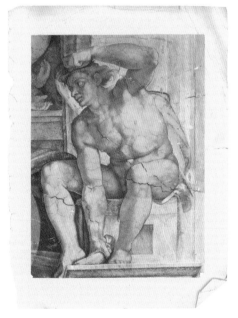
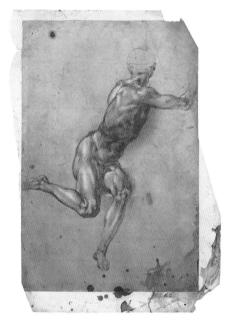
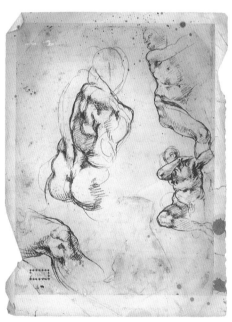

Pages from Bacon's studio. Michelangelo's and Muybridge's depictions of the male form greatly influenced Bacon's work.

top row from left:

Central panel of Francis Bacon *Triptych* 1970 (see pp 178–79)

figs 55 & 56 'Two men wrestling', pages from Eadweard Muybridge's *The human figure in motion* (first published 1887, 1995 ed). Bacon painted one of the five plates with blue paint, silhouetting the form of the male nude figure (top right). F16:54, 104:87

below row from left:

fig 57 Frederick Hartt, *The Library of Great Painters: Michelangelo*, Thames & Hudson, London, 1964 F17:33

figs 58 & 59 Frederick Hartt, *The drawings of Michelangelo*, Thames & Hudson, London, 1971 F17:32, F17:27

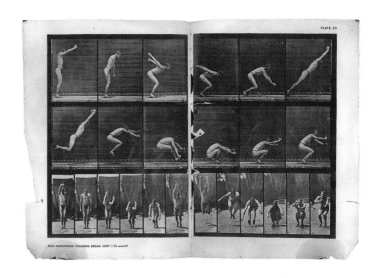

fig 60 'Man jumping', pages from Eadweard Muybridge's *The human figure in motion* (1955). F104:87

MUYBRIDGE AND MICHELANGELO

Of all Bacon's sources the photography of Eadweard Muybridge has the most ubiquitous presence in his paintings. Martin Harrison notes that Bacon had seen Muybridge's photographs previously. However, it was not until 1949, when the artist Denis Wirth-Miller introduced him to the complete eleven-volume set of Muybridge's *Animal locomotion* (1887), featuring 781 gravure plates, that the photographer's work became influential to Bacon.[7] The photographs also had a further implication: when the split-second images are viewed in rapid succession they form a moving photographic picture – a humble but vital precursor to cinema.

Muybridge's pioneering photographs of humans and animals in motion, made between 1872 and 1885, captured bodies performing an encyclopedic range of activities. From 1949 these sequenced images offered a virtual armature for Bacon's newly ambitious figure painting. Four different copies of the 1955 abridged version of Muybridge's *The human figure in motion* were found at Reece Mews after Bacon's death, along with more than 100 loose or torn pages from the same publication. A later edition from 1979 was found in the artist's bedroom.

The earliest derivation from Muybridge appears in Bacon's *Painting* 1950, but it has been argued that *Study from the human body* 1949 has a prior claim to the source.[8] Bacon's referencing of Muybridge continued and escalated from about this time. It sometimes took the form of a clear quotation, as in *Study of a nude* 1952–53 (p 123) and *From Muybridge 'The human figure in motion: woman emptying a bowl of water / paralytic child walking on all fours'* 1965 (p 151). At other times, Bacon took matters further and invoked Muybridge in his portraits. As he explained: 'I very often think of people's bodies that have particularly affected me, but then they're grafted very often on to Muybridge's bodies. I manipulate the Muybridge bodies into the forms of the bodies I have known.'[9] Other aspects of Muybridge's photographs are incorporated into works such as *Triptych* 1970 (pp 178–79) where the parallels between the twisted forms of the lovers in the central panel and Muybridge's photograph of male wrestlers (figs 55 & 56) are obvious. In addition, the complex system of ropes or wires that suspend the platforms supporting the figures on the left and right in *Triptych* is undoubtedly borrowed from Muybridge's serial photographs of a woman getting into and out of a hammock.

For the most part Muybridge was not absorbed in isolation by Bacon, but merged with other sources. Indeed, in respect to Michelangelo, Bacon said: 'Actually, Michelangelo and Muybridge are mixed up in my mind together, and so I perhaps could learn about positions from Muybridge and learn about the ampleness, the

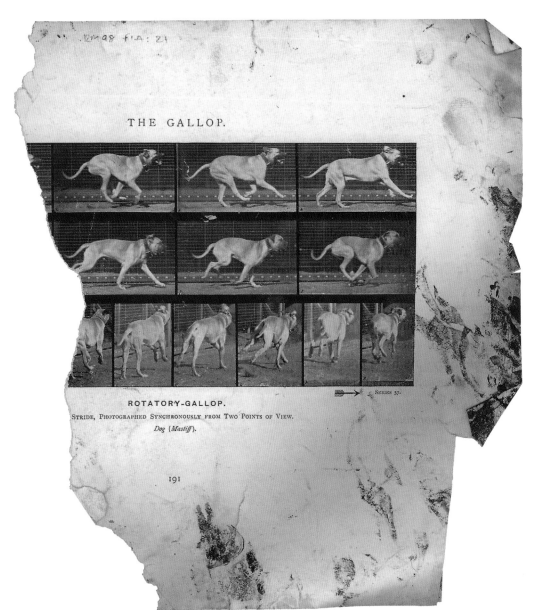

THE GALLOP.

ROTATORY-GALLOP.

STRIDE, PHOTOGRAPHED SYNCHRONOUSLY FROM TWO POINTS OF VIEW.

Dog (Mastiff).

SERIES 37.

191

Bacon collected many images of animals, which often appear in modified form in his paintings.

fig 61 Contact sheet of photographs by Peter Beard of a boxer dog with a muskrat in its mouth, c1964. F16:278
© Peter Beard

fig 62 Page from Eadweard Muybridge's *Animals in motion* (1901). F1A:21

grandeur of form from Michelangelo.'[10] Bacon hoarded more books in his studio on Michelangelo than on any other artist – with at least 16 copies of different monographs and more than 80 leaves torn from books with illustrations of the artist's work. Bacon's co-opting of Michelangelo was broad and far-reaching. The Florentine artist's primary interest was the heroic male nude, a form that from 1949 and throughout the 1950s came to dominate Bacon's work. The 'grandeur' of Michelangelo's nudes is clearly discernible in the massive athletic figures in Bacon's *Study from the human body* 1949 and *Lying figure in a mirror* 1971.

Muybridge's photographs of animals also provided Bacon with ample material for his paintings (see *Study for a running dog* 1954, pp 134–35). Images of animals and birds form one of the largest groups of subject matter in the studio archive. Bacon conflated various sources, as is evident in his combined use in *Untitled* c1967 (Faggianato Fine Art, London) of Muybridge's work (fig 62) and a photograph of a dog with a muskrat in its mouth taken by Peter Beard (fig 61) (Bacon gambled regularly at London's greyhound tracks in the 1950s). The distortions of extreme movement and high-speed photography created effects that Bacon transformed into arresting motifs. While the animals he most often painted were dogs and primates, birds are also an important part of his lexicon. His painting *Owls* 1956 (p 137), for example, is based on an image of two fledgling long-eared owls in a book titled *Birds of the night* (1945) (fig 97, p 136).

THE PHENOMENA OF MATERIALISATION

While Bacon's interest in Muybridge was well-documented, prior to the investigation of the contents of his studio the pervasive and very specific influence on his work of Baron Albert von Schrenck-Notzing's book *Phenomena of materialisation* (1920) had been underestimated. It has been noted that the influence of this book on Bacon is first evident in *Three studies for figures at the base of a crucifixion* c1944,[11] although its effects can arguably be detected in the earlier *Crucifixion* 1933 (p 87) (as can the influence of X-rays) and becomes even more apparent in his paintings from the late 1940s onwards.

In several of the illustrations in Schrenck-Notzing's book, white blobs of ectoplasm – the viscous substance supposedly exuded by spiritualist mediums during a trance – emerge from the mouths of mediums and float through the air. The blobs of white paint in Bacon's canvases, such as *Study for figure no 4* 1956 (p 139) and *Portrait of George Dyer staring at blind-cord* 1966, are their analogues in paint. Bacon consulted the book for new compositional ideas and there are compelling echoes of these images in many of his paintings. The teleplastic séances generally involved a single person seated in an enclosed, circular, tent-like structure where he – or more often she – was partially concealed behind substantial curtains (fig 63). The curtains in Bacon's *Head II* 1949 (p 99) and *Study from the human body* 1949 (p 103) are probably derived from the Schrenck-Notzing images.

fig 63 Page from Baron von Schrenck-Notzing, *Phenomena of materialisation*, London, 1920 (reprinted 1923).

This esoteric book purports to show supernatural forms exuded by spiritualist mediums during a trance. Bacon consulted the book for new compositions and there are echoes of these images in many of his paintings. F23:55

INTERVENTIONS, DRAWINGS AND HANDWRITTEN NOTES

In the later stages of his career Bacon thought about the paintings he had made earlier. How often he returned to his own work, repeating and augmenting it, is indicated by the many reproductions of his own paintings found in his studio, some taken from catalogues, book proofs and photographs and some with further interventions. He revisited his earlier work to develop favoured themes and explore deep-rooted concerns. On the wall of his kitchen-cum-bathroom he affixed photographs of his own paintings (fig 64). A photograph found in the studio (p 186) shows an earlier, larger version of *Portrait of a dwarf (The dwarf)* 1975 with an additional figure upside-down in a rectilinear cage. There is also a photograph of the left panel in *Triptych* 1987 (pp 212–13). Similarly, at least six reproductions of *Study for crouching nude* 1952 (opposite and p 121) were found in the studio, two of which contain the same formal change – the blocking out of the striated area in the foreground (fig 65).

Bacon's handwritten notes contain countless mentions of ideas for paintings formulated by him and often looking back at previous works. For example, the theme of the crouching nude or nude on a rail is one that Bacon returned to again and again (fig 66). Both the notes and drawings found in the studio offer an unmediated record of Bacon's thoughts. They were a way of focusing and clarifying his ideas for future paintings and served to define his intellectual identity. Even the walls of the Reece Mews studio bear traces of scribbled notes in pencil and paint; these too can be read as an index of Bacon's spontaneous imagination.

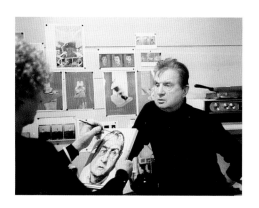

fig 64 Australian artist Brett Whiteley painting Francis Bacon's portrait in the kitchen at Reece Mews, London, October 1984. On the wall can be seen photographs of Bacon's own paintings. photographed by John Edwards F1A:144

In the decade that has followed the opening of his reconstructed studio in Dublin, Bacon's archival material has been the subject of considerable scholarly analysis. This has led to new revelations about the complexity of Bacon's relationship with his visual store of photographs and images. However, while intense focus on the studio contents has yielded many new insights, it is important to bear in mind that the artist was a sentient individual who was exceptionally visually literate and constantly looking at and absorbing material regardless of where he encountered it. His studios in Cromwell Place and later in Reece Mews meant he was within easy reach of the Victoria and Albert Museum. He was also thoroughly familiar with other museum collections in London, such as the National Gallery and the National Portrait Gallery.

Bacon was open to new developments in art and kept abreast of his contemporaries as well as the new generation of younger artists, such as Damien Hirst, Anthony Zych, Duane Michals, Vito Acconci, Ernest Pignon-Ernest, Marie-Jo Lafontaine, Brett Whiteley, Reinhard Hassert and Clare Shenstone. He engaged with some of these artists, and with photographers, by meeting or corresponding with them, occasionally posing for them and commissioning their work. The studio contents show that Bacon accepted gifts of books and other material from some of these individuals. He visited contemporary galleries and had an excellent visual memory of the works he encountered. Although it might be assumed that by the end of his life Bacon had all

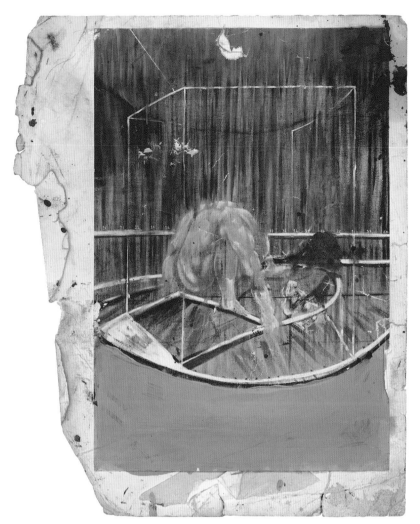

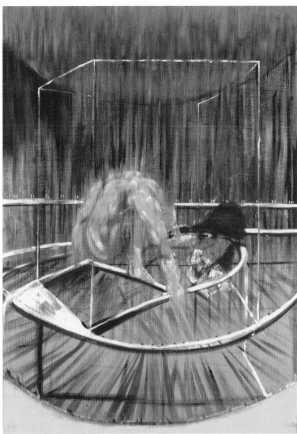

fig 65 Page from John Rothenstein and Ronald Alley, *Francis Bacon: catalogue raisonné*, London, 1964, showing *Study for Crouching nude* 1952. The lower part of the image has been thickly covered with grey paint following the curved line of the cage structure in the painting. F1:18

Francis Bacon
Study for crouching nude 1952
see p 121

fig 66 Handwritten notes by Francis Bacon: 'Think of crouching nude 1952 / Three Studies on structures with flesh coloured shadows 1 □ □ 2 □ 3 Think of Rodin nude / Think of Muybridge & Marey / also of painting 1974 / Personnage assis.' F107:9

but closed his mind to new developments in art, this could not be further from the truth. Among the contents of his studio was a review of work by the Young British Artists (YBA), as well as correspondence between Bacon and the Irish artist Louis le Brocquy that reveals he was particularly struck by Damien Hirst's early work *A Thousand Years* 1990, which he saw at the Saatchi Collection.

More importantly, the level of analysis of Bacon's sources brings a problematic dimension to an assessment of his work as it would do the artist a huge disservice to reduce his paintings to the sum of the influences they absorbed, rather than treating them as independent, supreme works of art. While the identification and dating of specific pictorial sources is informative and revealing, the correspondence between certain elements in the works to actual source motifs should not detract from the visual impact of his paintings and should never be interpreted as literal transcription.

Nevertheless, the studio contents have greatly assisted in deepening the understanding of the course of Bacon's creative life and how he assimilated his influences into the very texture of his work. The absorption of imagery was a complex affair and in many instances images and pictorial material that at first appeared insignificant often proved to hold the key to greater meaning. Sometimes the reference to a putative source is so oblique as to be discernible only to the artist. Clearly, the studio contents were the agents for the crystallisation of Bacon's ideas and artistic intentions and provide us with fresh interpretations and insights into his work. Despite their impression of spontaneity, Bacon's paintings are the product of deliberation and rational thought and this is borne out by what was found in his studio.

fig 67 Invitation card to the opening of an exhibition of photographs *Moins Trente* 1985, Bienale de la Jeune Photographie en France, attached to a page of photographic nudes. RM98F104:55B

opposite:

fig 68 Bacon's Reece Mews studio, 1998 photographed by Perry Ogden 1963:16

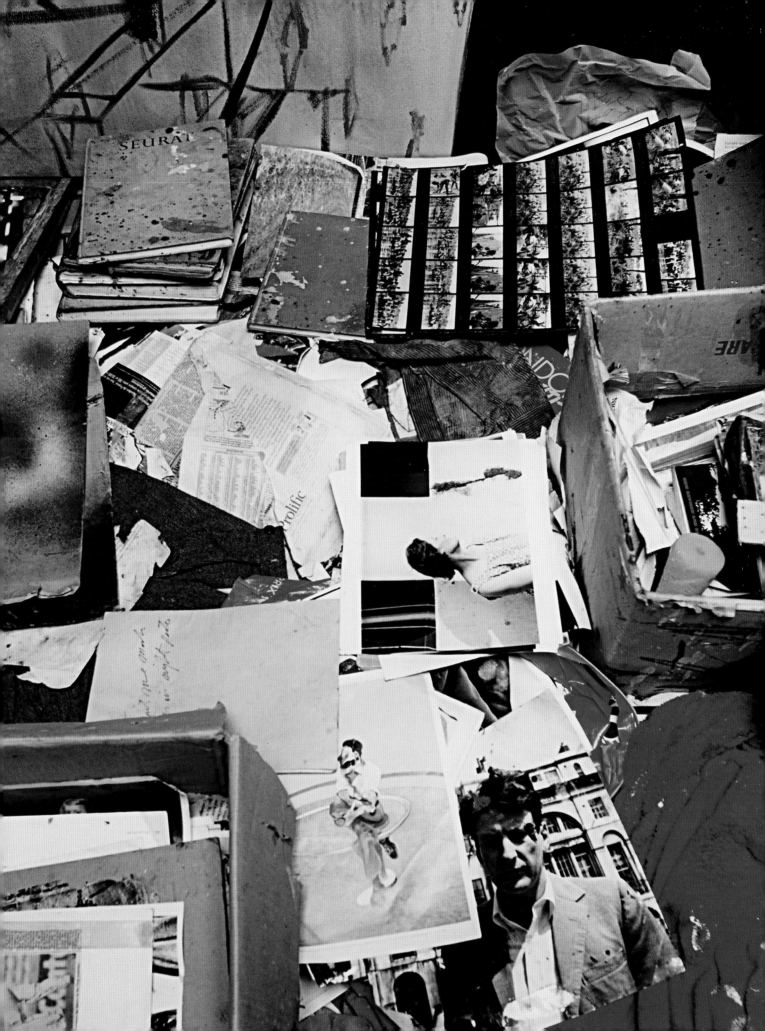

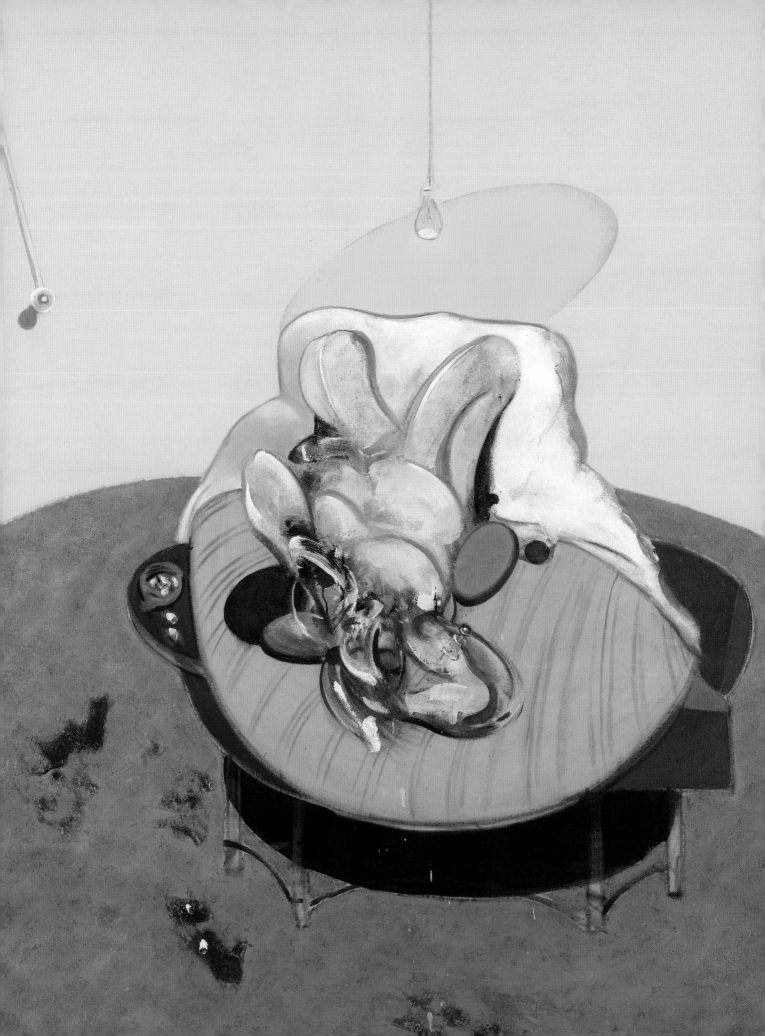

MAKING SENSE
OF AFFECT

Ernst van Alphen

The work of Francis Bacon has an impact that viewers cannot escape. The response to it is often extreme. People either love it or hate it: there is little in-between, because it never leaves them indifferent. Because of its strong impact, Bacon's work demands a critical approach that acknowledges and takes into consideration the affects produced by it. A starting point for such an 'affective' approach are the many interviews with Bacon – not only the most famous ones by David Sylvester, but also those by John Russell and Michel Archimbaud. The questions these interviewers posed to Bacon often demonstrate the impact on them of his work. A reading that more explicitly reflects on the affective impact of Bacon's images is by the French philosopher Gilles Deleuze. His book *Francis Bacon: logique de la sensation* (*The logic of sensation*), published in 1981, comprises a general aesthetic theory (comparable to his earlier book with Félix Guattari on Franz Kafka),[1] as well as a powerful assessment of Bacon's paintings.[2] This assessment concerns not what the paintings mean but how they work. Deleuze abducts the meaning of the phrase 'making sense' from the domain of semantics to that of the senses. According to Deleuze, a painting, and especially one by Bacon, should not be approached as a product, but as a *work* of art in the most literal sense: it is a union of forces, or a dynamic that has materialised onto canvas.

By considering painting as a union of forces Deleuze takes distance from the aesthetic notion according to which painting is a practice of mimesis. The origin of this conception of art goes back to the Greek legend of Zeuxis who was said to have painted grapes so realistic that they attracted doves who tried to eat them. Zeuxis's rival Parrhasius, wanting to outperform him, painted a curtain so realistic that even Zeuxis thought he could open it. This legend exemplifies the idea that the power of art should be explained in terms of its ability to represent or imitate the empirical world.

Although for many centuries mimesis has been an almost self-evident aesthetic pursuit, in the twentieth century the situation has changed radically. The lack of recognisable forms in art has become completely accepted. This relatively recent tendency to leave behind mimesis as an aesthetic principle has resulted in the tension between two poles: the tendency to abstraction and the tendency to figurative narrativity. According to Deleuze, in recent history few artists have succeeded in making great art by exploiting this tension between abstraction and narrativity. Instead, they escape either into complete abstraction (such as Jackson Pollock and Mark Rothko, among others) or into figurative narrativity (Balthus, Julian Schnabel).

Francis Bacon, however, resisted both tendencies so attractive to twentieth-century painters. With a tone of contempt he repeatedly distanced himself from abstract

opposite:

Francis Bacon
Lying figure 1969 (detail)
see p 159

expressionist painters who made their careers in the same period as he. And his remark about narrative painting in an interview with David Sylvester is deadly and expresses contempt: 'the moment the story is elaborated, the boredom sets in: the story talks louder than the paint.'[3]

Bacon's dismissal of narrative painting is based on the fact that such painting only stimulates the viewer to identify or recognise the story. It is the story that either fascinates or does not; the painting itself has no function besides that of illustrating or representing the story (mimesis). Such a practice of painting denies the specificity of art.

Deleuze explains the specificity of art by contrasting it with the specificity of his own profession. Whereas the philosopher works with concepts and is supposed to create new concepts, the artist works with *affects* and *percepts*. Affects are the non-personal emotions or affections that belong to the essence of art. When affects are non-personal they are not affections because they are disconnected from lived, human experience. Similarly, percepts are not the same as perceptions. They have not been processed by human experience (as phenomenology assumes), but are part of the concrete matter of the painting. This aesthetic notion of the specificity of art also implies that a painting is not spiritual but bodily. It situates itself on the surface of perception without any active intervention of our consciousness.

Bacon's paintings exemplify this aesthetic theory perfectly. Viewers are touched directly and almost violently by the material presence of his paintings. It is as if our skin is penetrated by affects generated by the presence of what we see: not a mediated story, but the material reality of the painting.

The fact that Deleuze (like Bacon) counters the recognition of stories or recognisable forms does not imply that he favours abstract art. On the contrary, according to the philosopher, artists always start a work with 'clichés', the so-called available images, forms and figures of our daily perception. They never begin to paint on an empty canvas as a *creation ex nihilo*. These available images and forms can be recognised. But an artist will struggle with these clichés; he or she will transform and re-contextualise them. This transformation of clichés disconnects the painted image from common experience and perception and enables the creation of new figurations and experiences. Bacon himself described this creative process:

> I had put a whole heap of reference marks on the canvas, then suddenly the forms that you see on the canvas began to appear; they imposed themselves on me. It wasn't what I set out to do. Far from it. It just happened like that and I was quite surprised by what appeared. In that case, I think that instinct produced those forms. But that's not the same as inspiration.[4]

In another interview Bacon formulated this creative procedure similarly but with less emphasis on the accidental and more on the input of the artist: 'Great art is always a way of concentrating, reinventing what is called fact, what we know of our existence – a reconcentration.'[5]

To paint, then, means to make something visible that otherwise remains invisible. The 'reference marks' or 'what we know of our existence' are transformed into something new, which can only be described by what you see on the canvas. This invisible reality that has been made visible should, however, not be understood as meanings, ideas or truths that were hidden under the surface of the painting. Instead,

the viewer is touched by affects; that is, by the surface layers, which are senseless as such, but are put into motion by the painter in such a way that they touch us.

This creation of new figurations and experience is performed on the basis of what Deleuze calls affects and percepts. These affects and percepts activate and stimulate the viewer's senses. It results in the viewer in what in another of his works Deleuze has called 'abstract thought' or 'abstract experience'. However, 'abstract' here has little to do with the way the term 'abstraction' is used in art discourse. Abstraction in Deleuze's sense does not mean a purification of forms or figures. Rather, it is a form of becoming. Abstraction consists of forces that, in the words of the American philosopher John Rajchman, 'push art forms beyond and beside themselves, causing their very languages, as though possessed with the force of other things, to start stuttering "and ... and ... and ...".'[6] This stuttering abstraction concerns a strange anorganic vitality that is able to see in cliché figurations other new ways of proceeding. With 'stuttering' Deleuze refers to the moment at which language is not yet language. The disintegration of language, or the inadequacy of it, is not an effect in retrospect but one that points to a language not yet possible.

In *The logic of sensation* Deleuze discusses the films of French director Jean-Luc Godard as examples of abstract art. For Deleuze, Godard's films are abstract not because their context ceases to be narrative in the conventional sense and is, instead, largely self-referential. Rather, they are abstract because they comprise a wide range of elements, a variety of discourses, past and present, and because these are combined in such a way that a non-narrative continuity is created. The abstraction is therefore not the result of a renunciation of narrative, but that of the attempt 'to attain an "outside" of other odd connections through a free abstract AND, which takes over the movement of the film'.[7]

Bacon himself described this process of creative becoming as distortion: 'What I want to do is to distort the thing far beyond the appearance, but in the distortion to bring it back to a recording of the appearance.'[8] And in another interview: 'You must distort to transform what is called appearance into image.'[9] The deformation and distortion described by Bacon results first of all in representations of movement, transformation and animation. His figures seem to be 'in movement', 'in transformation', or in turmoil. But these acts of distortion should also be understood as acts of violence or as wounding interventions. The wounding violence is then, however, not only directed to the represented figures but also to the viewers of his paintings. Viewers are touched by affects produced by the figures in movement. This is why one could say that Bacon's paintings do what they are about. They show 'wounded' figures in transformation, and by doing so they bring about in the viewer an affective transformation that can also be understood in terms of a 'wounding'.

Bacon's transformation of clichés, or what Deleuze in other contexts would call his abstraction or stuttering, makes the representational space we get to see into something unpredictable, grim and threatening. This 'touching', grim reality is in many respects inhuman because it is unknown to human experience. This reality can be understood as a zone in which so-far unknown experiences come about. The French writer Michel Leiris has described this so-far unknown reality as follows:

> These pictures ... being spaces filled with pure living presences indicative of
> nothing other than themselves, and therefore stamped with an absence of sense
> – with, in other words, nonsense – seem, in the dazzling nakedness of the very

moment … to be images in keeping the inanity of our situation in the world as ephemeral beings, more capable than other living creatures of brilliant and pointless ecstasies.[10]

Such a characterisation of processes activated by Bacon's work concerns first of all the viewer and how she or he is affected by his images. But Bacon's images do not only 'work' on the viewer; as I argued above, they also show the kind of aesthetics that they activate. In other words, they demonstrate what they represent. In that sense, Bacon's images are also allegories of this notion of aesthetics. Bacon's aesthetic does not only comprise a theory of the creative process. It is at the same time a theory of aesthetic reception. The creative process is doubled or mirrored in the way the viewer processes his images; in the way they are touched by affects that 'deform' and 'wound' them.

The allegorical dimension of Bacon's work is realised by his consistent use of highly specific motifs. In *The logic of sensation* Deleuze discusses three of these motifs: isolation, deformation and coupling. The figures he represents are again and again defined by one, or a combination, of these three processes or activities. I would like to add a fourth motif that can be recognised frequently in Bacon's images and that enables me to see his work as an allegory of the aesthetic processes his work brings about. It is the motif of 'tools of vision', or more specifically, 'the mirror and the lamp'.[11]

At first these tools of vision seem common, even banal, and can be found in a number of Bacon's works. But because they are so banal, critics usually do not pay them serious attention. The lamps in his works are just bare light bulbs hanging from a cord. These bulbs are often combined with light switches on the wall; in some cases only a light switch is represented. Throughout the history of western aesthetics the motifs of the mirror and the lamp have been loaded with meaning. An elucidation of the meanings of these motifs may provide an illuminating insight into Bacon's art and its specific aesthetic. For in Bacon's work the significance of the mirror and the lamp differs radically from the special value these objects have had in western aesthetics, where they have acted as metaphors for the revealing role of visuality and the human eye. In his influential book *The mirror and the lamp: Romantic theory and the critical tradition* (1953), MH Abrams takes these objects as metaphors for two antithetical conceptions of the creative mind. In the image of the mirror the mind is compared to a reflector of external objects. With the metaphor of the lamp the mind is compared to a radical projector that makes a creative contribution to the object it perceives. In the history of aesthetics the mirror metaphor characterises much of the thinking in terms of mimesis from Plato until the eighteenth century, while the lamp metaphor typifies the prevailing motif during the Romantic period.

Although Bacon at first appears to place himself within the western tradition by taking the human body as his favourite subject matter, he distances himself from that tradition by subverting the role of the motifs of the mirror and the lamp. Whereas mirrors, lamps and light switches are recurring elements in his work, his mirrors do not adequately reflect or reproduce, and nor do his lamps adequately project or highlight. The bodies of his figures are not reflected or elucidated by these visual devices; instead, they are dissolved by them. The figures lose their forms and boundaries as if a result of these visual tools. What we are confronted with is not the 'reflected body' or the 'illuminated body' but the 'body unbound'.

The motif of the mirror marks vision as thematic. The visible (the object of looking) as well as the visual (the act and experience of looking) are both framed by the mirror's reflection. According to the principles of the conventional mirror, the image we see in the mirror reflects our act of looking. Only the sense of sight is susceptible to the mirror effect. Although distorting mirrors exist, we expect perfect mimesis in a mirror. Hence, if the viewer who looks into a mirror does not see what is in front of it, a phenomenon has occurred that is at odds with the act of looking as mimetic.

In varying degrees, some of Bacon's works that contain representations of mirrors are instances of mimetic mirror reflections. In *Three studies of the male back, triptych* 1970 (pp 174–75) we see in the left and right panels a man shaving himself in front of a mirror. In the central panel he reads a newspaper. However, while the figure in the central panel (as in the other panels) sits in front of a mirror, we do not see his reflection. The reflections in the other panels appear 'normal', suggesting mimesis. The central panel, however, does not function according to the conventional laws of the mirror. The mirror image is black.

A significant painting in this respect is *Study of nude with figure in a mirror* 1969 (fig 69). Here we see a female nude exposed to the viewer as in a traditional painting. The mirror is not turned towards the woman, but towards the viewer who stands in front of the painting. In the mirror we see a dressed man on a bar stool apparently watching the naked woman. It is illuminating to read the painting as a commentary on Edouard Manet's *Un bar aux Folies-Bergère* (*A bar at the Folies-Bergère*) 1881–82 (fig 70), in the collection of the Courtauld Gallery in London. Bacon's painting seems to challenge the convention according to which the object of western representation is traditionally female and the subject a male voyeur. Manet's painting, however, can hardly be accused of unambiguously accepting this ideology of vision. Indeed, it presents the mirror as a distorting element, bringing about an uneasy identification between the voyeur on the right and the viewer in front, both of whom are addressed by the woman. Yet the directness of the woman's gaze in the Manet painting only just begins to undermine the power of the louche voyeur, a bourgeois gentleman who seems to be out of place in the bar but who, along with the viewer, is nevertheless the master of this looking situation.

The self-confident pose of the gangster-like man in the right of *Study of nude with figure in a mirror* embodies a double critique of this situation. First, the object-hood of the observed woman is not softened by a smile or a complying or subordinate look as is normal in the tradition of the female nude. The man's look turns the woman into an animal. Her objecthood is sharpened by her animal-like features (in particular her mouth and hair). Second, the woman's body is distorted, her legs replicating the posture of the man's legs. This similarity of pose suggests that the voyeur shares the animal features of the woman. And, by analogy, so does the viewer, whose function is represented by this man. Thus the onlooker is contaminated, his looking 'touches' his body as it touches her.

Conventional mirror images are seen as confirmation of the identity of the mirrored person. This is the case in mirror images in the literal sense, but also in mimetic representations that consider the mirror as a metaphor of what they pursue. Consequently, in Bacon's work it is not only the mirror that figures as visual motif but also paintings, photographs, cameras, shadows or reflections that are self-reflexive motifs of what representation is or does. What strikes the viewer immediately is that

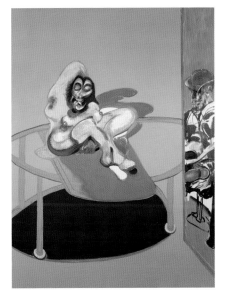

fig **69** Francis Bacon
Study of nude with figure in a mirror 1969
oil on canvas, 198 x 147.5 cm
Private collection

fig **70** Edouard Manet
A bar at the Folies-Bergère 1881–82
oil on canvas, 96 x 130 cm
The Samuel Courtauld Trust,
The Courtauld Gallery, London

the conventional distinctions between ontological dimensions are not clear at all. The space of representation is an ambiguous zone because represented space cannot clearly be distinguished from primary space. This entanglement of ontological dimensions is apparent in *Three studies of Isabel Rawsthorne* 1967 (Staatliche Museen Preussischer Kulturbesitz, Berlin) (fig 71). Here we see a female figure both inside and outside a room; we see her as a shadow on the white door, and in a painting or drawing nailed on the wall. The image on the wall encapsulates the tensions produced by the painting of which it is a part. As in many other Bacon paintings, it is as if the represented figure is coming out of the image; or, the other way around, as if the figure is sucked into the image. The figure is both inside and outside the image on the wall.

Studies from the human body 1975 (p 191) contains a comparable situation. On the right side we see a female figure walking into the primary space. In the centre a male figure lies on his back, half-inside and half-outside the flat surface of an image – or is it a window? On the left side a figure is totally encompassed by the dimension of representation. The direction in which the female figure walks, and in which the male figure looks, suggests that these figures are being sucked into the level of representation. If we read the direction of movement in the painting in this way, it is also possible to read the framing of the female figure's face by a circle as the beginning of this process of transformation. The circle has the same light-blue colour as the two surfaces of the levels of representation.

The image in *Three studies of Isabel Rawsthorne* is nailed onto the wall. This nailing of images is a recurrent motif in Bacon's work. Other examples are *Three figures and a portrait* 1975 (p 189), in which a portrait of Michel Leiris is nailed to the back wall, and *Three portraits: posthumous portrait of George Dyer, Self-portrait, Portrait of Lucian Freud* 1973, which shows images of Bacon and Dyer nailed to the wall in the left and right panels. All these examples suggest that representations are attempts to *nail the body down*. The most detailed version of this literal statement can be seen in *Two studies for a portrait of George Dyer* 1968 (fig 72). The scene is clearly one of mimetic, iconic representation in so far as we recognise the represented George Dyer also in the represented image in the painting. Whereas Dyer is obviously sitting for the portraitist – his pose is a pose, again literally – according to the title he is already merely a portrait, and has been sacrificed to representation. And this sacrificial nature of portraiture is hinted at by the nails that penetrate his body in the painted portrait, his mirror, linking it to Bacon's crucifixion paintings and his slaughtered oxen, as in *Figure with meat* 1954 (p 133). The two light bulbs, one for each portrait, provide the sitting George Dyer with substantial shadow and body extension, and the (doubly) painted Dyer with clear-cut black-and-whiteness: black background, white body. The embedded portrait is both emphatically iconic (it replicates Dyer's pose) and absurdly different: naked, nailed down, pinned up.

The mirror motif does not only return in Bacon's depiction of photographs, drawings and paintings in his images, but also in the motif of the double. Many of his works feature doppelgangers. In the well-known *Triptych inspired by TS Eliot's poem 'Sweeny Agonistes'* 1967 we see two resting women in the left panel and two wrestling men in the right who look like doubles. In *Crucifixion* 1965 (fig 73) we see two 'gangsters' and, similarly, in the central panel of the triptych *Two figures lying on a bed with attendants* 1968 (fig 74) are two seemingly identical men. In both works

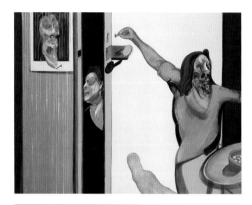

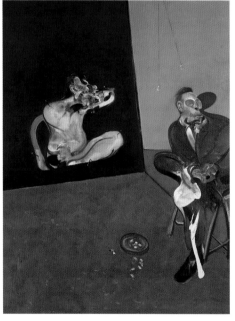

fig 71 Francis Bacon
Three studies of Isabel Rawsthorne 1967
oil on canvas, 119.5 x 152.5 cm
Nationalgalerie, Staatliche Museen zu Berlin

fig 72 Francis Bacon
Two studies for a portrait of George Dyer 1968
oil on canvas, 198.8 x 147.4 cm
Sara Hilden Art Museum, Tampere

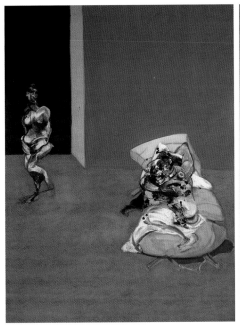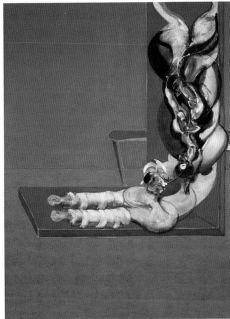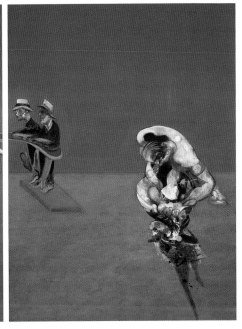

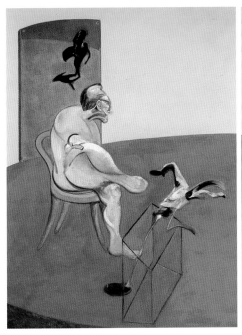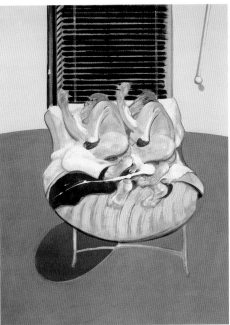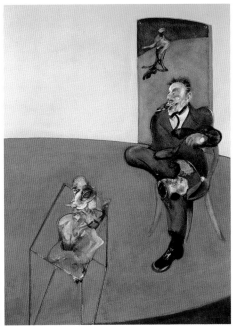

top:

fig 73 Francis Bacon
Crucifixion 1965

oil on canvas, triptych, each 198 x 147.3 cm
Staatsgalerie Moderner Kunst, Munich, Germany.
Gift of Galerie-Vereins, Munich eV

below:

fig 74 Francis Bacon
Two figures lying on a bed with attendants
1968

oil on canvas, triptych, each 198 x 147.5 cm
Tehran Museum of Contemporary Art, 1972

the identical identity of doubles is emphasised. Together, the motifs of the mirror, the doubles and the represented pictures suggest identity as problematic. Whereas the doubles have too much identity in the sense that they are identical, the identity of the mirrored and represented figures is not established in the mirror image or other kind of images. Rather, the figures' identities are unbound or lost in these representations.

The representational motif related to that of the mirror is the lamp. Sources of light in the form of bare bulbs hanging at the end of a cord recur in Bacon's work. These centres of light never create a division between light and dark areas as they do in the painterly tradition of chiaroscuro practised most famously by Caravaggio and Rembrandt. Bacon's light bulbs never illuminate an area of the represented space; all they do is create shadows. But the shadows are not clear-cut, realistic projections of the figures; they never function as a mirror image or repetition of the figure's profile, reconfirming his or her identity. The shadows are overly substantial, like bodily fluids streaming out of the figure's body; or the opposite: they are air-like as though the figure is dissolving into a ghost. This ghost-like shadow appears, for instance, in *Self portrait* 1973 (p 185), whereas over-substantial shadows occur in *Study from the human body after Muybridge* 1988 (p 217) and *Lying figure* 1969 (p 159). There is a long tradition concerning the symbolic meaning of shadows. They are considered, for example, to confirm the identity of the subject. Having a shadow substantiates subjectivity and is synonymous with being alive; being a shadow means being dead; while not having a shadow means being fictional.

This symbolism of the shadow receives yet other meaning in Bacon's paintings. Reproducing light is represented as destructive in his work. It does not reconfirm identity and nor does it illuminate. The relationship between light and shadow lies elsewhere – in another insistent reflection on representation. The representation *of* the body coincides with perception *by* the body: they both unmake the body. Representation and perception are ultimately conflated. This statement requires a reconsideration of the narrativity of Bacon's images. Although no consistent narratives can be postulated from his paintings, this does not imply that narrativity plays no role at all. Even if it is not possible to recognise a story of which a painting is an illustration, narrativity is nevertheless intensely experienced by viewers. Something is going on. The illusion of narrative Bacon's work arouses does not, however, concern the representation of a perceived sequence of events, but rather the representation of perceiving as a sequence of events. Sequentiality does not concern the object but the subject of perception. The narrative is not the content of perception, but defines the structure of perception itself.

Understanding perception as a sequence of events also illuminates the implications of certain key expressions used by Bacon in his interviews, such as 'orders of sensation', 'levels of sensation', 'domains of sensation' and 'moving sequences'.[12] Deleuze has read these expressions as referring to the idea that sensation is a cumulative sum of responses by the several sense organs. Colour, taste, touch, smell, sound or weight together constitute the different levels of sensation. This implies that Bacon attempts to give visibility to a unity of the senses: 'He is putting a multisensible figure into the visual range of the eye.'[13]

Such a reading of 'levels of sensation' acknowledges the fact that in Bacon's oeuvre the body is central; it is one integrated sense organ. It is the space to where the sense

stimuli are directed, and the place where the sense responses are made tangible. Bacon expresses the bodily tangibility of the responses of the senses in an extreme way as deformations of the body. It is as if the body is tortured by its abundance of sense organs and sense experiences. This deformation of the body can then be read as the bodily response of the senses, of the bodily experiences of the outside world via the senses. With this in mind it makes sense that in many of Bacon's paintings the heads of the figures are even more deformed than the rest of their bodies. Most of the senses are concentrated in the head: sight, smell, hearing and taste. The head is exemplary for the body as a sense organ.

The body as a sense organ is not only a pertinent term for the body in Bacon's work, but also for the effect his paintings have on the viewer. Bacon himself, at least, aimed for such an effect. In interviews he declared several times that he did not want to address the viewer via their brains but via their nervous systems, by means of affects. He rejects illustrative, narrative and abstract art because it works on the brain and not on the nervous system. These remarks about how he wants to affect the viewer imply that the figures in Bacon's paintings can be seen as representing viewers: the bodies in the paintings exhibit the kind of responses that the viewer is also intended to have. His figures are *hit* by sense perception in the same way as the viewers of Bacon's paintings are. Their sense experiences are depicted as body deformations. Responses of the senses do not represent stimuli proportionally; they are not controlled, automatic and singular. Rather, they work like chain reactions. The response of one sense works like a stimulus for the others. This causes the senses to run wild because the several sense organs are not independent of one another but integrated into one big organ: the body.

The figures in his paintings, and also the viewers of his paintings, are touched, wounded and, yes, deformed by the affects released in the perception of representation turned into the representation of perception. This explains why Bacon's aesthetic comprises a theory of the creative process as well of aesthetic reception: the figures in his work can be seen as allegories for how the viewer is affected. The dynamics materialised on the canvas demonstrate perception not as a process by which the subject controls his world, but as a process in which the body disintegrates. His painting does what it is about and what it shows. It gives the phrase 'making sense' a new unheard of meaning.

following pages:

Francis Bacon
From Muybridge 'The human figure in motion: woman emptying a bowl of water / paralytic child walking on all fours' 1965 (detail)
see p 151

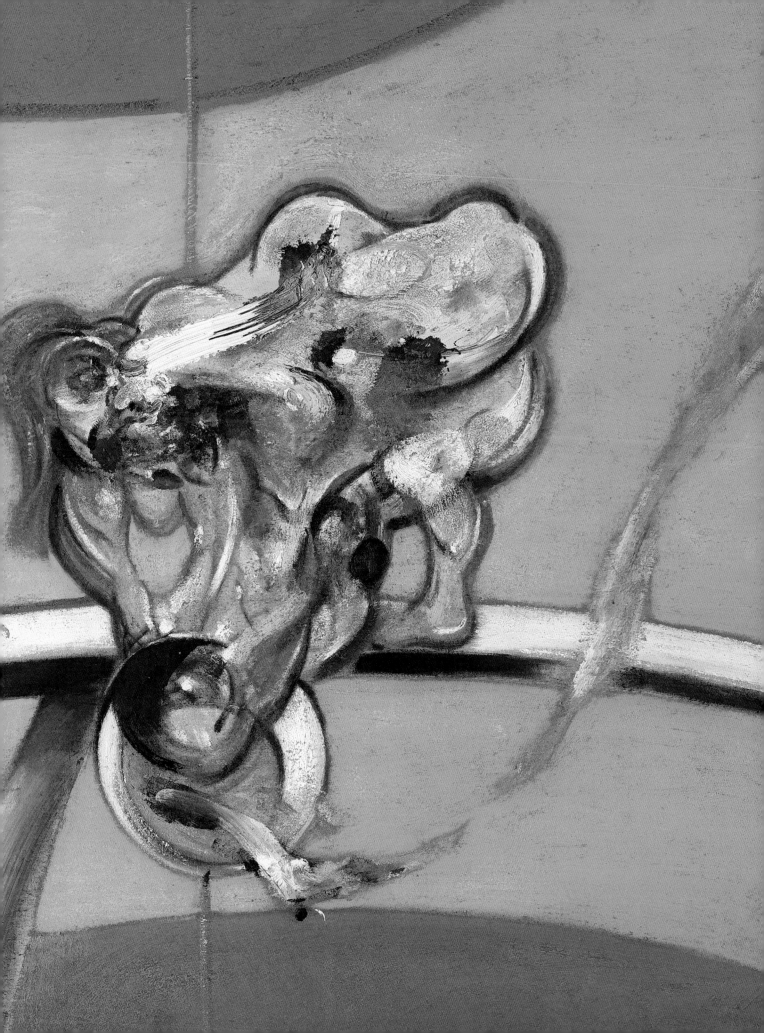

I WORK MUCH BETTER IN CHAOS ... CHAOS FOR ME BREEDS IMAGES.

FRANCIS BACON

FIVE
DECADES

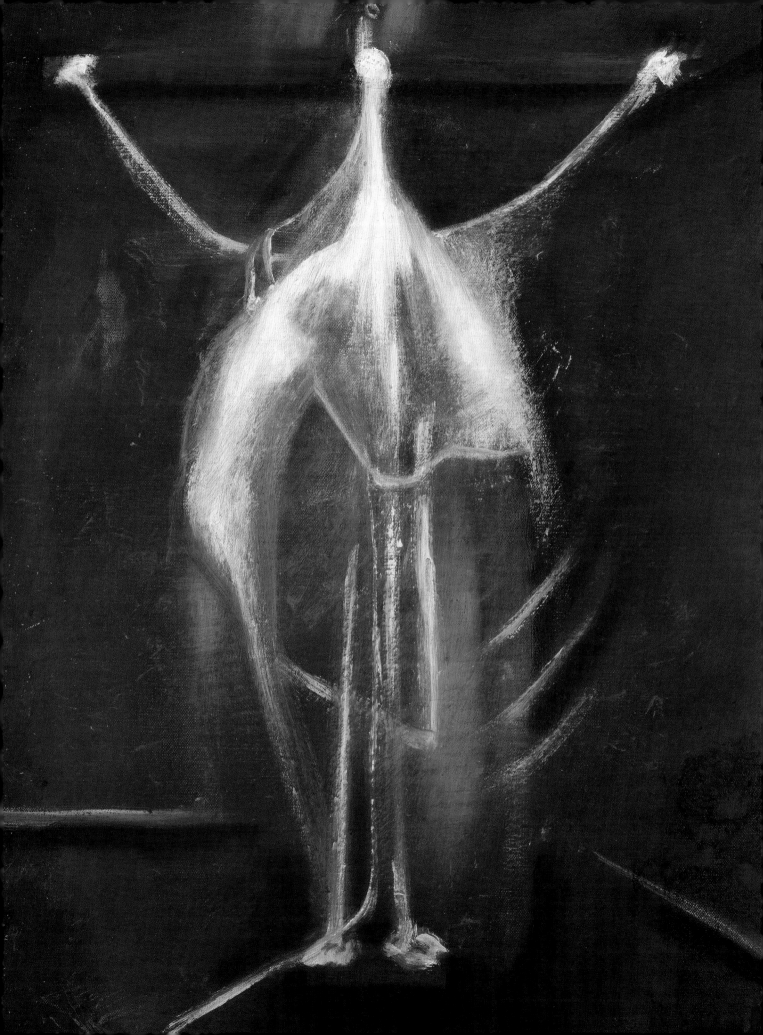

INTRODUCTION
TO A CHRONOLOGY

Anthony Bond

This publication covers the five decades between 1940 and Bacon's death in 1992, with a stand-alone early work from 1933. Many excellent chronologies of Bacon's life are already in existence – the most recent being the 2008 Tate Britain exhibition catalogue *Francis Bacon*,[1] which itself draws on colourful biographies written by Daniel Farson (1993), Andrew Sinclair (1993) and Michael Peppiatt (1997).

Without reiterating this prior work I will introduce each of the five decades by referencing significant personal and public events in Bacon's life that may have direct relevance to selected works. While I respect Bacon's aversion to biographical or psychoanalytical interpretations of his paintings, there is no doubt that his life and times are reflected in many of the choices he made and in the overall ethos of his practice. With this in mind, I will briefly summarise his life from his childhood in Ireland through to his arrival in London in 1929 where his transformation into a painter began in the lead up to the Second World War.

fig 75 Helmar Lerski
Portrait of Francis Bacon c1928–29
gelatin silver print
The Estate of Francis Bacon
© Lerski, courtesy Museum Folkwang, Essen

opposite:

Francis Bacon
Crucifixion 1933
see p 87

Francis Bacon was born in Dublin in 1909, the second of five children. One of the people closest to him in his childhood, and indeed throughout his life, was his nanny Jessie Lightfoot. In 1914 the family moved to London where they spent the dark years of the First World War. They returned to Ireland in 1919 at the time of the emergence of the Black and Tans – an armed auxiliary force of the Royal Irish Constabulary that brutally suppressed the Irish independence movement. In 1926 the family moved into Staffan Lodge where Bacon had some of his first sexual experiences with the stablehands employed by his father. Bacon was routinely whipped by his father and later described his love-hate relationship with him as a kind of sexual attraction that set up his tendency towards masochistic sex:

> … I disliked him, but I was sexually attracted to him when I was young. When I first sensed it, I hardly knew it was sexual. It was only later, through the grooms and the people in the stables I had affairs with, that I realised that it was a sexual thing … [2]

It was at Staffan that Bacon's father caught Francis wearing his mother's underwear and banished him from the family home. In 1927 he was sent to live in Berlin with a

relative who was also apparently highly unsuitable. Berlin during the Weimar Republic was a moral-free zone; the young Francis was probably not much improved by his experience there, although he no doubt enjoyed himself. He also witnessed firsthand the rise of Nazism in Germany, and traces of Nazi imagery inform some of his immediate postwar paintings. Living through the Irish Troubles, two world wars and the Great Depression had a profound impact on Bacon.[3]

Between 1927 and 1929 Bacon spent time in Paris. In that short period he saw exhibitions by Picasso and Chaim Soutine that affected him profoundly. It was also where he first encountered the Russian director Sergei Eisenstein's classic film *Battleship Potemkin* (1925), which heavily influenced his later imagery. The film *Un chien andalou* (1929) by the Spanish director Luis Buñuel also screened at this time and Bacon responded to its surrealism. Much later he told Michel Archimbaud how the films of Eisenstein and Buñuel, as well as those of the French directors Jean-Luc Godard and Alain Resnais, influenced him indirectly: 'Images enter your brain, and then you just don't know how they are assimilated or absorbed. They're transformed, but you don't know exactly how.'[4]

In 1929 Bacon moved from Paris to London where he enjoyed modest success as a furniture designer. In 1930 the Australian artist Roy de Maistre arrived in London. He became a close friend and mentor to the younger Bacon, introducing him to his circle of friends, including influential collectors and artists such as Graham Sutherland. Through de Maistre, Bacon befriended the Australian writer Patrick White who commissioned him to make a desk. White also acquired a glass-and-steel dining table of the kind that Bacon later depicted as a stage for the figures in his paintings.

It was de Maistre who encouraged Bacon to try oil painting. De Maistre and Sutherland were also painting crucifixions at this time, which must have made an impression. However, while de Maistre and Sutherland were genuinely religious, Bacon was already a confirmed atheist and was attracted to the subject of crucifixion as an example of the cruel things people do to each other.[5] Back in London in 1929 Jessie Lightfoot again took charge of Bacon's domestic needs and remained his close companion until her death in 1951.

In 1933 Hitler was appointed Chancellor of Germany and the great showpieces of the Nuremberg rallies began to be seen in Europe's popular press. In the same year Bacon painted *Crucifixion*. The work was noticed by the English art critic Herbert Read who included it in his book *Art now* (1933) (fig 79, p 86) where it appeared alongside Picasso's *Baigneuse* (*Bather*) 1929. This was important for Bacon, who

regarded Picasso as a role model. In 1934–35 Bacon was included in a few group exhibitions, and with his lover Eric Hall joined with de Maistre to re-form the London Artists' association for young artists.

In 1938 Picasso's great anti-war painting *Guernica* 1937 was shown at the Whitechapel Gallery in London, one year after the bombing of the Basque town by Nazis in the Spanish Civil War. The year 1938 was also when the frenzy of fascism was let loose in Germany with Kristallnacht, or the Night of Broken Glass, when German soldiers and civilians undertook a series of violent attacks against Jews and destroyed their synagogues, shops and businesses. The Second World War broke out in 1939 although Bacon avoided conscription because of his serious life-long affliction with asthma.

Bacon travelled back and forth to Europe during these years and was aware of developments there. It was an extraordinary time to be a young and impressionable artist. Although Bacon did little painting of great significance during the war years, he re-emerged in the mid 1940s with an extraordinary body of work.

Another way of characterising Bacon's life in these decades is by the obsessive and lasting affairs he had with a succession of lovers. From 1929 until 1949 he had a relationship with Eric Hall, a collector, businessman and great supporter of Bacon. In 1952 he began a tumultuous and sometimes violent affair with Peter Lacy, an ex-Royal Air Force pilot with whom he often travelled to Tangier in Morocco. Lacy took up residence in Tangier and died there in 1962; Bacon was informed of his death on the day of his first retrospective exhibition at the Tate Gallery in London.

George Dyer was possibly Bacon's most important lover, and appears frequently in his paintings. They met in 1963 and shared a turbulent life until Dyer's death in 1971 on the eve of a major exhibition of Bacon's work at the Grand Palais in Paris. In 1976 Bacon met John Edwards with whom he had a paternal relationship that lasted until the end of his life. Although Edwards had a long-term lover outside the relationship and Bacon had a final passionate affair with José Capello, a young Spanish businessman, it was Edwards who inherited the artist's estate in 1992.

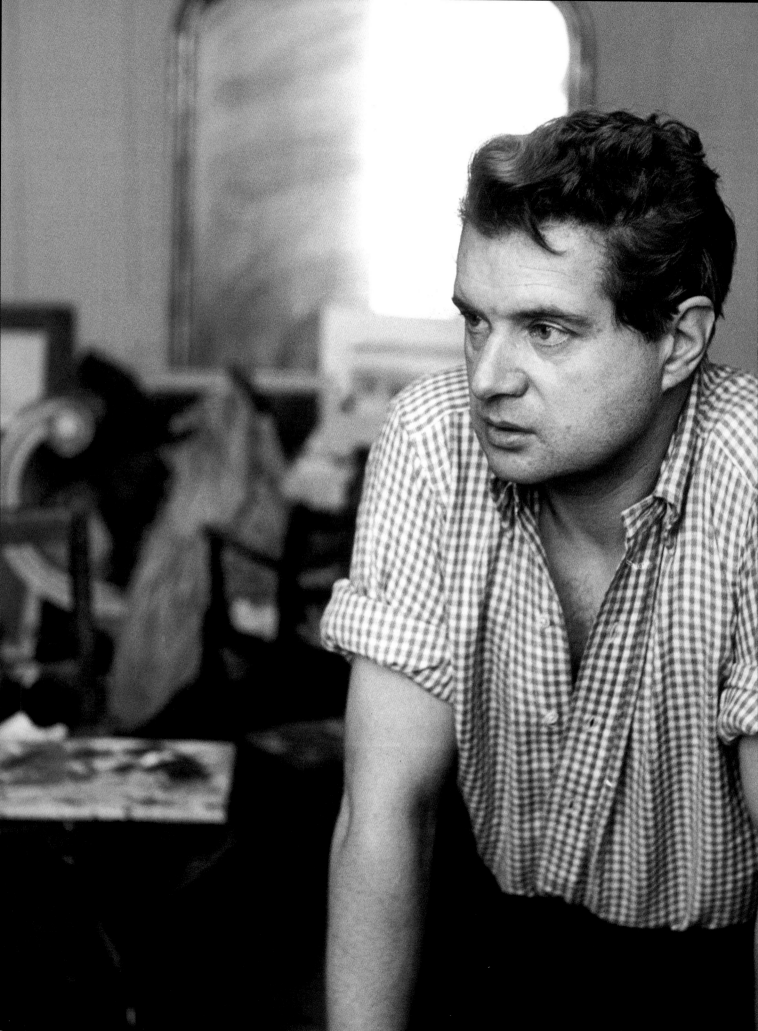

1940s

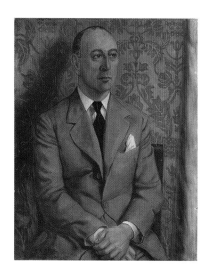

fig 76 Roy de Maistre
Portrait of Eric Hall c1936

oil on canvas, 91.3 x 71 cm
The Estate of Francis Bacon
© Caroline de Mestre Walker

page 82:

Henri Cartier-Bresson
*British painter, Francis Bacon, London,
Great Britain, 1952*

Bacon seems to have done little painting during the war years. Excused from military service because of his asthma he worked for a time in Civil Defence, although this too was short-lived because of the serious effects on his breathing of the constant bombing and demolition in London. With his lover, the collector and businessman Eric Hall, he moved to a cottage in Hampshire where he completed some paintings, one of which, *Figure getting out of a car* 1939–40 (fig 80, p 88), formed the basis for his first major triptych, *Three studies for figures at the base of a crucifixion* c1944 (fig 24, p 41).

The earlier painting had been suggested by a photograph of Hitler getting out of a car, however it was later painted over and survives only in reproduction. Bacon collected a number of images from the period of the Third Reich in Germany, often showing powerful Nazis in cars or behind a bank of microphones. The image of the Dictator merged in his paintings with that of the Pope and possibly his own violent and overbearing father.

In 1940 Bacon's father died and his mother moved to Africa, where his two sisters already lived in Rhodesia (Zimbabwe). Bacon often visited them there and collected wildlife photographs that occasionally appear in a transformed state in his paintings.

Three studies for figures at the base of a crucifixion is probably Bacon's first great work and was inspired by the distorted figures of Picasso's surrealist period. The painting was acquired by Hall who gifted it to London's Tate Gallery in 1953.[6] The figures in the painting have monstrously deformed bodies that are part-human, part-beast. Two of them have gaping maws for mouths, their lips drawn back in a ghastly grimace expressing their pain. This use of the mouth to conjure extremes of emotion recurs in Bacon's work but most disturbingly so in the 1940s. Four related works are included in this exhibition: *Figure in a landscape* 1945 (p 91), *Figure study I* (p 93) and *Figure study II* (p 95), both 1945–46, and *Study for a figure at the base of a crucifixion* 1943–44 (p 89).

In 1946 Bacon created *Painting 1946*, a work that he subsequently cited as an example of what can happen subconsciously when making art. Bacon claimed to have set out to paint a bird alighting in a field but somehow, without any conscious decision on his part, the image turned into a painting of a screaming man under an umbrella surrounded by impaled carcasses.

Painting 1946 was bought by the Museum of Modern Art in New York – Bacon's first museum acquisition. The proceeds of the sale enabled Bacon and Hall to decamp to Monte Carlo for an extended period where they lived well, the artist having had some success at the gaming tables. Returning to London in 1948 he joined Hanover Gallery where he had his first solo exhibition in 1949 featuring *Head I* 1947–48 (p 97) and *Head II* 1949 (p 99), as well as *Study from the human body* 1949 (p 103) and *Study for a portrait* 1949 (p 101).

Bacon was an ardent collector of photographs, not only high-quality photographs commissioned or bought from professional photographers, but also images torn from newspapers, art journals and pictorial magazines such as *Picture Post*. In 1961 he moved into Reece Mews in South Kensington where he stayed until the end of his life. Most of his source material from this period survives, but only fragments remain from his earlier studio near Cromwell Place, which he occupied between 1943 and 1951. We do know that such source material existed, however, because of the published photographs that the American art historian Sam Hunter took at Cromwell Place that show a montage of source materials, including movie stills, news photographs and a reproduction of Velázquez's *Portrait of Pope Innocent X* c1650 (fig 53, p 54).[7]

There has been much speculation about the imagery circulating in these earlier years that Bacon must have encountered. Photographs of the Nuremberg rallies in Germany, for example, which began to appear in the press, show the sky corrugated by the narrow vertical beams of searchlights and are reminiscent of the curtains that appear in Bacon's paintings in the 1940s and 1950s. However, as with most of Bacon's sources, there are invariably alternatives. In the case of the searchlights there is also the fact that in 1930 Bacon designed curtains made from white rubber that hung in tight folds and which had a very similar effect. In any case, Bacon consumed images ravenously and, consciously or unconsciously, drew on multiple sources for his final compositional devices. His own explanations are often contradictory. AB

fig 77 Montage of images from art history and popular culture from Bacon's Cromwell Place studio, 1950.
arranged and photographed by Sam Hunter
Dublin City Gallery The Hugh Lane F1A:201

fig 78 Francis Bacon
Painting 1946
oil and pastel on linen, 197.8 x 132.1 cm
Museum of Modern Art, New York

Crucifixion
1933

oil on canvas
60.5 x 47 cm
Courtesy Murderme

This painting was Bacon's public debut and explores a theme that he returned to throughout his life. For Bacon, however, the art-historical topic of crucifixion was less a religious motif than a cipher for suffering. He described it as 'a magnificent armature on which you can hang all types of feeling and sensation'.[8] The likeness to Picasso's biomorphic forms has been noted by many commentators, including the influential critic Herbert Read who reproduced *Crucifixion* opposite Picasso's *Baigneuse* (*Bather*) 1929 in his 1933 book *Art now* (below). Bacon himself acknowledged the influence, saying that Picasso's work in the late 1920s first spurred him to paint: 'I admired Picasso greatly … Everything of his that I saw at the time had a huge effect on me.'[9] After seeing it in *Art now*, the well-known English art dealer Sir Michael Sadler bought *Crucifixion* and later sent Bacon an X-ray of his own skull as material for a new portrait.

fig 79 Spread from Herbert Read, *Art now* (1948), juxtaposing Bacon's *Crucifixion* 1933 and Picasso's *Baigneuse* (*Bather*) 1929.

© The Estate of Francis Bacon/DACS and Succession Pablo Picasso/ADAGP. Licensed by Viscopy

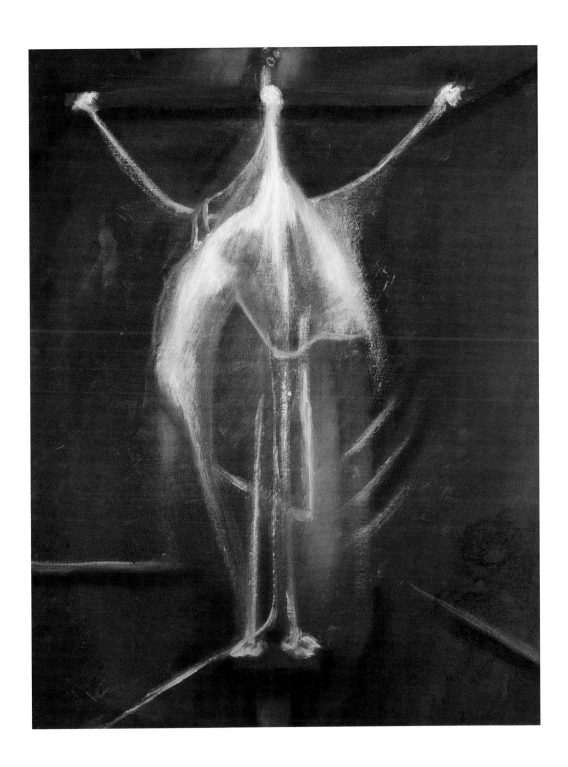

Study for a figure at the base of a crucifixion
c1943–44

oil and pastel on board
94 x 74 cm
Courtesy Murderme

This study is a variation on the right panel of Bacon's breakthrough triptych *Three studies for figures at the base of a crucifixion* c1944. The latter was painted after a decade when Bacon destroyed nearly all of his work, including images derived from photographs of Hitler getting out of a car, which he painted over (below). This study is closely related to one of these destroyed paintings. Bacon's bold and often horrific vision emerged at the tail end of a shattering war, in a Britain worn out by profound violence. Bacon was excused from active military service due to his asthma: 'I was turned down … because I was an asthmatic and then I started to work much more regularly and seriously.'[10] However, he did encounter the violence of war while working in Civil Defence and Air Raid Precautions. The figure in this image has been linked to the vengeful Eumenides of ancient Greek mythology. Drawn from both Aeschylus's bloody play *Oresteia* and TS Eliot's reinterpretation of it in his play *The family reunion* (1939), these frightening creatures appear in many of Bacon's works.

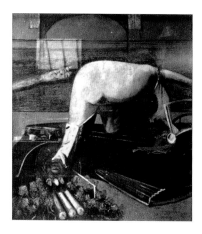

fig 80 *Figure getting out of a car*
c1939–40

oil on canvas, 145 x 128 cm
reworked c1946 and retitled
Landscape with car

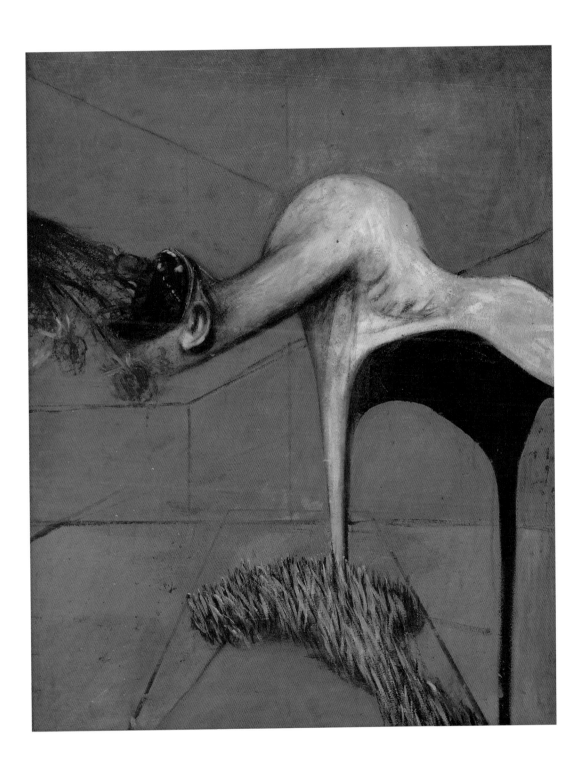

Figure in a landscape
1945

oil on canvas
144.8 x 128.3 cm
Tate, London. Purchased 1950.
N05941

'*What is left after you're dead but your bones and your teeth?*'
Francis Bacon, nd[11]

Figure in a landscape is an early example of Bacon's use of photographs as source material. It is partly based on a photograph of the artist's lover, Eric Hall, reclining in a chair in London's Hyde Park – an image that Bacon has transformed into a menacing and complex painting. The work also foreshadows the artist's later series of screaming popes and is related to the umbrella in *Figure study II* 1945–46 (p 95). The figure's coat is painted using a thin wash combined with dust from the studio floor, a ploy Bacon used as both a visual effect and as a metaphorical reflection on the nature of existence (he later commented that 'dust seems to be eternal').[12]

A lifelong atheist, Bacon's outlook was akin to the philosophy of Jean-Paul Sartre, whose seminal text *Being and nothingness* was published two years before Bacon painted *Figure in a landscape*. The figure is often understood to be holding a machine gun, however the structure is based on an earlier, now destroyed, painting titled *Study for man with microphones* (below). Here the figure is obscured by a thick black shadow, which echoes Sartre's famous assertion that 'nothingness haunts being'.[13]

fig 81 *Study for man with microphones* 1946 (first state)
oil on canvas, 147 x 128 cm
subsequently overpainted

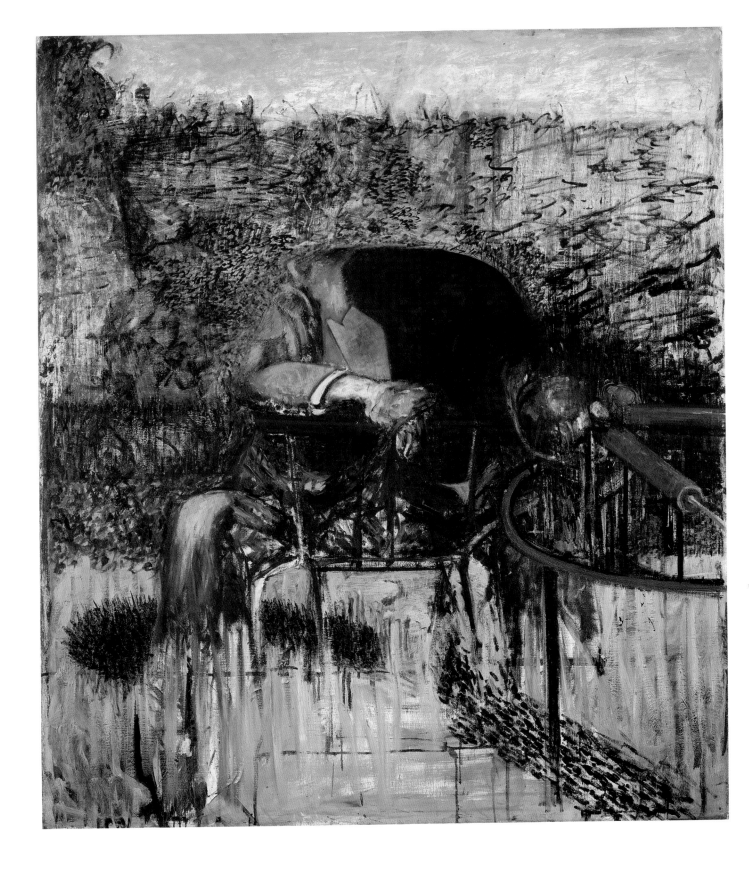

Figure study I
1945–46

oil on canvas
123 x 105.5 cm
Scottish National Gallery of Modern Art,
Edinburgh. Accepted by HM Government
in lieu of Inheritance Tax and allocated to
the Scottish National Gallery of Modern
Art, 1998

Painted at the close of the Second World War, *Figure study I* is informed
by the pervasive, ominous atmosphere of postwar Britain. However, the work
has multiple sources and draws together images from both the popular press
and art history. Bacon scholars Martin Hammer and Chris Stephens have
linked the painting to a photograph of Hitler laying flowers at his parents'
grave (below right).[14] While a source photograph was never found in Bacon's
studio, he did accumulate images of Hitler and sometimes included direct
references to the Nazis in his work. These include early (now destroyed)
works, such as *Figure getting out of a car* c1939–40 (fig 80, p 88) through
to the much later *Crucifixion* 1965, in which a figure's arm is decorated with
swastikas. *Figure study I* and *Figure study II* 1945–46 (p 95) also resemble
Giotto's portrayal of Mary Magdalene draped in a shawl in the fourteenth-
century fresco cycle in the Arena Chapel in Padua, Italy (below left).

fig 82 Giotto di Bondone
*Noli me Tangere, detail of Christ and
Mary Magdalene* c1305 (detail)
Scrovegni (Arena) Chapel, Padua

fig 83 Hitler at his parents' grave.
photographed by Heinrich Hoffmann
© Bundesarchiv – Federal Archives, Germany

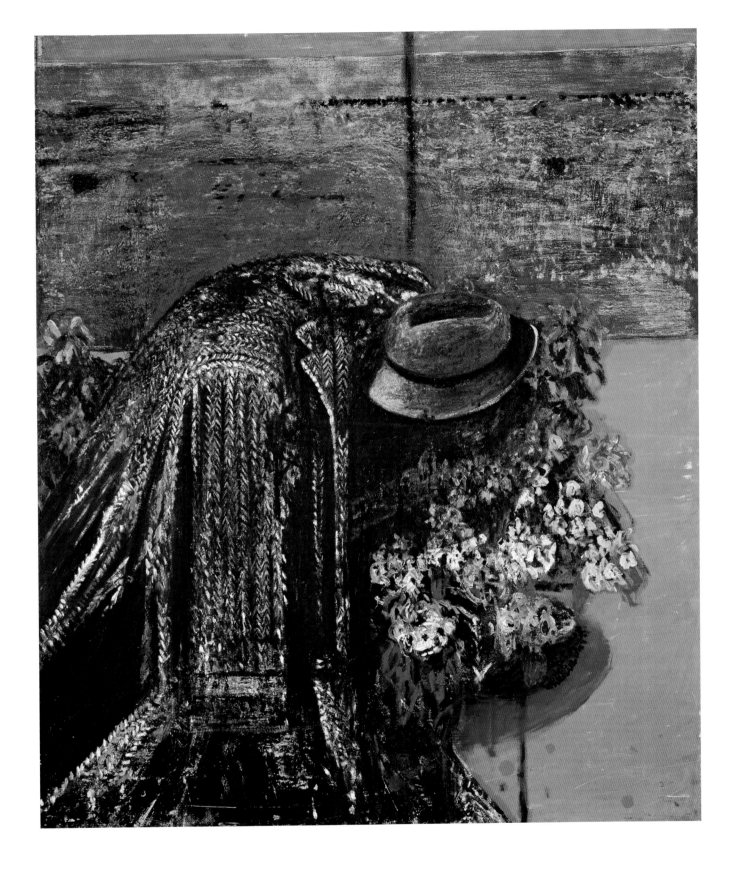

Figure study II
1945–46

oil on canvas
145 x 129 cm
Kirklees Museums & Galleries.
Presented by the Contemporary
Art Society to Batley Art Gallery

Figure study II is an early depiction of the scream, a motif that came to define the horror implicit in Bacon's paintings. The theme first appeared in *Figure in a garden* 1936 and became a hallmark from 1944.[15] It was informed by a broad range of sources, including the French artist Nicolas Poussin's seventeenth-century painting *Massacre of the innocents* (below left); a book of photographs of diseases of the mouth; and the screaming nurse in Sergei Eisenstein's revolutionary film *Battleship Potemkin* (1925). It was a painting of this nurse in 1957 that marked the end of Bacon's fascination with the image.[16]

The kneeling figure in *Figure study II* bears a resemblance to Giotto's fourteenth-century depiction of Mary Magdalene (fig 82, p 92), although Bacon resisted this allusion to the story of Christ's crucifixion by giving the work a nondescript title. The painting is also reminiscent of the German film director Leni Riefenstahl's image (below right) of a photographer sheltering from the rain under blankets and an umbrella, demonstrating the breadth of imagery that Bacon drew upon.

fig 84 Nicolas Poussin
The massacre of the innocents
c1628–29

oil on canvas, 147 x 171 cm
Le musée Condé, Chantilly

fig 85 Leni Riefenstahl
Photographer sheltering from the rain from *Schonheit Im Olympische Kampf* 1937

photogravure, 14 x 19 cm
Private collection
© Leni Riefenstahl Estate

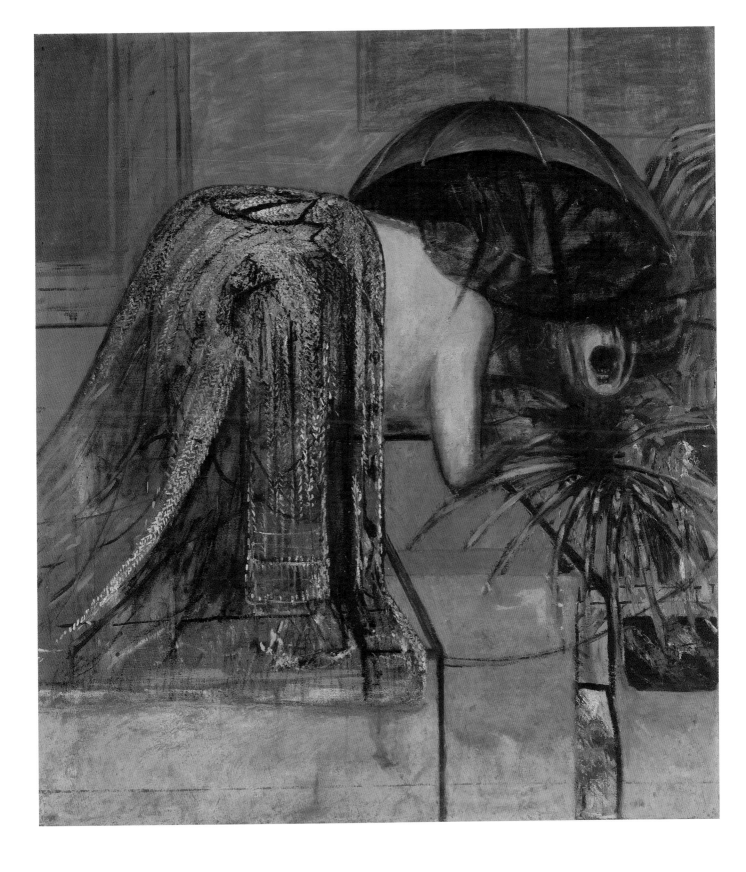

Head I
1947–48

oil and tempera on board
100.3 x 74.9 cm
Metropolitan Museum of Art, New York.
Bequest of Richard S Zeisler, 2007
2007.247.1

In the late 1940s Bacon embarked on a series of monochrome paintings of heads. The form in *Head I* is heavily worked, with the ear, in particular, painted in thick impasto that makes it almost sculptural. The figure has both human and animal traits and suggests a chimp with bared teeth, reflecting Bacon's interest in blurring the boundaries between man and beast.
For the philosopher Gilles Deleuze this slippage between animal and human in Bacon's work cannot be resolved: 'This is not an arrangement of man and beast, nor a resemblance; it is a deep identity, a zone of indiscernibility … the man who suffers is a beast, the beast that suffers is a man.'[17]

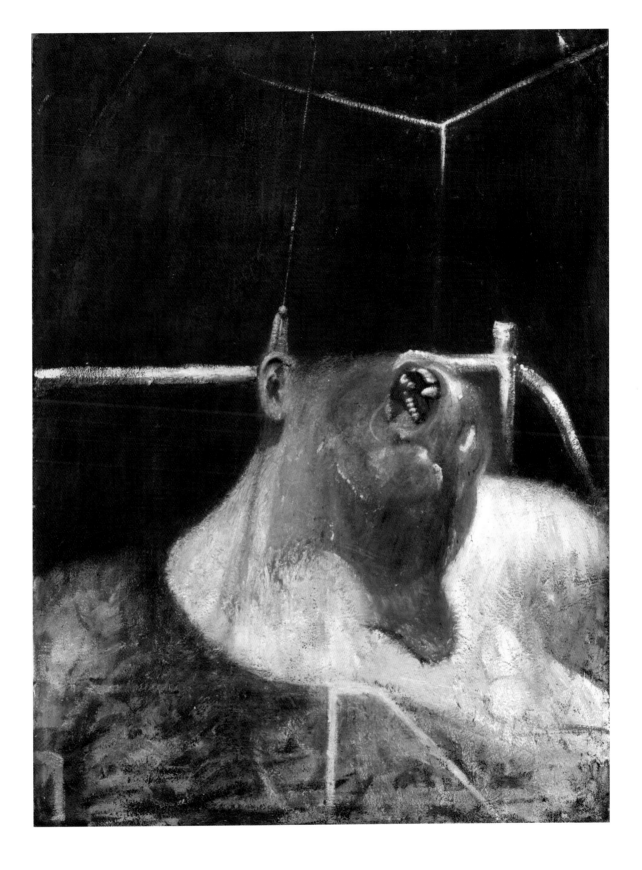

Head II
1949

oil on canvas
80 x 63.6 cm
Ulster Museum, Belfast. Donated by the
Contemporary Art Society, London, 1959.
National Museums Northern Ireland

Bacon built up the thick impasto surface in *Head II* over four months –
a long period of time for an artist who generally worked on his paintings
much more quickly. The impact of the work is not immediately apparent
in photographic reproduction, particularly the fat leathery wall of wrinkled
paint that hangs off the canvas. Areas of exposed linen amplify the
weight of the paint on three sides. There is a horizontal structure to the
underpainting, which has been finished with a thin coat of dry vertical
brushmarks that imply fabric bearing down on the figure. As with *Head I*
(previous page), the image here is located somewhere between human and
animal and exemplifies Bacon's desire to 'paint like Velázquez but with the
texture of a hippopotamus skin'.[18]

Study for a portrait
1949

oil on canvas
149.4 x 130.6 cm
Museum of Contemporary Art Chicago.
Gift of Joseph and Jory Shapiro
1976.44

Study for a portrait shows a man confined in a cube or cage, a device that became a defining feature of Bacon's work. The cage is claustrophobic and the figure's open mouth is often interpreted as a scream. The scream in Bacon's paintings is drawn from the screaming nurse in Sergei Eisenstein's 1925 film *Battleship Potemkin* (below). However, in this image it could also be a gasp for air. Bacon scholar Martin Harrison has linked this image of gaping mouths to the artist's asthma, which was triggered in his childhood by his father's dogs.[19] The experience of struggling for breath must have been terrifying and an echo of that helplessness and physical panic is apparent here.

fig 86 Screaming nurse (N Poltavseva) film still from *Battleship Potemkin* dir Sergei Eisenstein (1925).

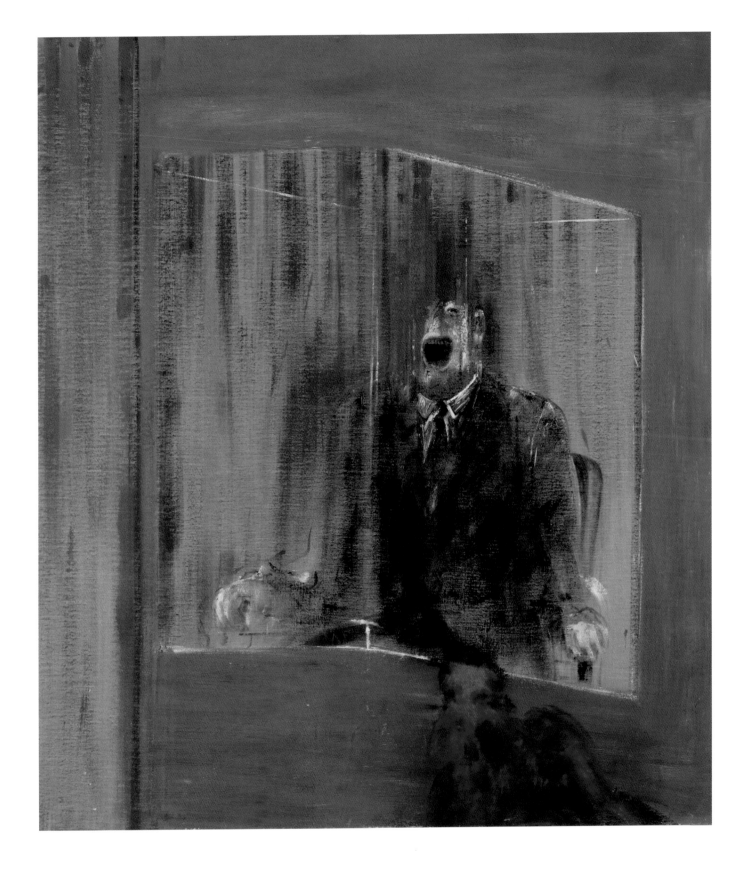

Study from the human body
1949

oil on canvas
147 x 134.2 cm
National Gallery of Victoria, Melbourne.
Purchased 1953

Study from the human body is Bacon's first nude and is painted with
tenderness and a gentle erotic charge.[20] The transparent curtain creates
a sense of depth and has been linked to Titian's *Portrait of Cardinal Filippo
Archinto* 1558 (below), in which a thin veil falls across the subject's face
and the right half of the composition. Bacon infuses this motif with
an ominous atmosphere: the man moves away from us into a dark and
indiscernible space. As the English art critic Robert Melville said in the
year the work was painted: 'Every activity in these paintings of men going
in and out of curtains, or imprisoned in transparent boxes, has an air of
extreme hazard.'[21]

fig 87 Titian
Portrait of Cardinal Filippo Archinto
1558

oil on canvas, 114.8 x 88.7 cm
Philadelphia Museum of Art,
John G Johnson Collection 1917

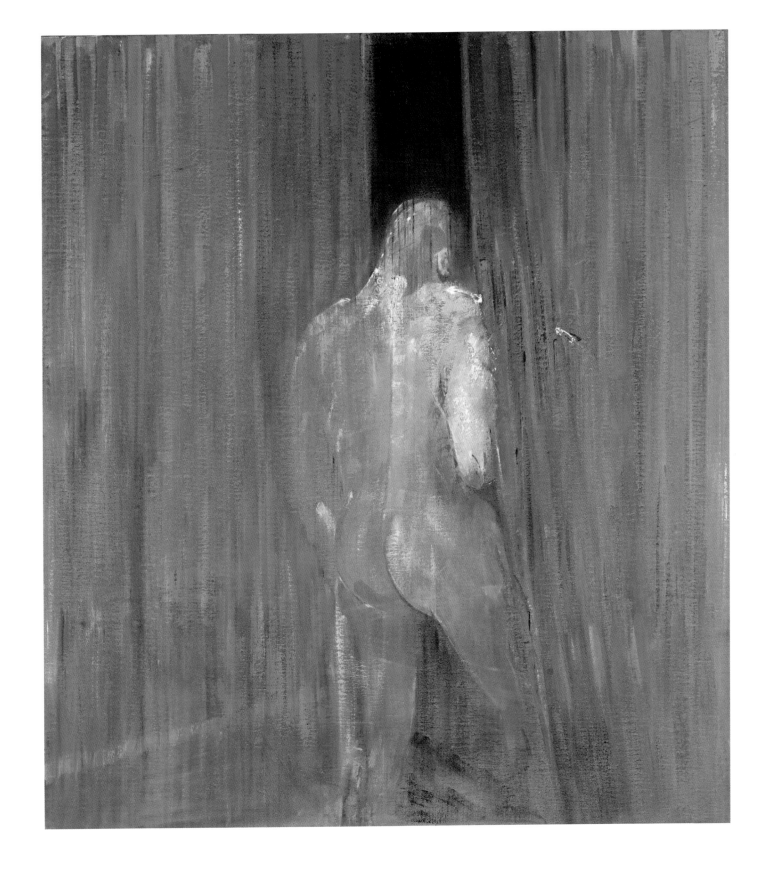

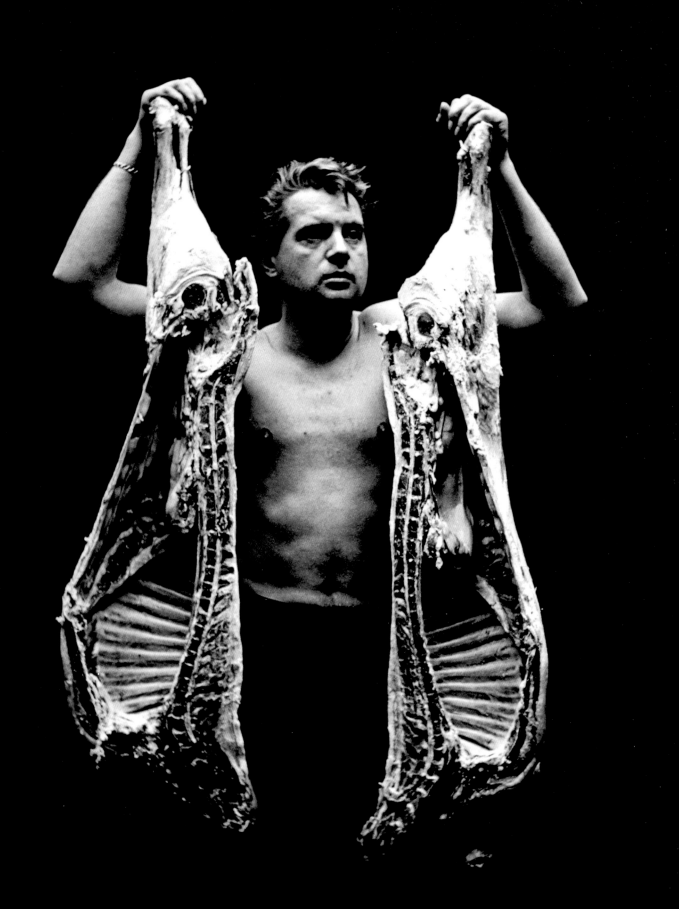

1950s

fig 88 Peter Lacy, c1959
photographed by John Deakin
Dublin City Gallery The Hugh Lane F14:99

page 104:

John Deakin
Portrait of Francis Bacon 1962
John Deakin/Vogue © The Condé Nast Publications Ltd

In 1951 Jessie Lightfoot died. She was Bacon's childhood nanny and accompanied him when he was expelled from the family home. Her death devastated Bacon and may have been partly accountable for his restlessness in the following years.

This decade was for Bacon one of experimentation with subject matter and technique. He moved from place to place, including to South Africa, Kenya and Morocco, not settling into a studio until 1961. Nonetheless, it was a very productive period. Many of the paintings from this time were done in series and often hastily completed for exhibition deadlines. His bodies of work included the van Gogh paintings of 1957 and the men in blue from 1954. The latter typify the thin washes that Bacon used in the 1950s, with the artist adopting heavier paint for his figures and flat areas of strong colour in the 1960s.

His lover during these years was Peter Lacy, who in 1956 moved to Tangier, Morocco. Bacon visited him there, stopping off in Monte Carlo on the way to make some money at the casino tables. The subjects and techniques he used in his work at this time are varied, the artist having not yet settled into the standard canvas formats that he employed from the early 1960s. His paint is seldom brightly coloured with some exceptions, such as the van Gogh series represented here by *Study for a portrait of van Gogh IV* 1957 (p 143).

The paint tends to be much thinner than in his work of the late 1940s and often comprises grey and blue washes. Bacon's repertoire of imagery was drawn from personal experience and includes the men in suits, grappling couples, movie stills and wildlife photographs. He also repeatedly referred to other artists' paintings, such as van Gogh's self-portrait *The painter on the road to Tarascon* 1888 and Velázquez's *Portrait of Pope Innocent X* c1650. The figures in Bacon's work are usually incomplete and blurred, with the violent distortions and thick, flesh-like paint not appearing until the 1960s.

In the 1950s The Colony Room in Soho became Bacon's favoured social setting. The club was run by Muriel Belcher, a formidable woman who Bacon often painted in later years (fig 89). In 1949 Belcher obtained a licence for the club to remain open from 3pm until 11pm; in those days English pubs closed in the early afternoon. Bacon was a founding member of The Colony Room and Belcher commissioned him to bring along his wealthy admirers in exchange for £10 a week and as much champagne as he could drink.

While the 1950s might be remembered by some as a period of almost utopian stability following the Second World War, it was in fact a time of great upheaval. Events

in this decade included the Korean War, which broke out in 1950, and the 1952 Mau Mau Uprising in Kenya. In 1956 the Soviet army crushed the Hungarian independence movement and in Egypt General Nasser nationalised the Suez Canal. France engaged in a full-scale battle with Algerian separatists in 1958, while in the following year Fidel Castro took power in Cuba. Bacon collected news photographs of many of these events, some of which appear to haunt his paintings.

In the 1950s Bacon saw the French director Alain Resnais's film *Hiroshima mon amour* (1959). Resnais, who Bacon admired, based the film on a book by the French writer Marguerite Duras, a friend of the artist's. A poster from the film, creased and torn, became the source for several of Bacon's paintings, such as the portraits of his bohemian friend Henrietta Moraes in which an arc seems to cut through her face.

The 1950s also marked the end of the official persecution of homosexuals in England, with the 1957 report of the Wolfenden Committee recommending its decriminalisation. Bacon's openly gay behaviour and his published imagery during this period had, to say the least, been reckless. The claustrophobia of these years is captured in the English director Basil Dearden's film *Victim* (1961), starring Dirk Bogarde and Sylvia Syms. The film was initially banned in the United States and was controversial even in London. The veil of secrecy surrounding homosexuality at this time seems to haunt many of Bacon's works. AB

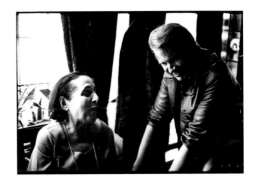

fig 89 Francis Bacon and Muriel Belcher at the Colony Room 1975. photographed by Peter Stark
© Peter Stark

Untitled
(study after Velázquez)
1950

oil on canvas
198 x 137 cm
The Estate of Francis Bacon
Courtesy Faggionato Fine Art, London

Untitled (study after Velázquez) foreshadows two themes that defined Bacon's work in the 1950s and draws together a range of seminal influences. Showing a seated man clutching the arms of his chair, it has the same compositional structure as *Pope I – study after Pope Innocent X by Velázquez* 1951 (p 115) and resembles Bacon's many other paintings of screaming popes – derived from Velázquez's c1650 painting – that were to come. The scream recalls the iconic image of the screaming nurse with bloodied eye and smashed glasses from Sergei Eisenstein's film *Battleship Potemkin* (1925) (fig 86, p 100). Here, however, the figure is stripped of all papal attire. In a necktie and collared shirt he relates more closely to Bacon's series of six men in business suits, painted in monochrome blues, from the same decade. *Untitled (study after Velázquez)* is striking for its use of rich red and black vertical marks that echo the rubber curtains Bacon made as a furniture designer in his early twenties. Here the structure of the curtains cuts through the figure's face.

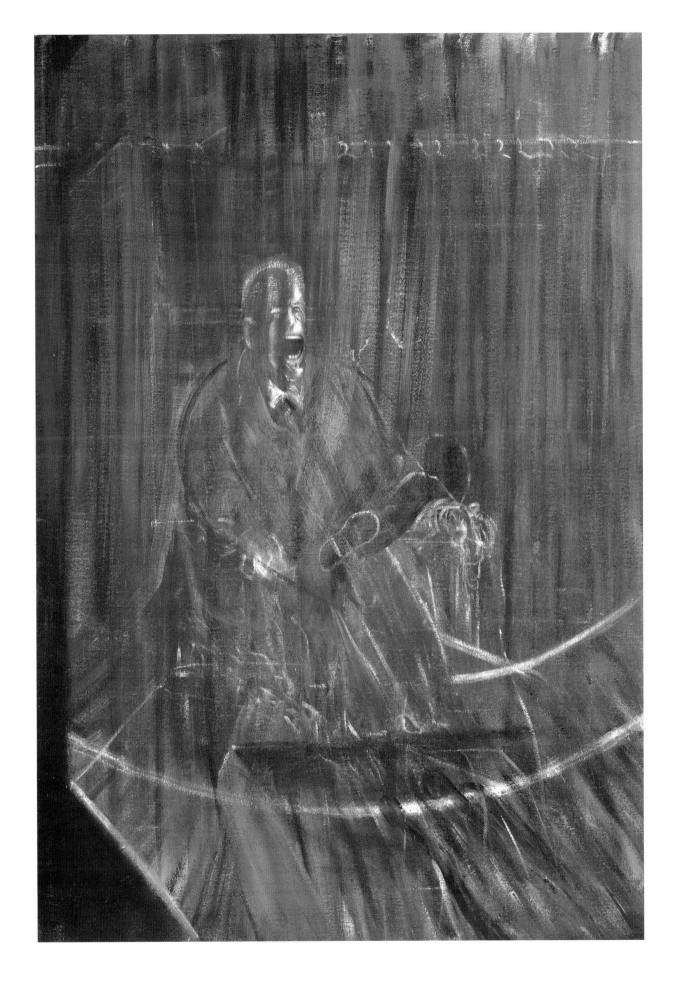

Untitled (crouching nude)
c1950

oil on canvas
196.2 x 135.2 cm
The Estate of Francis Bacon
Courtesy Faggionato Fine Art, London

Untitled (crouching nude) is a vigorously painted image. The crouching figure has a raw animal energy: every part of the canvas is alive with brushwork that seems to infuse and animate its bristling muscles. The composition features many of the motifs that define Bacon's work in this decade, including the white prism or frame in which the figure is contained, and the background curtain with a second rail in the lower foreground. The curtains are painted in thin dry brushstrokes over a dark ground. The crouch is a posture that Bacon iterated in the 1940s and 1950s and it implies oscillating energy squeezed into a ball, ready to explode.

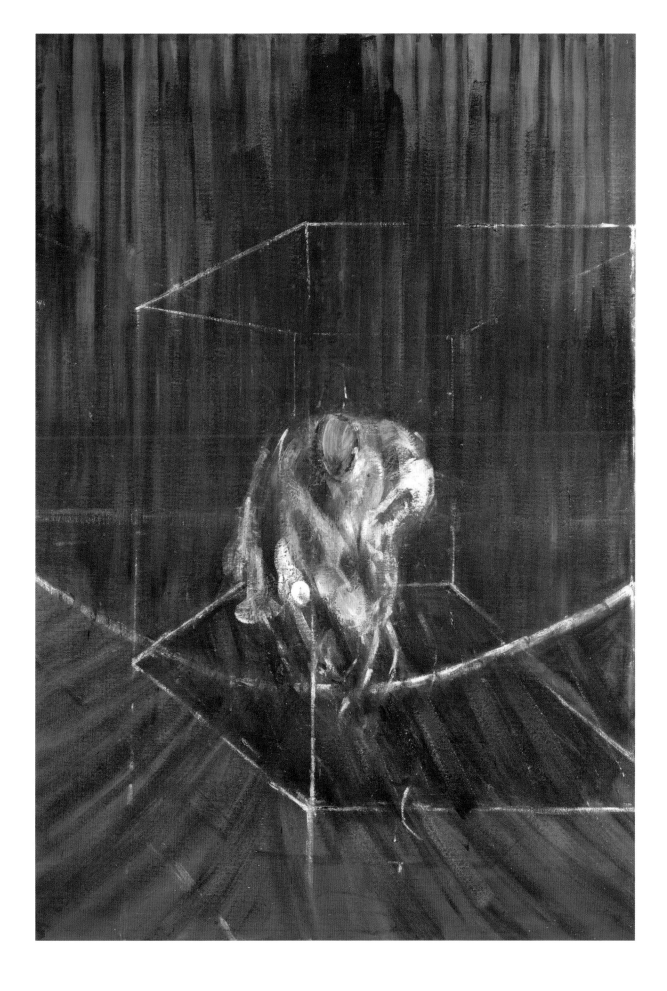

Untitled (figure)
1950–51

oil on canvas
198 x 137 cm
The Estate of Francis Bacon
Courtesy Faggionato Fine Art, London

This painting is informed by a book that Bacon kept in his studio, *Phenomena of materialisation* (1920) by Baron Albert von Schrenck-Notzing. This book purported to show photographs of séances in which figures, often glimpsed through curtains, were accompanied by ghostly and ectoplasmic forms. *Untitled (figure)* shows a caged man hovering within a structure that loosely derives from the curved steel furniture that Bacon designed when aged in his early twenties (below). The figure itself is rendered in a milky blue-and-white substance laid down in a thin translucent coat. On closer inspection one can see that he wears a collar and tie; in this the work prefigures Bacon's paintings from the 1950s of men in blue. The striations that mark many of Bacon's works cut through the man in this painting, amplifying his translucence and making him appear more ethereal.

fig 90 These pages show three views of Bacon's first studio at Queensberry Mews West, South Kensington, London in 'The 1930 look in British decoration', *Studio*, August 1930, pp 140–41. F14:99

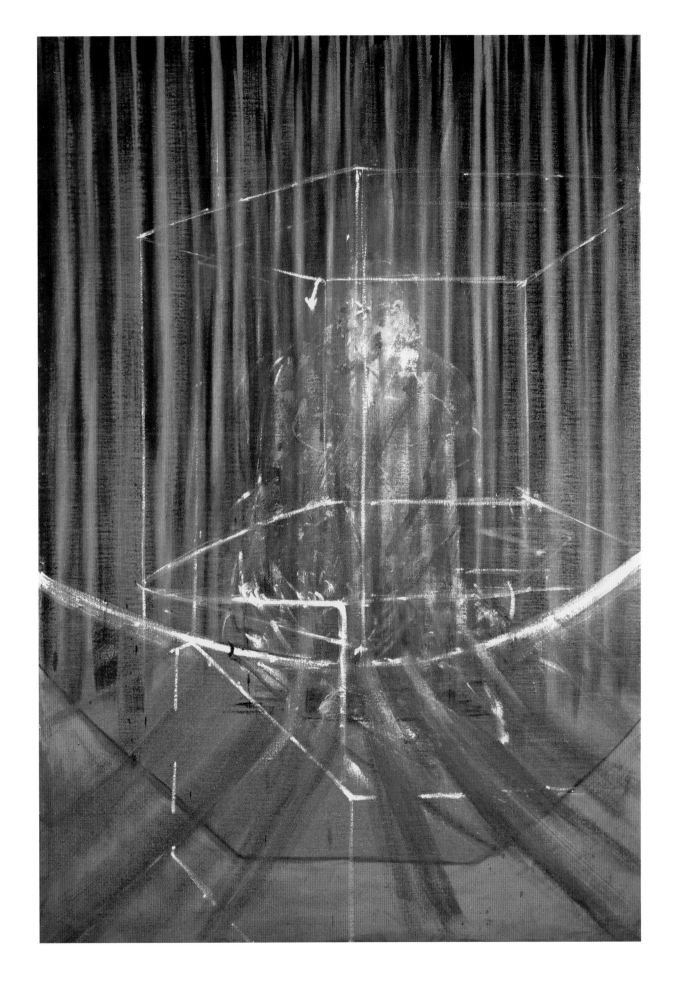

**Pope I – study after
Pope Innocent X by Velázquez**
1951

oil on canvas
198 x 137 cm
Aberdeen Art Gallery &
Museums Collections

Pope I – study after Pope Innocent X by Velázquez was directly inspired by Velázquez's *Portrait of Pope Innocent X* c1650 (below). As Bacon explained: 'I became obsessed by this painting and I bought photograph after photograph of it. I think really that was my first subject.'[22] The various reproductions of the painting found in Bacon's studio are crumpled, torn, pinned and overpainted and these distorted images informed more than 40 of his works. Despite his admiration for Velázquez's portrait, Bacon did not see the original while in Rome for fear that it would overwhelm his homage to it. Bacon came to regret his pope series, feeling that *Portrait of Pope Innocent X* was one of the greatest paintings of all time and that it was useless to try to replicate it: 'I've always thought this was one of the greatest paintings in the world and I've had a crush on it.'[23]

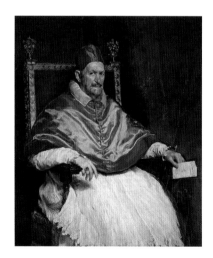

fig 91 Diego Velázquez
Portrait of Pope Innocent X c1650
oil on canvas, 140 x 120 cm
Galleria Doria Pamphilj, Rome

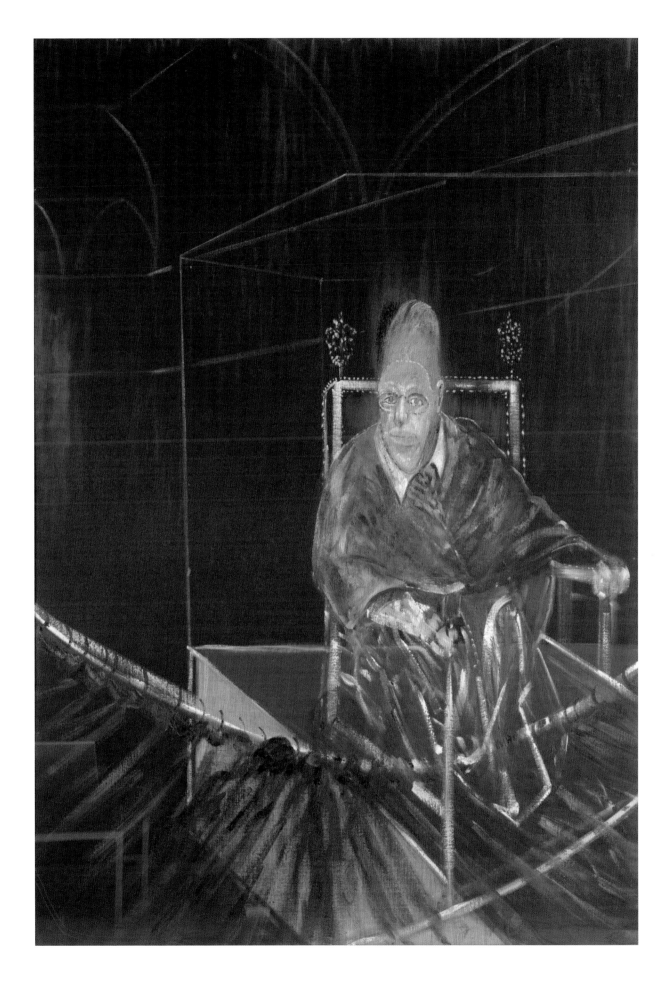

Portrait of Lucian Freud
1951

oil on canvas
198 x 137 cm
Whitworth Art Gallery,
University of Manchester

This is the first of several portraits by Bacon of the renowned British figurative painter Lucian Freud, who he met in the mid 1940s. It was largely painted in Freud's absence and is based on a photograph of the Czech-born German writer Franz Kafka (below), reflecting Bacon's tendency to work from memory and from photographs that were not always of the subject. While Bacon and Freud did not remain lifelong friends they were both known for their confronting and visceral depictions of the human body. They were each deeply interested in flesh. However, while Bacon's flesh is often fluid, dissolving and falling away from the bone, Freud's is meaty, heavy and solid. Both artists worked differently: Freud took a long time to build up the image in slabs of paint, whereas Bacon worked quickly, making loose and gestural marks in thin washes punctuated by accretions of dense scumbled oil paint.

fig 92 Franz Kafka and Ottla Kafka c1914.

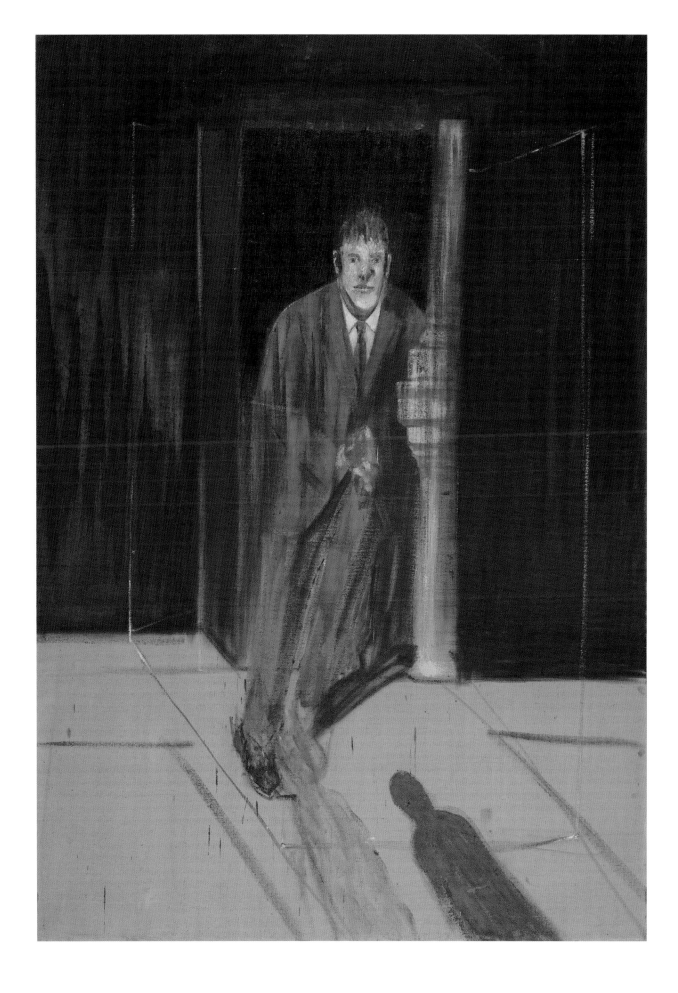

Untitled (crouching figures)
c1952

oil on canvas
147.3 x 132.2 cm
The Estate of Francis Bacon
Courtesy Faggionato Fine Art, London

At the time this painting was made Bacon was sexually involved with Peter Lacy, an ex-Royal Air Force pilot whose violent sexual antics gave a sadomasochistic charge to their relationship. *Untitled (crouching figures)* is marked by gestural brushwork that reflects the potential for violence embodied by the coupling figures. Bacon made many paintings of wrestling men that tacitly depict scenes of homosexual sex. These works often derived from a sequence of images by the pioneering nineteenth-century English photographer Eadweard Muybridge (below). Bacon saw a slippage between violence and eroticism in Muybridge's wrestling figures, saying that they 'appear, unless you look at them under a microscope, to be in some form of sexual embrace'.[24]

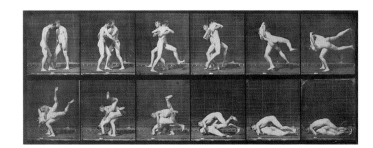

fig 93 'Two men wrestling', plate 347 in Eadweard Muybridge's *Animal locomotion* (1887).

black and white photograph
Private collection

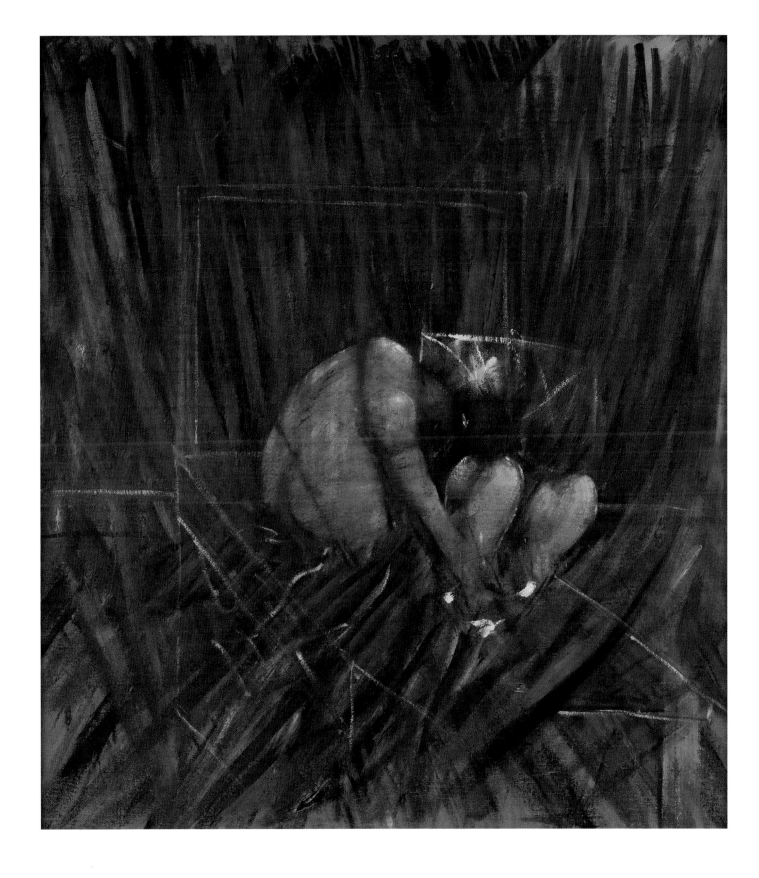

Study for crouching nude
1952

oil and sand on canvas
198 x 137.2 cm
Detroit Institute of Arts, Detroit.
Gift of Dr Wilhelm R Valentiner

Bacon kept several reproductions of *Study for crouching nude* in his studio, along with notes about how to develop its 'dual themes of athleticism and defecation'.[25] It was a formative painting that he intended to reprise in subsequent images. It was also a testing ground for later motifs, such as the circular railing on which the figure perches and the shadow, which in this image hovers menacingly to the right. Bacon said of the work: 'I tried to make the shadow as much *there* as the image. In a funny way, and though I hate the word, our shadows are our ghosts.'[26]

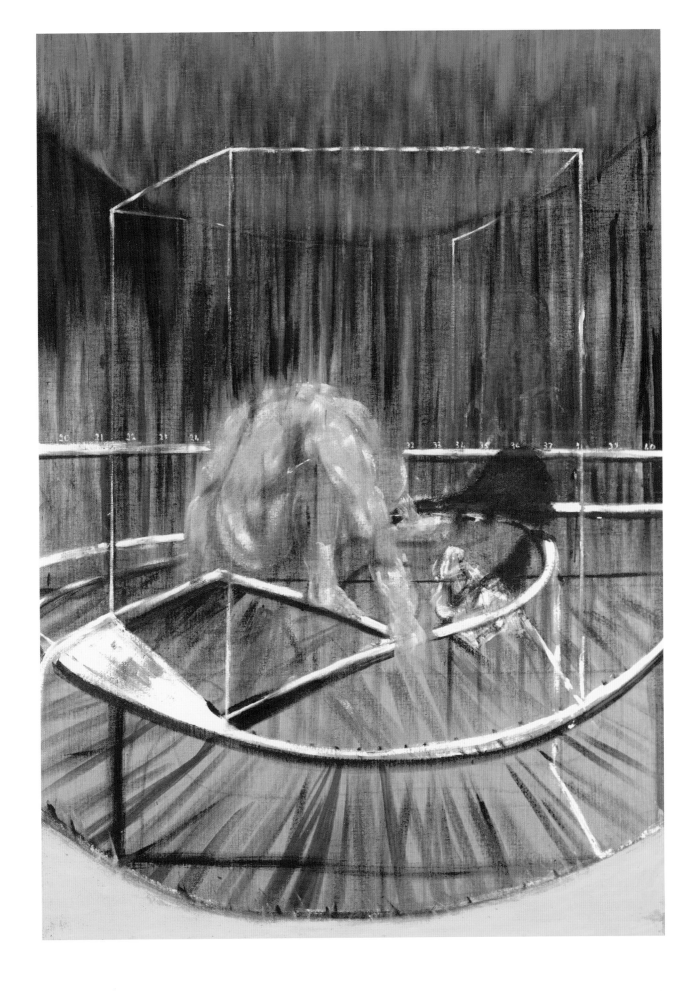

Study of a nude
1952–53

oil on canvas
61 x 51 cm
Robert and Lisa Sainsbury Collection,
University of East Anglia
UEA 29

This painting derives from an Eadweard Muybridge photograph of a man posing as if he is about to dive into a pool (below). Muybridge pioneered a study of human and animal motion by taking a succession of high-speed photographs of figures performing various actions – from running to throwing a bucket of water. Muybridge's images formed the basis of many of Bacon's works, particularly his paintings of male nudes. Yet, often sensual, Bacon's nudes are also obliquely informed by Michelangelo. As he explained: 'Michelangelo and Muybridge are mixed up in my mind together … Michelangelo made the most voluptuous male nudes in the plastic arts.'[27] Lit up in a dark and cavernous space, the man in *Study of a nude* faces away from the viewer and into the painterly void beyond. Chris Stephens has suggested that despite its intimate scale, this work invokes the sublime – an experience of beauty and awe triggered by a sense of great distance. Notions of the sublime were revived in the mid twentieth century in the form of French philosopher Jean-Francois Lyotard's concept of the postmodern sublime.

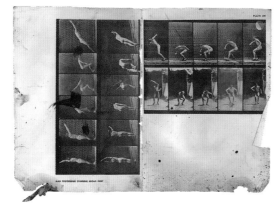

fig 94 'Man performing jumps' in Eadweard Muybridge, *The human figure in motion* (1955).

Dublin City Gallery The Hugh Lane F104:87

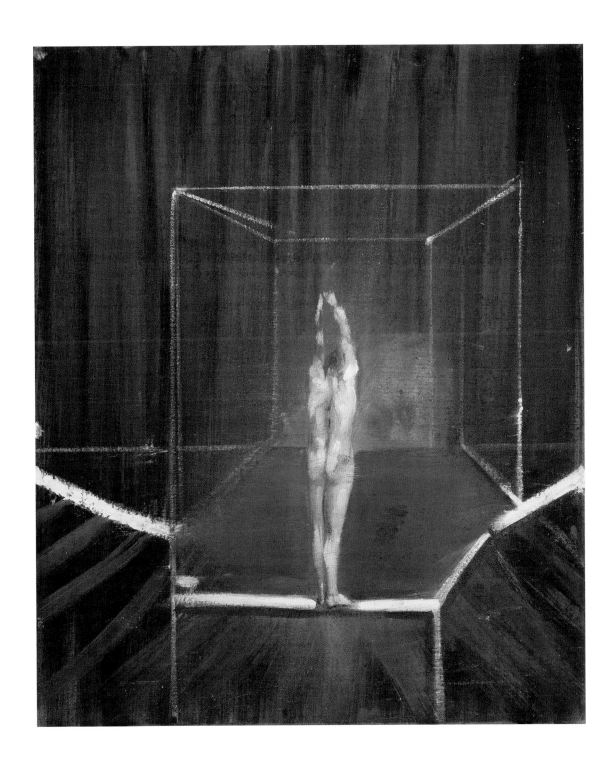

Study of a baboon
1953

oil on canvas
198.3 x 137.3 cm
Museum of Modern Art, New York.
James Thrall Soby Bequest, 1979
1198.1979

In 1950 and 1952 Bacon visited Africa where his family had settled after his father's death. On his return to England he said of the experience: 'I felt and memorised the excitement of seeing animals move through the long grass.'[28] *Study of a baboon* is one of several depictions by Bacon of African wildlife, which remained a lifelong fascination for the artist. Bacon was also known to refer to photographs of animals while painting portraits of his friends. During a sitting with his interviewer David Sylvester, for example, he is said to have looked at an image of a rhinoceros, demonstrating how permeable the boundaries were for him between human and animal.

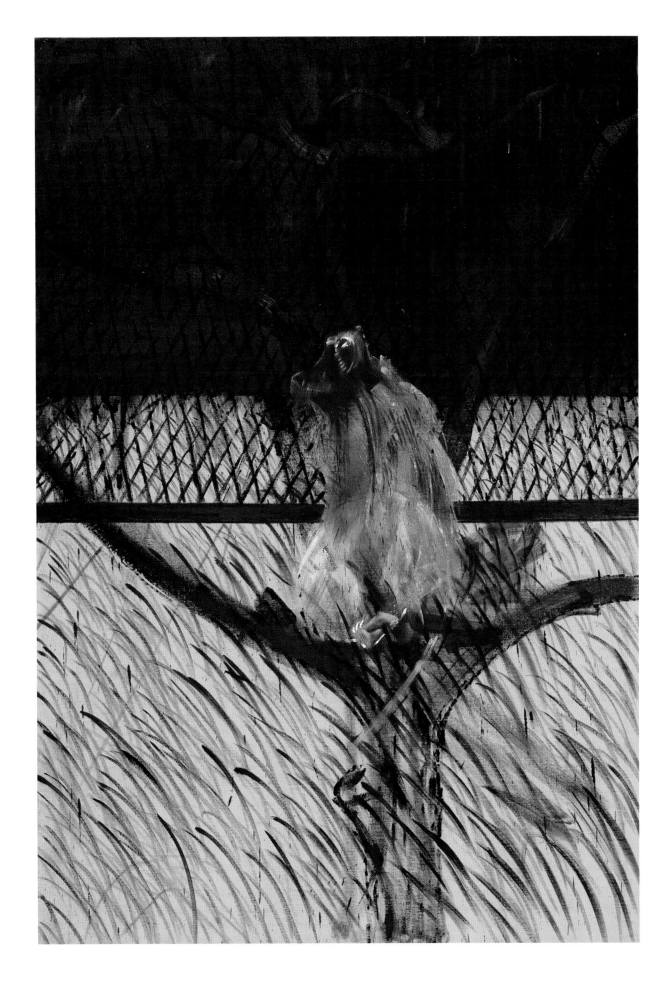

The end of the line
1953

oil on canvas
152.5 x 117 cm
Collection of Samuel and
Ronnie Heyman, New York

In the 1950s Bacon stayed at the Imperial Hotel in Henley-on-Thames outside London. The hotel was opposite the old railway station. Bacon befriended the stationmaster and the station itself made its way into this image. Martin Harrison has suggested that pages from *Railway Magazine* found in Bacon's studio are possible sources for this work.[29] He also speculated that the ambiguity of affection and potential brutality in the boxer's stance might have reflected Bacon's relationship with his lover Peter Lacy, which was often marked by violence.

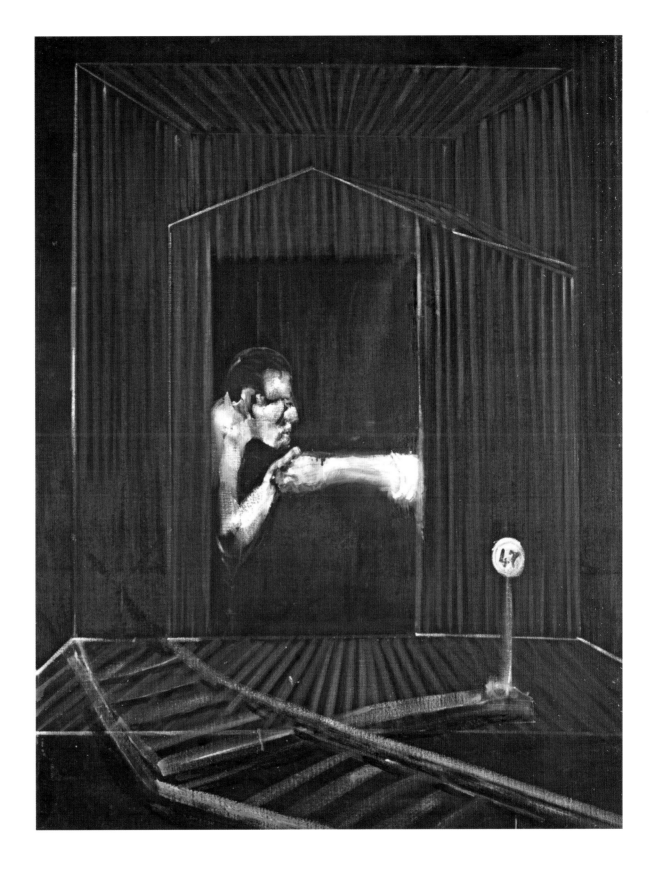

Untitled
(half length figure in sea)
c1953–54

oil on canvas
198 x 136.5 cm
Courtesy Murderme

Paintings of the ocean and bathers have a strong presence in the art-historical canon but they do not form a significant part of Bacon's oeuvre. *Untitled (half length figure in sea)*, however, does show a very strong theme in his work: namely the isolation of the human figure in the landscape or hovering above a flat, abstract, acrylic field. Curator Anthony Bond has noted that the curve of the figure's back echoes that of the young male bather in the French artist Georges Seurat's post-impressionist painting *Une baignade, Asnières* (*Bathers at Asnières*) 1883–84, a reproduction of which was in Bacon's studio (below). Bacon admired the evocative qualities of this work, describing it as 'one of the greatest examples of the painting of grass that has ever been done by anybody'.[30] In *Untitled (half length figure in sea)* the figure is barely discernible, demarcated only by a vertical brushstroke set against the turbulent horizontal brushwork of the sea. Both the figure and the sea are dark, mysterious and indistinct.

fig 95 Seurat's *Bathers at Asnières* (*Une baignade, Asnières*) 1883–84 illustrated in John Russell, *Seurat*, Thames & Hudson, London, 1965, from Bacon's studio.

Dublin City Gallery The Hugh Lane

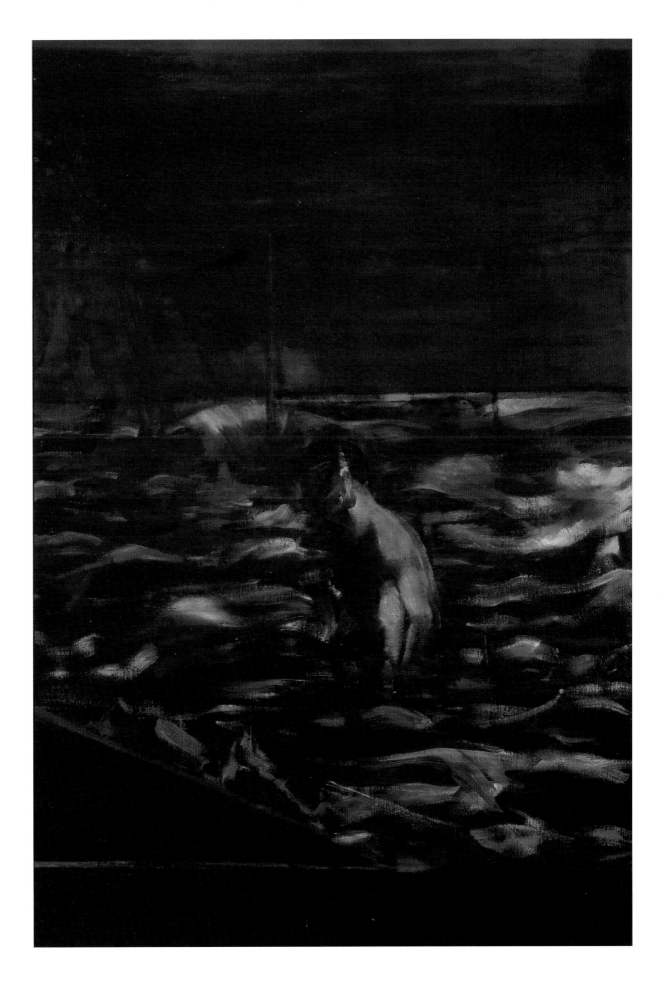

Untitled (sea)
c1954

oil on canvas
155 x 117.5 cm
The Estate of Francis Bacon
Courtesy Faggionato Fine Art, London

Divided into four bands of blue, this composition resonates distantly with abstraction, which was the dominant art form at this time. Michael Peppiatt has noted the influence on Bacon's colourful grounds of the post-painterly abstract colour fields of the American artist Barnett Newman.[31] However, Bacon disdained abstract painting, preferring the tension brought about by walking the line between figuration and distortion. He commented to David Sylvester that: 'Anything in art seems cruel because reality is cruel. Perhaps that's why so many people like abstraction in art, because you can't be cruel in abstraction.'[32] While Bacon's figures are often dynamically unstable, this figure appears to be on the brink of dissolving into a whiff of sea spray or foam.

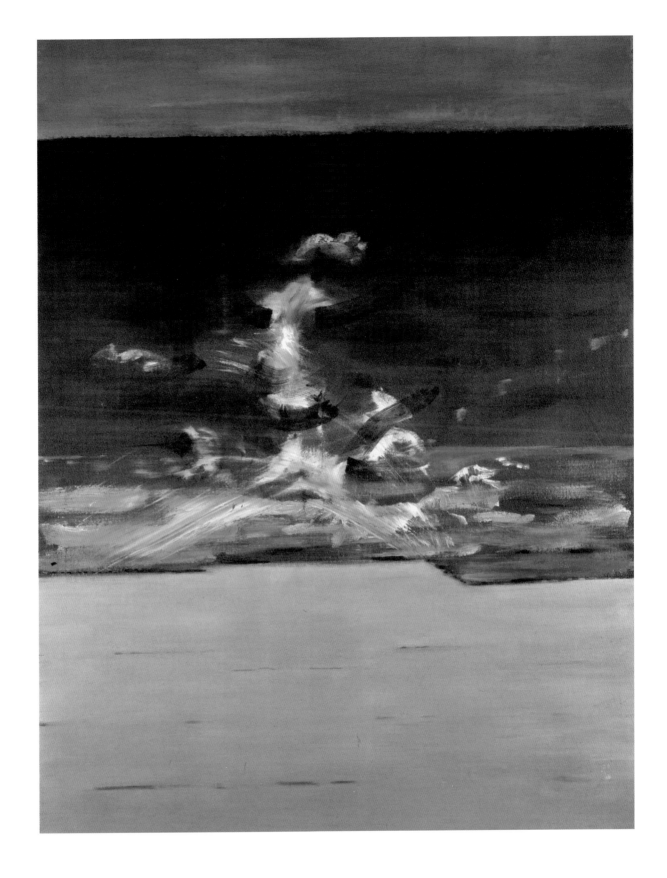

Figure with meat
1954

oil on canvas
129.9 x 121.9 cm
Art Institute of Chicago.
Harriott A Fox Fund
1956.1201

Meat first appeared in Bacon's groundbreaking 1946 work *Painting 1946*. *Figure with meat* iterates that image, with a figure – closely related to Bacon's popes – seated in front of two sides of meat. With its sumptuous reds, oranges, creams and blues, *Figure with meat* is a painterly depiction of meat that embodies Bacon's fascination with it and his belief in the parity of human and animal flesh. As he once remarked to David Sylvester: 'we are meat, we are potential carcasses. If I go into a butcher's shop I always think it's surprising that I wasn't there instead of the animal.'[33]

The motif of suspended carcasses became iconic, such that the artist was subsequently pictured stripped to the chest and flanked by two carcasses by the *Vogue* photographer John Deakin (p 104), a Soho character and Bacon's drinking companion.

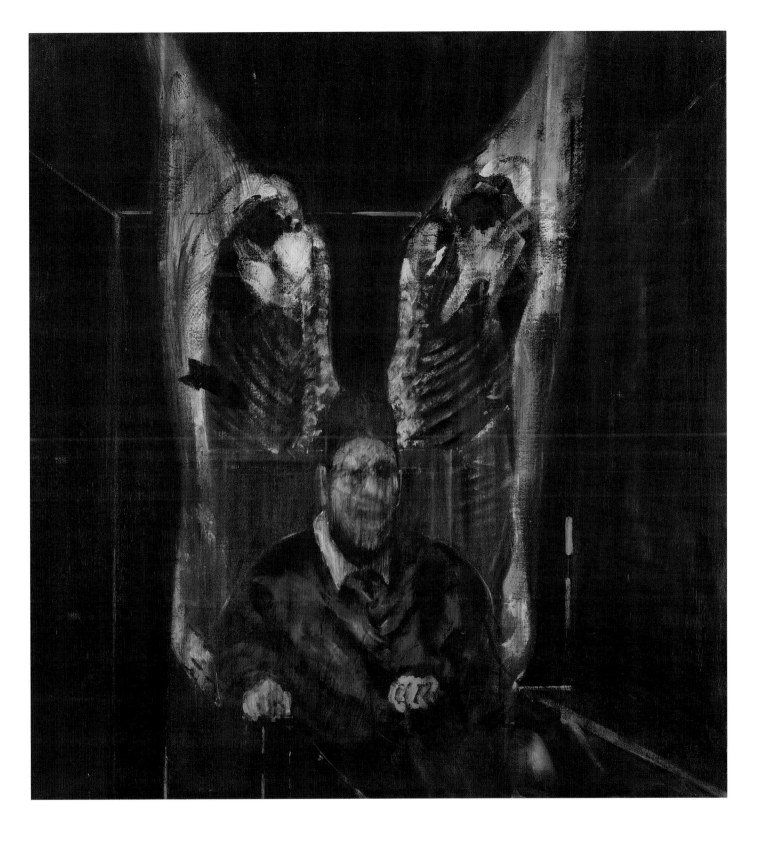

Study for a running dog
1954

oil on canvas
152.7 x 116.7 cm
National Gallery of Art, Washington.
Given in memory of Charles Edward
Rhetts by his wife and children, 1976
1976.7.1

One of Bacon's main visual resources was Eadweard Muybridge's series of photographs of humans and animals in motion. *Study for a running dog* is based on Muybridge's image *Dog walking; mastiff dread* (below). Bacon captures the animal's movement with blurred painterly marks, which he sometimes achieved by dragging fabric through wet paint. Dogs triggered Bacon's asthma and this depiction of the animal recalls the anxiety entailed in the attacks brought on in his childhood by his father's red setters.[34]

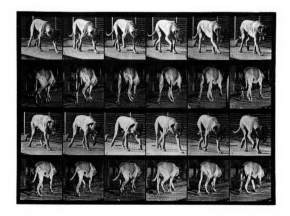

fig 96 Plate 704 in Eadweard Muybridge's *Animal locomotion* (1887).

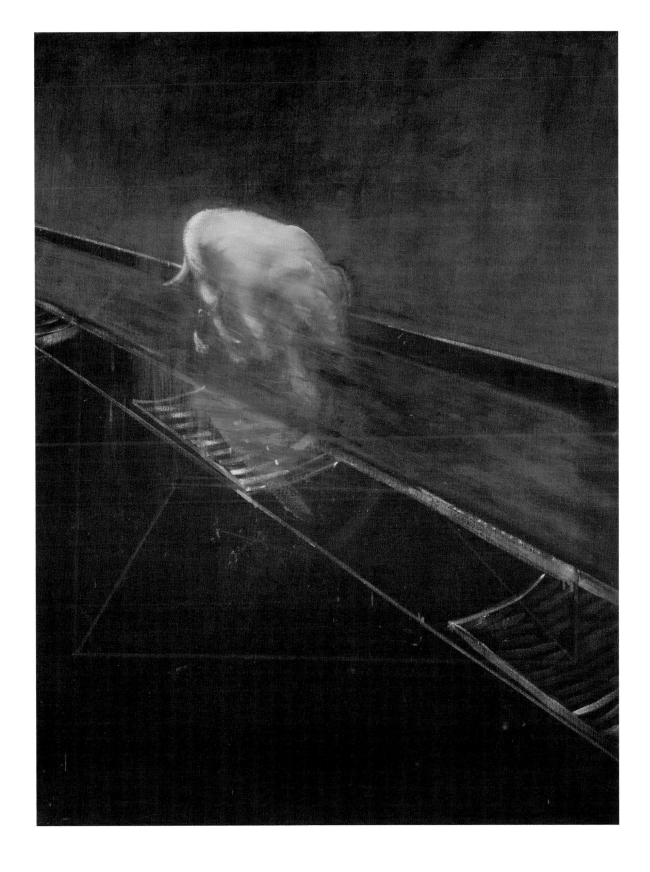

Owls
1956

oil on canvas
60.96 x 50.8 cm
Private collection
Courtesy Dr Rebecca Daniels

This small image is based on a photograph of two long-eared owls by Eric Hosking in his 1945 book *Birds of the night* (below). Bacon kept many photographs of birds in his studio. Birds of prey feature in several paintings and are the basis of the mythological figures, including the Eumenides, that haunt his later works. Behind the birds in this painting is a shape that closely resembles the head of a sphinx. Together, the owls and the sphinx are evidence of Bacon's attachment to motifs of antiquity. Owls appear in many Greek mythologies that Bacon encountered through the Greek tragedian Aeschylus, and the sphinx conjures the story of Oedipus as well as ancient Egyptian art in general.

fig 97 *Newly fledged long-eared owls (daylight)* in Eric J Hosking and Cyril W Newberry, *Birds of the night* (1945).
© Eric Hosking

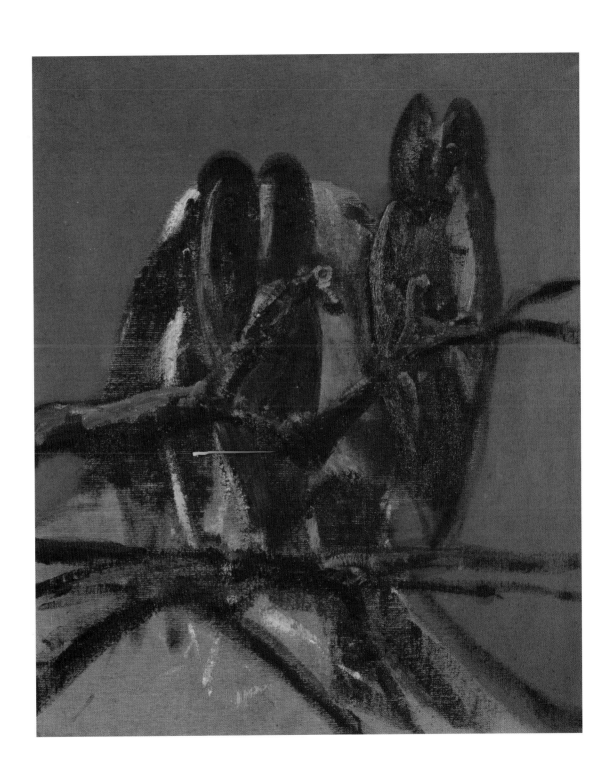

Study for figure no 4
1956

oil on canvas
152.4 x 116.8 cm
Art Gallery of South Australia, Adelaide.
Gift of the Contemporary Art Society,
London, 1959

The male figure in *Study for figure no 4* is seated in an awkward posture that is typical of Bacon's images of suited men in sombre dark blues that he painted in the 1950s. The cubic, cage-like structure that encloses the figure lends a claustrophobic atmosphere – an atmosphere that defines Bacon's work at this time and perhaps reflects his broader experience of the decade.

Bacon's images of anxious, furtive men positioned uncomfortably in enclosed spaces hints at the sense of social and physical claustrophobia suffered by homosexual men in 1950s Britain. It was not until 1967, following the recommendations of the 1957 Wolfenden Committee report, that homosexuality was officially decriminalised.

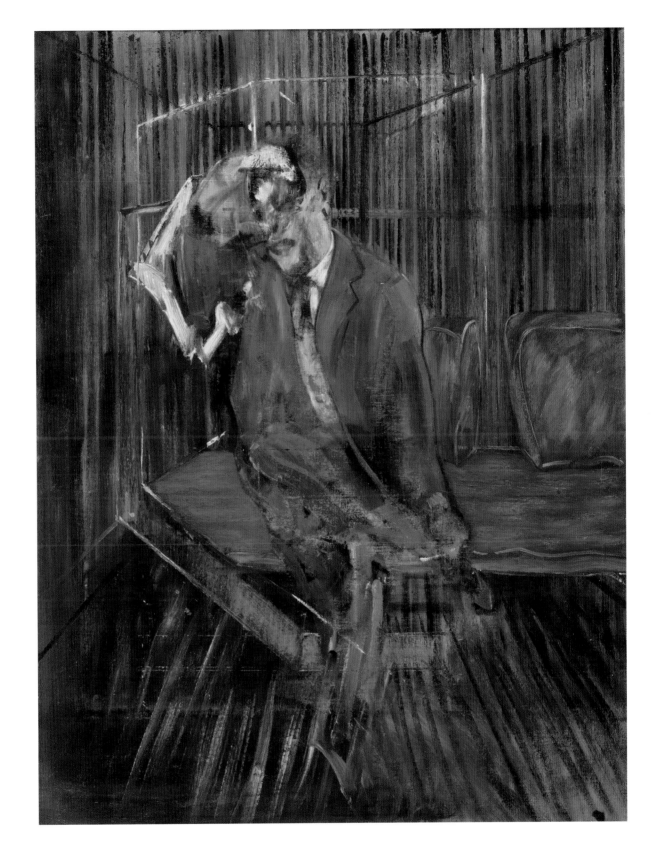

Figure in landscape
1956–57

oil on canvas
152.5 x 118 cm
Birmingham Museums and
Art Gallery, UK

With patches of orange and yellow underlying the layers of ochre and
olive green, *Figure in landscape* reflects the hot light of Tangier, Morocco,
where Bacon travelled in 1956 to be with his lover Peter Lacy. Although
homosexuality was illegal in Britain it was unofficially tolerated in
Tangier and many prominent homosexuals spent time there, including
the American poet Allen Ginsberg who asked Bacon to paint a portrait
of him having sex with his boyfriend (a painting that never eventuated).
It is difficult to read the physical entanglement of the two figures in this
image as anything other than a sexual encounter, reflecting the more
permissive atmosphere of Tangier.

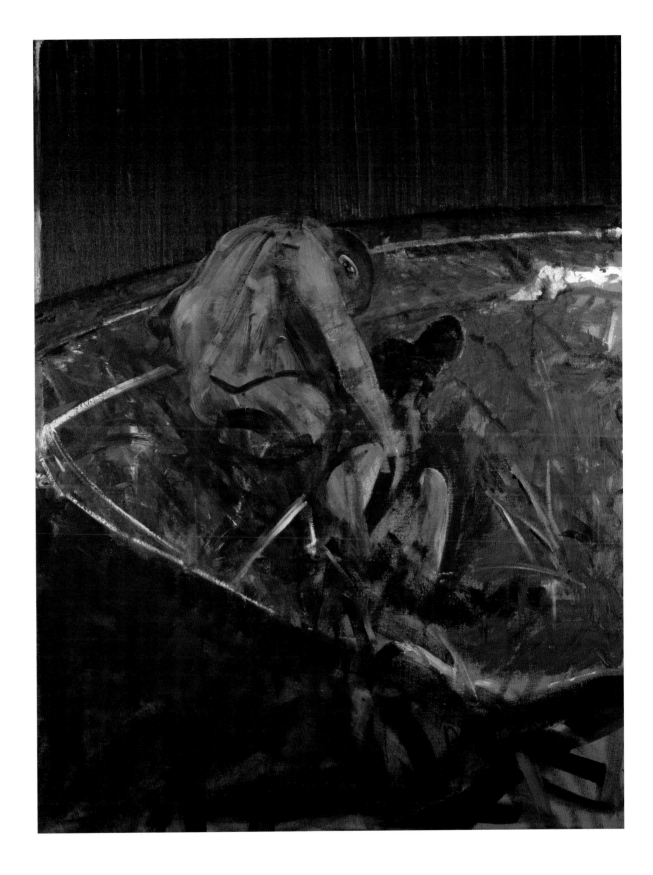

Study for a portrait of van Gogh IV
1957

oil on canvas
152.4 x 116.8 cm
Tate, London. Presented by the
Contemporary Art Society, 1958
T00226

Study for a portrait of van Gogh IV is one of a series of works that Bacon hastily painted for a 1957 exhibition. It is inspired by a reproduction of van Gogh's work *The painter on the road to Tarascon* 1888 (below), which was destroyed in the Second World War. Although Bacon later disowned the series (in much the same way as he did his paintings of popes) as a futile attempt to go beyond a great artist of the past, van Gogh remained a touchstone for him. 'That haunted figure on the road seemed just right at the time – like a phantom.'[35] He kept a volume of van Gogh's letters in his studio from which he invoked the line: 'Real painters do not paint things as they are … they paint them as *they themselves* feel them to be.'[36]

fig 98 Vincent van Gogh
The painter on the road to Tarascon 1888

oil on canvas, 48 x 44 cm
Destroyed in the Second World War

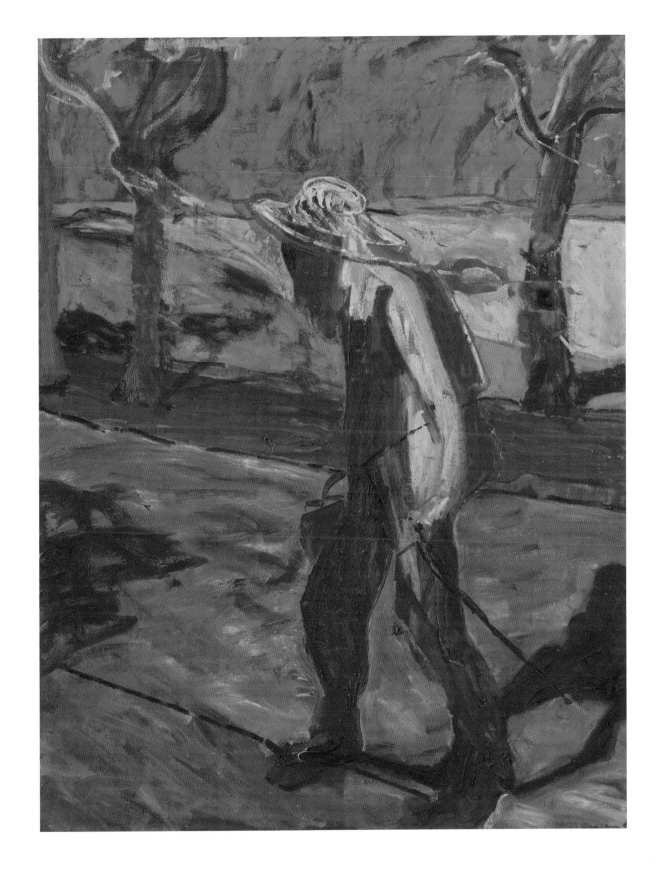

1960s

fig 99 George Dyer standing in
a London street, c1964. Dyer was
Bacon's lover from late 1963 until
his death in Paris in 1971.
photographed by John Deakin

Dublin City Gallery The Hugh Lane
RM98F149:79B

page 144:

Irving Penn
Francis Bacon 1963

© 1963 (renewed 1991) Condé Nast Publications Inc

In 1958 Bacon moved from London's Hanover Gallery to Marlborough Fine Art where he held his first solo exhibition in 1960. He stayed with Marlborough for the rest of his life, with the gallery's director, Valerie Beston, managing his affairs in the way Jessie Lightfoot had done in his youth.

The 1960s were a period of consolidation for Bacon and marked a pinnacle in his career. By now he had adopted a standard canvas format measuring 198 x 147.5 cm, a roughly golden section that perfectly framed three quarter-life-sized figure paintings. He also used a smaller format measuring 35.5 x 30.5 cm for a series of portrait heads that are among the most adventurous of his works from the 1960s. The thick twists of paint in these portraits convey likeness with the most extraordinary precision while seeming to consist of only a few wild strokes and turns of the brush.

Bacon began using flat areas of acrylic paint to frame and isolate his figures, which were mostly painted in oils and positioned near the centre of the canvas. He continued to leave large areas unpainted so that the linen provides additional texture and colour. A narrow band of raw canvas nearly always separates the acrylics and oils, possibly to prevent the oil bleeding into the acrylic but also to lend a spatial turn to the form in much the same way as the margins in Cézanne's compositions. The strong hues and grand scale of these paintings perfectly match the spirit of the 1960s and contrast with the predominantly dark, even monochromatic, tendency of his paintings in the claustrophobic atmosphere of 1950s London.

In 1961 London's Royal College of Art produced a vibrant new generation of painters working with figurative pop-art imagery, including David Hockney, Allen Jones and Derek Boshier. Hockney once claimed that his move to figuration was made possible by the precedent set by Bacon. The year 1961 was also when the German Nazi Adolf Eichmann was finally brought to trial for his war crimes. The images in the press of Eichmann in court enclosed in a glass witness box seem to be an example of life following Bacon's art. In the autumn of this year he moved into the Reece Mews studio that became home to his vast and chaotic accumulation of source materials which he drew on for his creative imagery. The studio, which he stayed in for the rest of his life, was his most productive working space.

In 1962 Bacon was given his first major retrospective at the Tate. It was a significant acknowledgment of the importance his work was now accorded in England. The day of the opening was marred, however, by news of Peter Lacy's death in Tangier. A decade later this scenario was tragically repeated when Lacy's successor, George Dyer, died on the eve of Bacon's retrospective at the Grand Palais in Paris in October 1971.

Bacon met Dyer in 1963, the artist claiming that he caught Dyer trying to burgle his home. A petty criminal, Dyer was nevertheless by all accounts a gentle man who Bacon was able to dominate completely – unlike Lacy, who had physically beaten Bacon in what was often a dangerous sadomasochistic affair. Dyer became the focus of an extraordinary number of paintings over the next nine years and even after his death continued to feature in Bacon's work. His striking profile appears again and again, often without his name acknowledged in the title. In this exhibition, for example, the painting *Three studies of the male back, triptych* 1970 (pp 173–75) is based on the intimate domestic subject of Dyer shaving.

Bacon's more stable life based around the Reece Mews studio and The Colony Room in Soho enabled him to consolidate relationships with friends and other artists, all of whom appear in his paintings in the 1960s, including Isabel Rawsthorne, Muriel Belcher, Henrietta Moraes and Lucian Freud. Bacon also began a series of self-portraits that he continued to paint until the end of his career. He travelled, now accompanied by Dyer, and on one trip on the *Orient Express* was accompanied by John Deakin who took intimate photographs of Bacon and Dyer on the train and in Greece. Bacon had been commissioning Deakin to photograph his friends since 1961 and it was these images that often became the source material for his portraits.

The year 1968 was tumultuous with, among other events, student riots in Paris, Martin Luther King's assassination in the United States and the crushing by the Soviet Army of the Prague Spring in Czechoslovakia. It was at this point that the spirit of the 1960s seemed to come to an end. The combination of youthful rebellion and disillusion with late modernism provided the grounds for a relativist French philosophy that gave rise to a postmodern theory that influenced the visual arts and art criticism into the 1980s.

In 1968 Bacon visited New York for the first time where he held an exhibition at the New York branch of Marlborough Fine Art. He stayed with Dyer at the Algonquin, a bohemian hotel frequented by artists and writers. By this time Dyer was beginning to feel less central to Bacon's life, although Bacon was clearly still obsessed with him. Several of Bacon's friends claimed to have found Dyer to be a delightful man, but he did not understand art and had no intellectual interests so was marginalised in the artist's fast-talking social context. It was at the Algonquin that Dyer attempted suicide, a harbinger of what would occur in Paris in 1971. AB

fig 100 Bacon and George Dyer
on the *Orient Express* in 1965.
photographed by John Deakin
Dublin City Gallery The Hugh Lane
RM98F149:11A

Study for self portrait
1963

oil on canvas
165.2 x 142.6 cm
Amgueddfa Cymru – National Museum
Wales. Purchased 1978

In *Study for self portrait* the artist's face is distorted by turbulent brushwork, a technique that is typical of Bacon's work after 1960. As the artist noted in a letter to his friend, the French writer Michel Leiris: 'For me realism is the attempt to trap appearance with all the sensations that a particular appearance starts up in me.'[37] In this painting the figure is set in an ordinary space surrounded by the trappings of the everyday, yet there is something deeply isolating about the composition. The couch wraps around the convulsing figure, separating it from its surroundings. The eye sockets are darkened and seem hollow, disappearing into shadow.

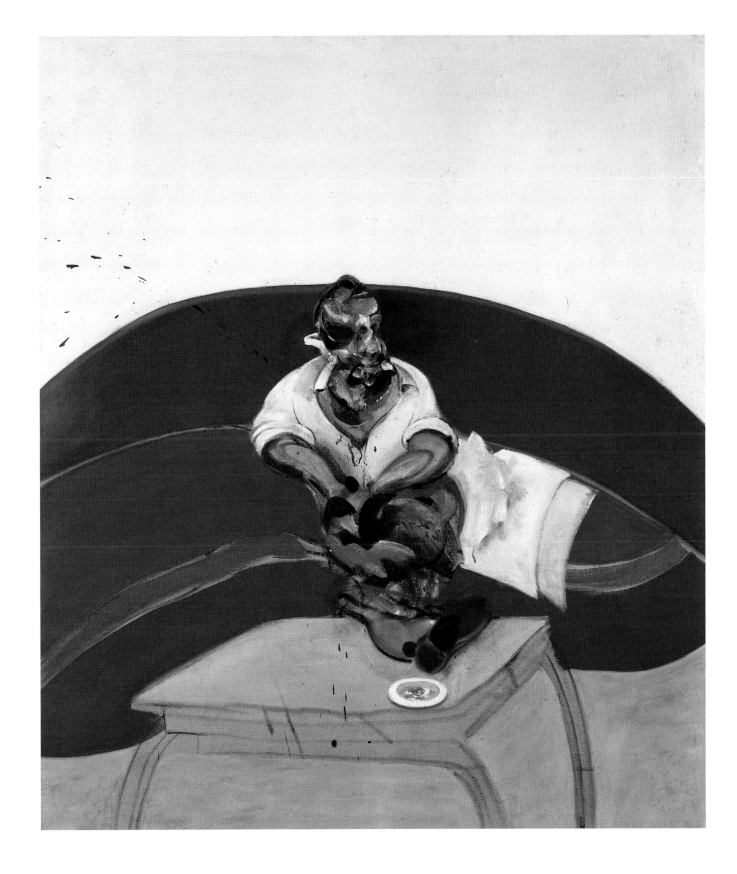

From Muybridge
'The human figure in motion: woman emptying a bowl of water / paralytic child walking on all fours'
1965

oil on canvas
198 x 147.5 cm
Stedelijk Museum Amsterdam.
Purchased 1980

This painting, which brings together a female nude with a bucket of water and a paralytic child on all fours, pays homage to the groundbreaking photographs of Eadweard Muybridge (below). *From Muybridge* captures the motion of the water flung from the bucket – a motif that reappears in the later work *Jet of water* 1988. There are many possible sources for the elliptical structures in Bacon's paintings. Martin Harrison has suggested that they combine different sources, ranging from photographs of operating theatres in the medical books Bacon kept in his studio, as well as the racetracks he encountered as a child through his father's horse training.[38] The structure in this painting also resembles a coffee table that Bacon designed in the 1930s. When Bacon considered turning his hand to sculpture, this was one of the works that he thought could form the basis for a three-dimensional object. He proposed constructing the railing in the image and setting both of the figures on tracks so that they could be moved around it.

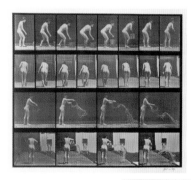

figs 101a & b 'Woman throwing a bucket of water', plate 401 and 'Handicapped boy crawling', plate 539 from Eadweard Muybridge's *Animal locomotion* (1887).

Private collection

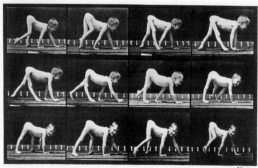

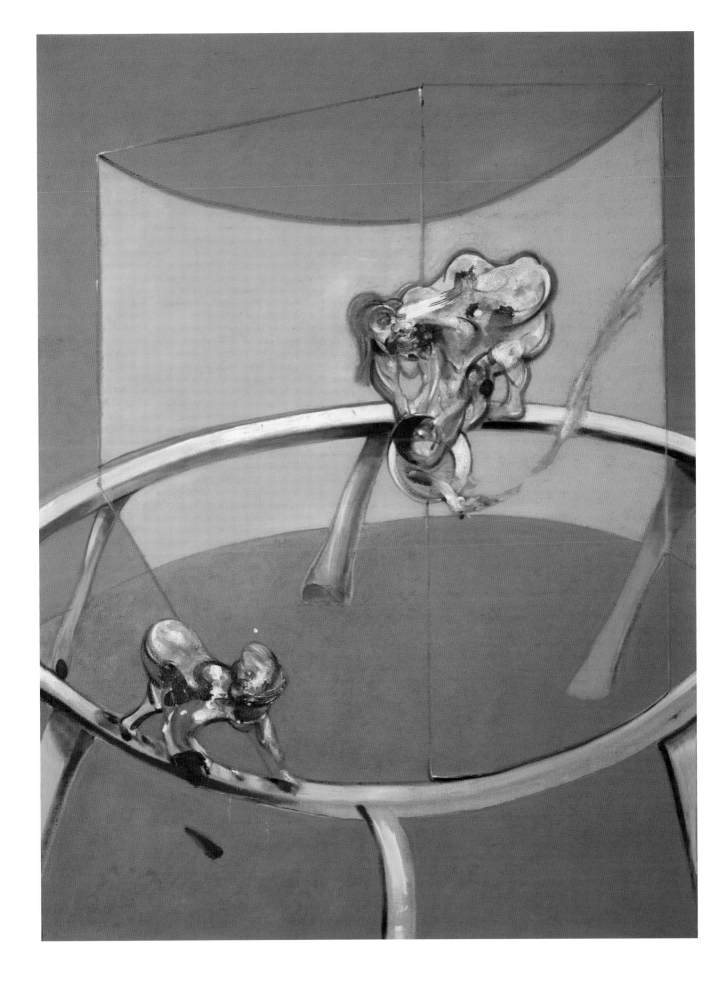

Portrait of Henrietta Moraes
on a blue couch
1965

oil on canvas
198 x 147.5 cm
City of Manchester Art Gallery, UK

Henrietta Moraes was described in her obituary as 'foul-mouthed, amoral, a thief, a violent drunkard and a drug addict. Yet she was witty, wonderfully warm and lovable.'[39] Moraes, who spent a short time in prison for cat burglary, allegedly had an affair with Bacon's friend and fellow figurative painter Lucian Freud, who also painted her portrait. It was this colourful flair and character that captivated Bacon. He painted several portraits of Moraes, the majority based on photographs he commissioned from John Deakin (below), a *Vogue* photographer and the artist's Soho drinking companion. Bacon directed the poses in the photographs, which then became the basis for many subsequent compositions, including *Lying figure with hypodermic syringe* 1963. In *Portrait of Henrietta Moraes on a blue couch* the distorted figure sits in front of a naturalistically painted door that opens onto a void. Darkened doorways recur in Bacon's work, evoking a sense of the unfathomable beyond.

fig 102 Henrietta Moraes, c1963 photographed by John Deakin
Dublin City Gallery The Hugh Lane
F1A:107

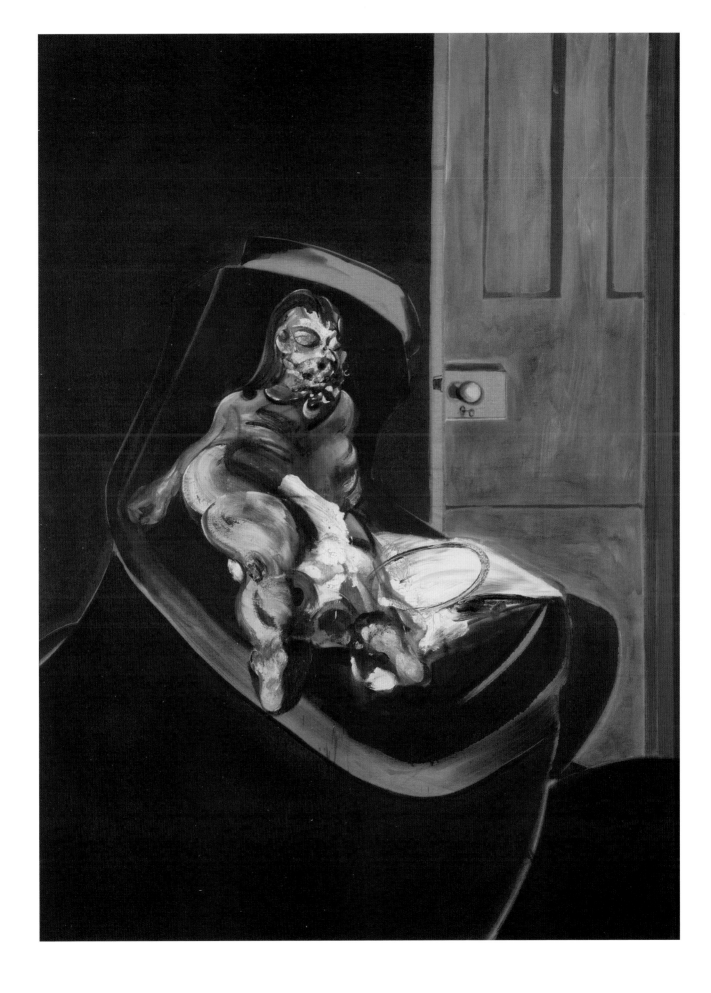

Portrait of Isabel Rawsthorne
1966

oil on canvas
81.3 x 68.6 cm
Tate, London. Purchased 1966
T00879

The painter and set designer Isabel Rawsthorne was a longstanding friend of Bacon's and the subject of several portraits. Bacon was impressed by her intellectual and artistic connections – she had been painted by Picasso and André Derain in Paris and subsequently became close to the Swiss artist Alberto Giacometti, arranging a meeting between him and Bacon in 1975. This is a contorted yet canny portrait. As Bacon said: 'What I want to do is to distort the thing far beyond the appearance, but in the distortion to bring it back to a recording of the appearance.'[40] Here the warping of Rawsthorne's face does not diminish its likeness; rather, it captures something of her essence.

fig 103 Isabel Rawsthorne in a Soho street, c1965 photographed by John Deakin
Dublin City Gallery The Hugh Lane F17:63

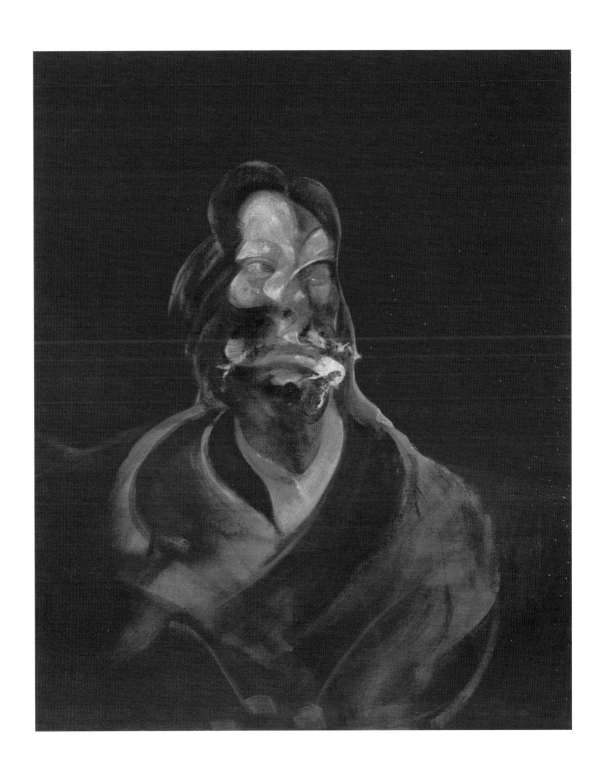

Untitled (dog)
c1967

oil on canvas
30.5 x 35.6 cm
Private collection
Courtesy Richard Nagy Ltd, London

Bacon's paintings of dogs were largely based on photographs by Eadweard Muybridge. *Untitled (dog)* forms part of a group of images, including *Study of a dog* 1952 and *Man and dog* 1953, that take Muybridge's photographs of animals in motion as their starting point. This work may also be based on images of a boxer dog with a muskrat in its mouth taken by Bacon's friend, the wildlife photographer Peter Beard (below).

Bacon's animal is composed of only a few broad sweeps of paint and has a lithe, animated quality. It looks hesitantly over its shoulder, recalling one of Bacon's favourite lines from TS Eliot's 1941 poem *The dry salvages*: 'the backward half-look / over the shoulder, towards the primitive terror.'[41]

fig 104 Detail of a photographic contact sheet of a boxer dog with a muskrat in its mouth, c1964. photographed by Peter Beard

Dublin City Gallery The Hugh Lane
F16:278

© Peter Beard

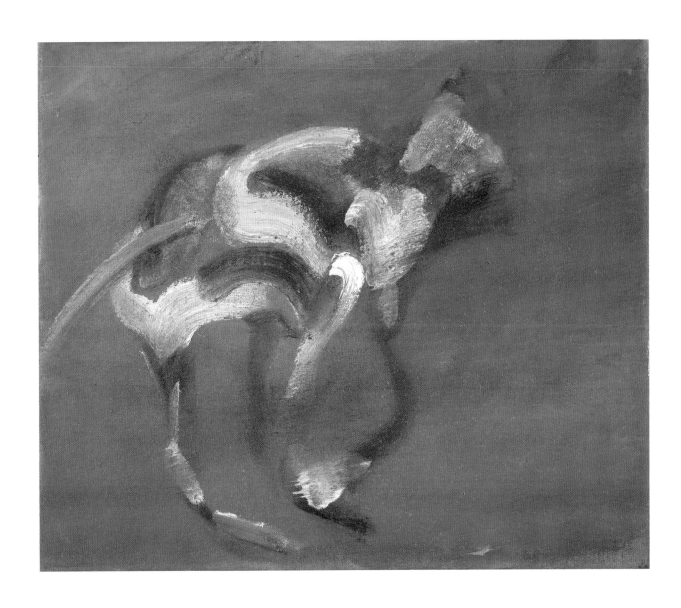

Lying figure
1969

oil on canvas
198 x 147.5 cm
Fondation Beyeler, Riehen/Basel

Lying figure was adapted from photographs of Bacon's friend and frequent model Henrietta Moraes (below). The syringe shown in her arm features prominently in the earlier work *Lying figure with hypodermic syringe* 1963. Bacon said: 'I've used the figures lying on beds with a hypodermic syringe as a form of nailing the image more strongly into reality or appearance … I put the syringe [in] because I want a nailing of the flesh onto the bed.'[42] Bacon's use of the word 'nailing' implies violence and echoes the theme of crucifixion, as though the bed on which the figure is sprawled were a cross. The very idea of 'nailing the image more strongly into reality' suggests that Bacon felt that the image was fleeting and impermanent. The act of painting is here a way of making the figure concrete.

fig 105 Henrietta Moraes, c1963 photographed by John Deakin
The Estate of Francis Bacon

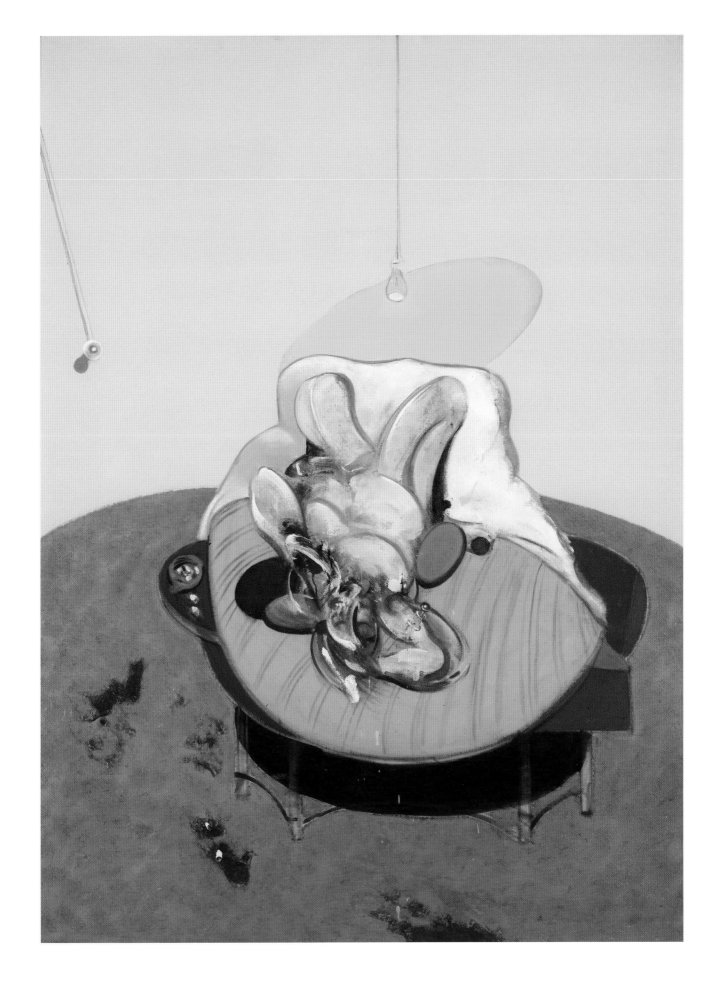

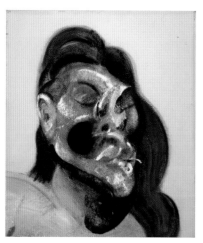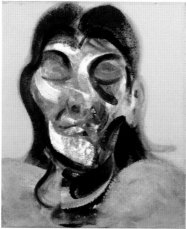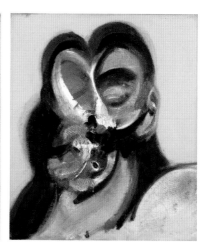

Three studies for portrait of Henrietta Moraes
1969

oil on canvas
triptych, each 35.5 x 30.5 cm
Private collection

In this triple portrait Henrietta Moraes's face resembles a baboon, particularly in the right-hand panel which has a raw, animalistic quality. In her analysis of Bacon's work in general, Dawn Ades invokes the French philosopher Georges Bataille, who held that thought does not ennoble us and neither does it differentiate humans from other animals. As Ades writes, the 'violent pulling together of man/beast in such a way that the traditional distinction between them is brought into question was part of Bataille's continual attack on the "idealist deception" that man practises on himself.'[43] She sees the same attack in Bacon's paintings.

Three studies for portrait of Henrietta Moraes demonstrates this tendency, collapsing the clear-cut distinction between human and animal. Moraes's face disintegrates across the three panels in a series of fluid brushstrokes and accretions of paint. Bacon has added texture to the composition by means of pressing fabric (perhaps an old jumper) into the wet paint in a series of gestures and interruptions that give the peculiar impression of liquid flesh.

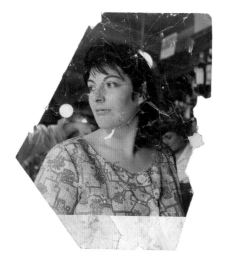

fig 106 Henrietta Moraes, c1960 photographed by John Deakin
Dublin City Gallery The Hugh Lane F104:93

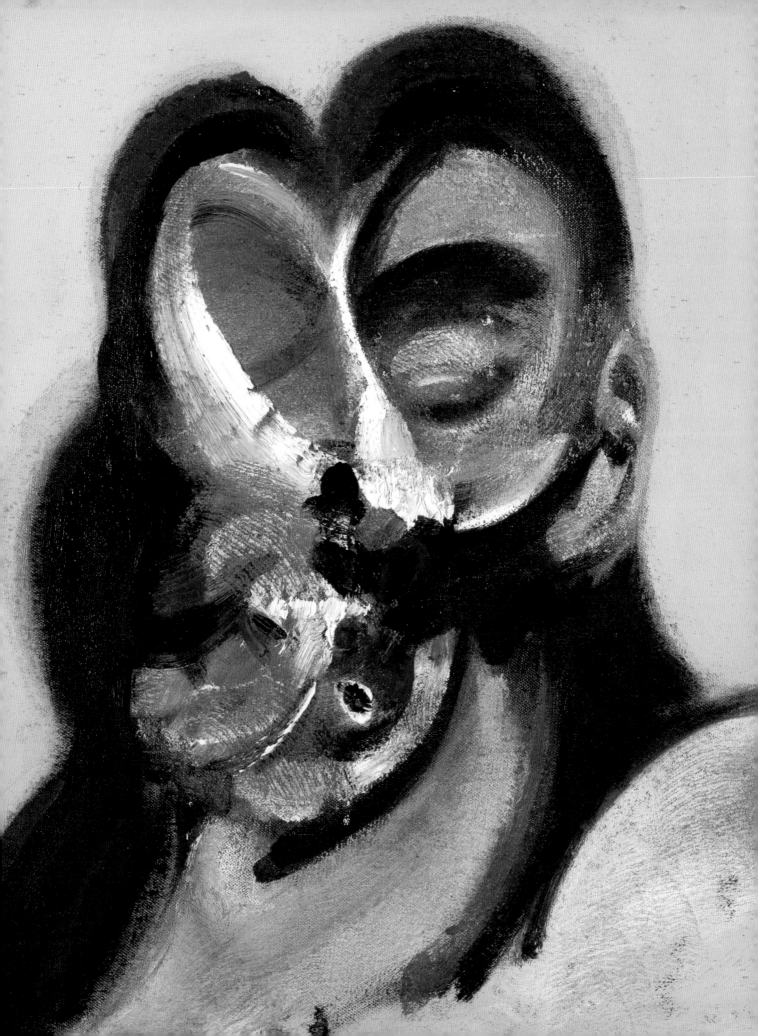

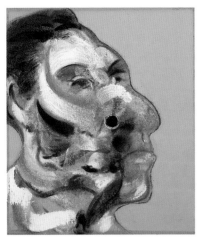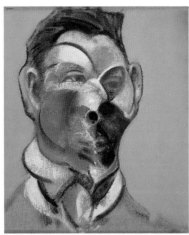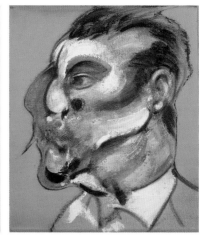

Three studies of George Dyer
1969

oil on canvas
triptych, each 36 x 30.5 cm
Louisiana Museum of Modern Art,
Denmark. Donation: Ny Carlsbergfondet

When asked about his triptych portraits Bacon said: 'I get them rather like police records, looking side face, front face and then side face from the other side.'[44] This approach is particularly apt for this portrait of George Dyer, a petty criminal from London's East End and Bacon's handsome, naive and self-destructive lover. Bacon met Dyer in the autumn of 1963; he claimed he first encountered Dyer trying to break into his house. Portraits of Dyer dominated Bacon's work in the 1960s. This one was painted at the decade's close, two years before Dyer's death in a Paris hotel room in 1971. Dyer attempted suicide in 1968, and something of his annihilative will is evident in this portrait. The little black holes in his face could be read as points of oblivion that reflect his own darkness.

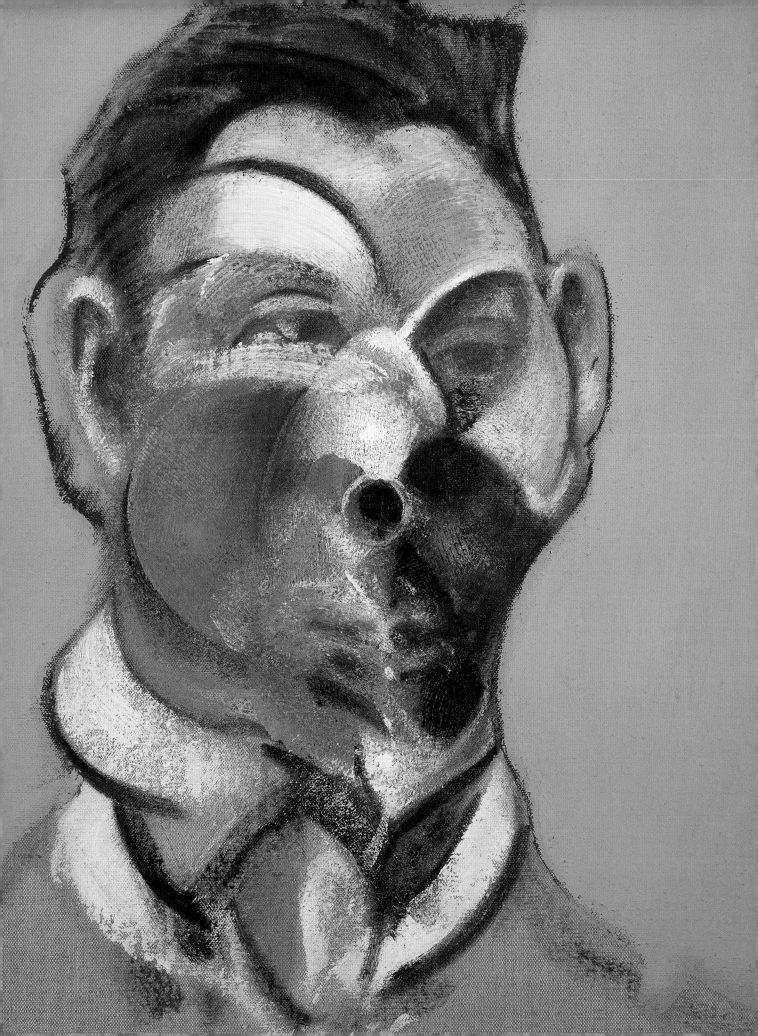

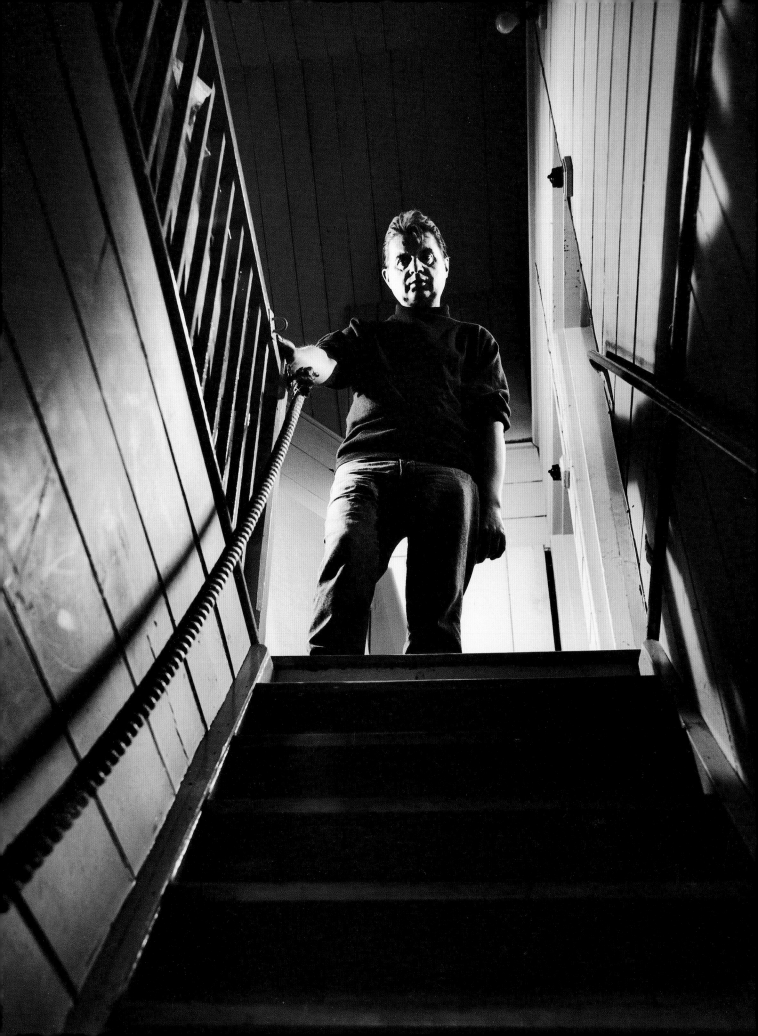

1970s

fig 107 John Edwards c1980s
unknown photographer

page 164:

Jorge Lewinski
Francis Bacon 1970

If Bacon's work of the 1960s is characterised by portraits of his friends and the overwhelming presence of George Dyer, then the 1970s was when he produced some of his most poignant triptychs.

At first he tenderly portrayed his domestic life with Dyer, as in *Three studies of the male back, triptych* 1970 (pp 173–75), which shows his lover reflected in a mirror while shaving. By this time, however, Dyer had begun to feel marginalised by Bacon's intellectual associates and became increasingly fractious and attention seeking. Although he accompanied Bacon when he had to travel for exhibitions, Dyer spent most of his time expensively entertaining people he picked up in bars, which did not help his emotional stability. In September 1970 Dyer planted cannabis in Bacon's apartment and reported him to the police – a cry for attention that, unsurprisingly, rebounded on him.

The year 1971 was momentous. The art critic John Russell's book on Bacon was published, and went on to become a seminal document on his work.[45] Bacon was also at last scheduled to have a major retrospective at the Grand Palais in Paris. In some ways he was an artist of the old school and still looked to Paris as the centre of the artistic world, which made his exhibition there a particularly pleasing development.

Dyer travelled to Paris with Bacon but reacted badly to all the attention focused on the artist. While Bacon was overseeing the installation of the exhibition, Dyer picked up a young Algerian man and took him back to the hotel. To avoid a confrontation, Bacon arranged to stay in another room with a friend. On the eve of the opening, Bacon asked Valerie Beston to check if the Algerian man had gone so that he could return to his room. Instead, Beston found Dyer dead in the bathroom from an overdose of barbiturates that had been prescribed for Bacon.

Despite the tragic circumstances, Bacon displayed extraordinary self-control at the exhibition opening, falling back on his native good manners and charm to get through the press preview and private viewing and to give every appearance of having a delightful night.[46] We know that Dyer's death shattered him to the extent that he broke his own precedent of never painting the dead. He had previously said to David Sylvester that there was no point in painting the dead; that when someone you love is gone, there is nothing to be done about it. Over the next few years, however, he painted a number of smaller memorial paintings and several triptychs that are undoubtedly among his greatest works. Perhaps the most extraordinary of these, *Triptych, May–June 1973* 1973 (private collection, Switzerland), is a graphic representation of Dyer's death and breaks another of Bacon's rules of never illustrating or narrating a story.

We are fortunate to have the Tate Gallery's *Triptych – August 1972* 1972 (pp 181–83) in this exhibition, the second of Bacon's three great memorial triptychs to Dyer.

While finalising everything at the Grand Palais and meeting his commitments to the media and lenders, Bacon made arrangements for Dyer's funeral to be held in the East End of London, where Dyer's family lived. Bacon attended the funeral but kept his distance from the family, not wanting to intrude. Not all of them reacted well to Bacon, who they blamed for Dyer's alienation and alcoholism. Bacon did not go to the wake but went directly from the funeral to a hospital where his old friend John Deakin was dying. A few months earlier Bacon's mother had died in Rhodesia (Zimbabwe). Bacon later described this period as a time when everyone he loved died. He even credited these events as having triggered his shift to self-portraiture: he had predominantly painted people he was close to but now they were all dead.

In the mid 1970s Bacon met John Edwards who became his lover and, like Dyer, featured in many portraits and figure studies. Disconcertingly, Edwards appears in one work with his head grafted onto Dyer's body as photographed in his underpants by Deakin in the Reece Mews studio some years earlier. Bacon's relationship with Edwards was paternal, with none of the angst of his earlier love affairs with Eric Hall, Peter Lacy or Dyer. Although Bacon and Edwards each had sexual partners outside their relationship, their mutual affection lasted until the artist's death in 1992.

In 1975 David Sylvester's interviews with Bacon – a remarkable and telling portrait of the artist – were published. In the same year Bacon travelled to New York for an exhibition of his recent paintings at the Metropolitan Museum of Art and met Andy Warhol and Robert Rauschenberg.

From the mid 1970s Bacon began spending more time in Paris. In 1977 Michel Leiris introduced him to Galerie Claude Bernard, where he exhibited that year. In the 1970s he became friends with Reinhard Hassert and Eddy Batache whose Paris apartment he often visited. Bacon painted a double-portrait of Hassert and Batache in 1979, which is included in this exhibition (p 199). Another of Bacon's close friends, Muriel Belcher, died in 1979 as did Sonia Orwell in 1980. Since 1950 Belcher's club The Colony Room had been a home away from home for Bacon, and Belcher appeared in a number of his paintings. The close of the 1970s was in some ways the end of a journey, although Bacon continued painting throughout the next decade. AB

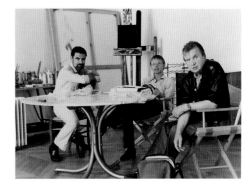

fig 108 Eddy Batache (left) and Reinhard Hassert with Francis Bacon in Bacon's Paris studio at rue de Birague, 1986.
Art Gallery of New South Wales. Acquired 2012

Studies of the human body
1970

oil on canvas
triptych, each 198 x 147.5 cm
Private collection
Courtesy Ordovas

Here Bacon's figures clamber along a railing, which is related to the curved structures that populate such works as *From Muybridge 'The human figure in motion: woman emptying a bowl of water / paralytic child walking on \all fours'* 1965 where a paralytic child and a woman throwing water traverse a thin circular railing (p 151). The lean, minimal composition in *Studies of the human body* represents Bacon's later strategy of placing writhing or convulsing figures on a clean ground of flat colour. The contrasting relationship between thickly painted dynamic bodies and flat planes of colour dominates many of Bacon's works. The blankness of this lilac space accentuates the dynamic dissolving flesh of these figures, one of which squats, headless, under an umbrella. As David Sylvester explained, we 'see the three figures as being up there in space, largely because the colour and tone of the ground give such a compelling intimation of the infinite'.[47]

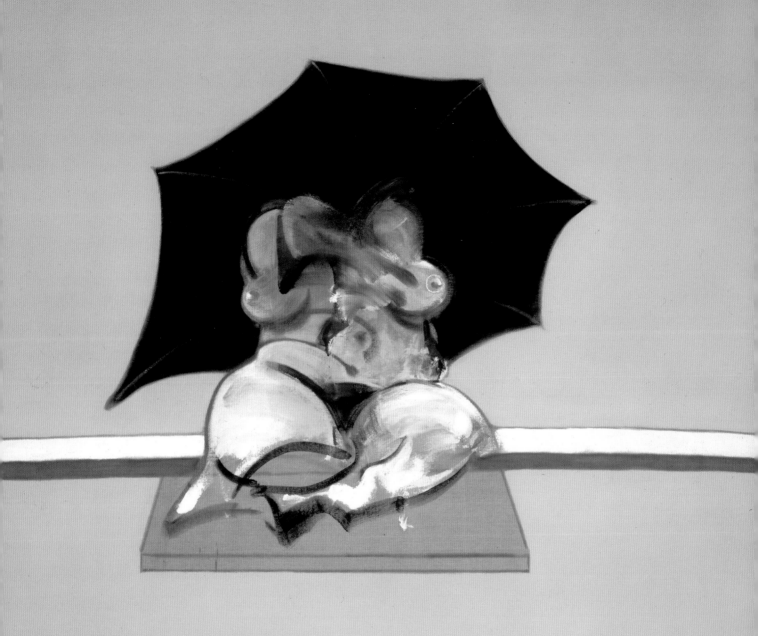

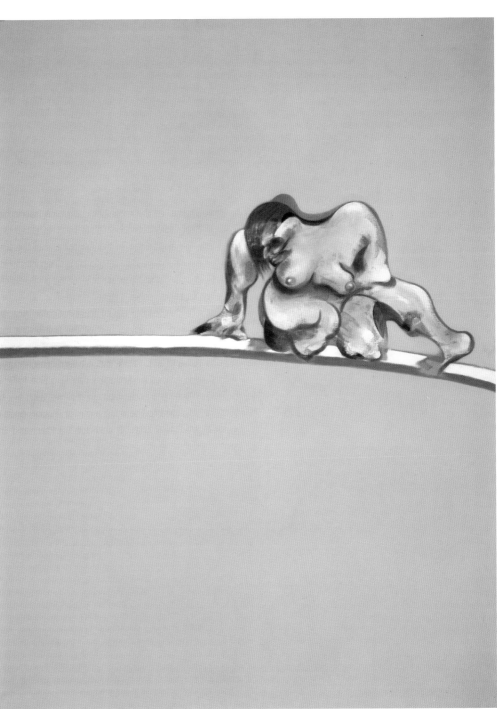

Three studies of the
male back, triptych
1970

oil on canvas
each 198 x 147.5 cm
Kunsthaus Zürich, Vereinigung Zürcher
Kunstfreunde

In *Three studies of the male back, triptych* Bacon has painted his lover George Dyer from behind with his face reflected in a mirror suspended in a cage-like apparatus. In the central panel the figure reads a newspaper and the mirror image is replaced by a deep black void. The curved floor stretching across the three panels recalls a racetrack or the curved walls of Bacon's grandmother's house in Ireland. This curve recurs in many paintings, with the richness of this particular incarnation not so apparent in reproduction. The lower half of the painting is made up of two colours: brown paint stippled over purple. In the flesh, the purple glows, creating a subtle tonal effect. While it is a twentieth-century setting, the format of this work echoes Velázquez's painting *The toilet of Venus* 1647–51 (below), in which a nude woman reclines with her back to the viewer, her face reflected to them via a mirror. Bacon once commented to the writer Hugh Davies that: 'If you don't understand The Rokeby *Venus* you won't understand my paintings.'[48]

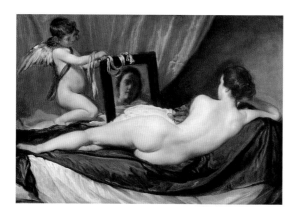

fig 109 Diego Velázquez
*The toilet of Venus
(The Rokeby Venus)* 1647–51

oil on canvas, 122.5 x 177 cm
National Gallery, London.
Presented by the National
Collections Fund, 1906

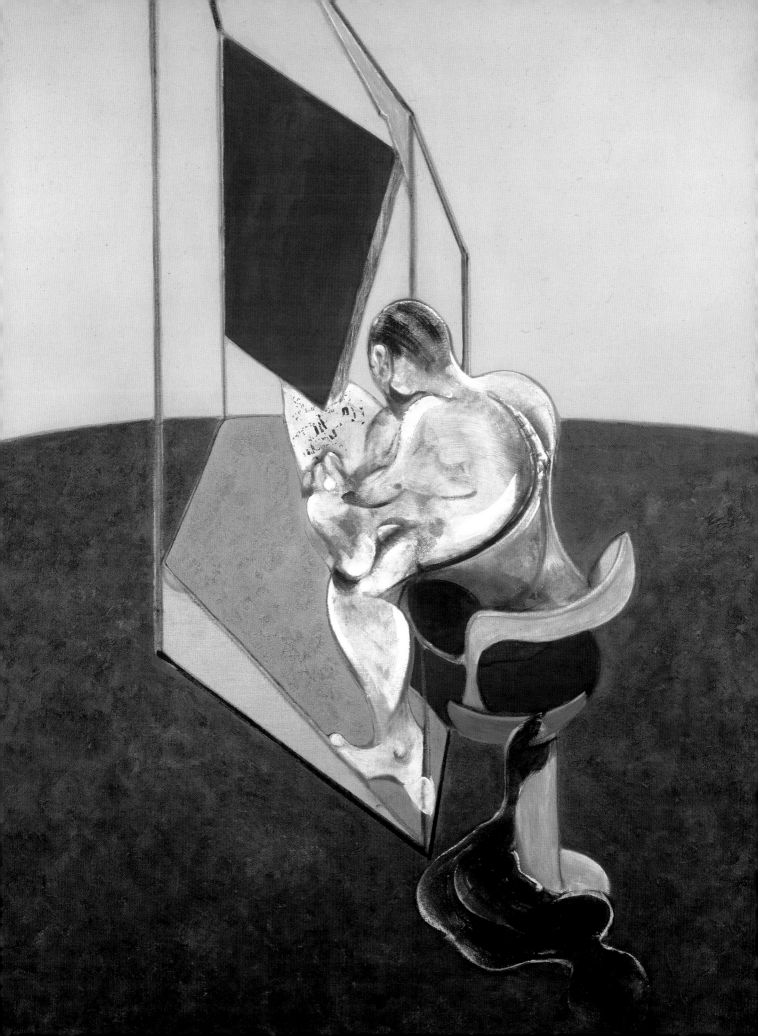

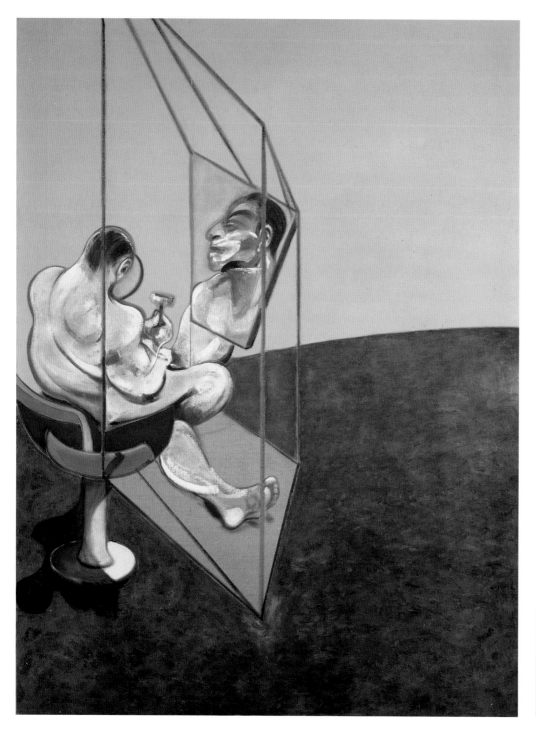

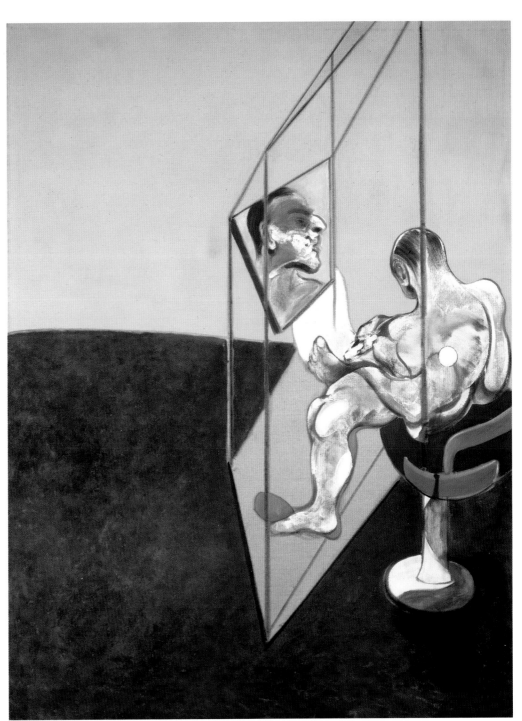

Triptych
1970

oil on canvas
each 198 x 147.5 cm
National Gallery of Australia, Canberra.
Purchased 1973

The figures in the left and right panels of this painting are derived from
a photograph by Eadweard Muybridge showing a woman climbing into
(or out of) a hammock (below). It may also be inspired by a scene from
the artist Man Ray's 1929 film *Les mystères de Château du Dé* featuring
swings and a swimming pool. In *Triptych* the two suspended figures convey
a sense of gravity. The figure in the right-hand panel resembles Bacon's
lover George Dyer; those in the central panel the eroticised wrestling figures
that feature in many of the artist's paintings; while the figure on the
left-hand panel recalls Bacon's suited men in blue from the 1950s.

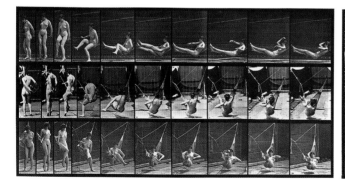

fig 110 'Woman in a swing', plate
261 in Eadweard Muybridge's *Animal
locomotion* (1887).

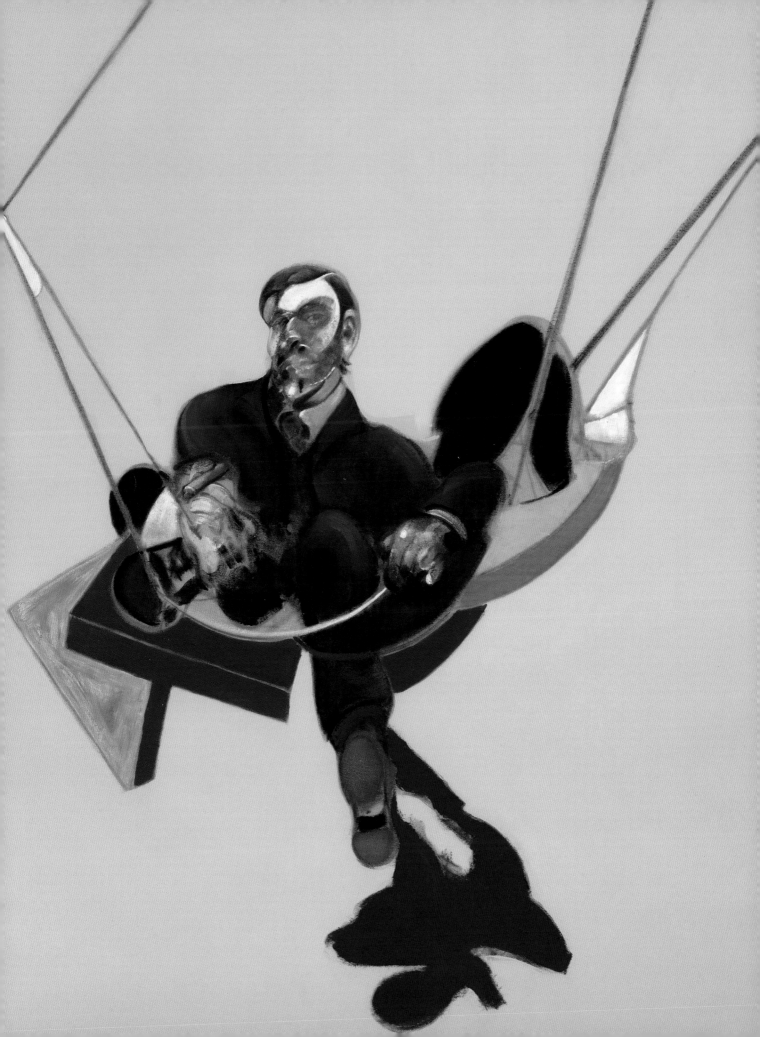

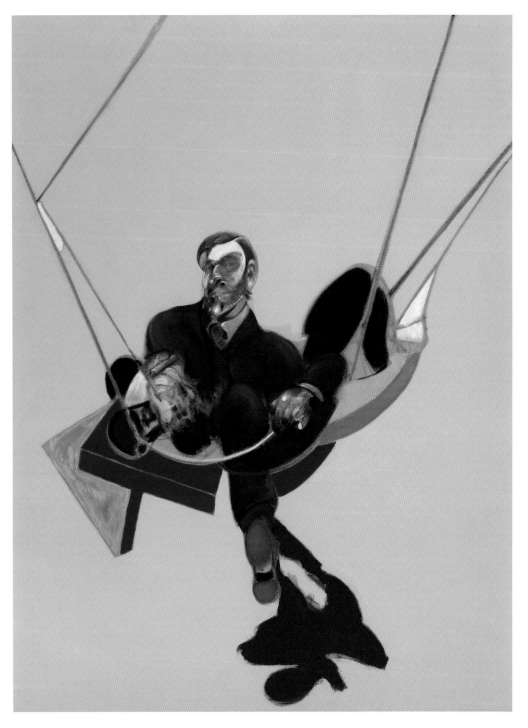

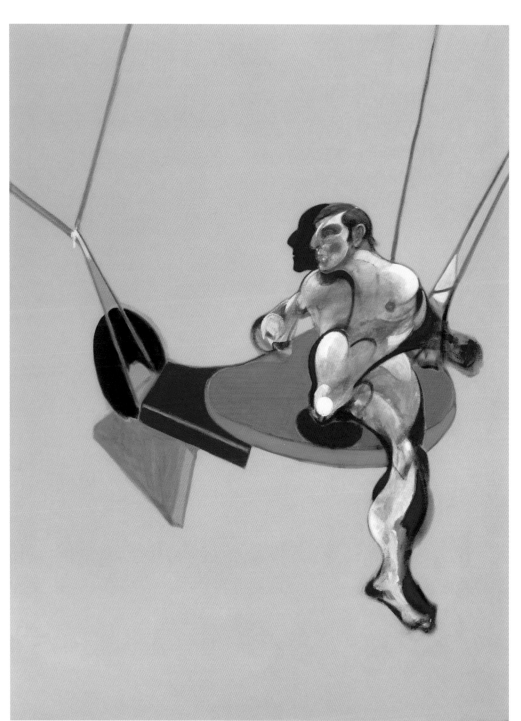

Triptych – August 1972
1972

oil on canvas
each 198 x 147.5 cm
Tate, London. Purchased 1980
T03073

In 1971 Bacon travelled with George Dyer to Paris for his retrospective exhibition at the Grand Palais. The day before the opening, however, Dyer was found dead in his hotel room from an overdose of barbiturates. Bacon did not grieve publicly, but in the following years produced a series of triptychs that memorialise his lover. One of these is *Triptych – August 1972*, which includes two figures based on a series of photographs by John Deakin of Dyer, wearing only his underpants, seated in Bacon's studio (below). In the central panel the figure is writhing on the floor. The shadows in each panel become liquid, perhaps representing the life flowing out of Dyer's body. This painting parallels a handwritten note found in Bacon's studio that reads 'Shadow Thicken and lie on floor'.[49] In the year this work was painted, Bacon commented to his biographer Michael Peppiatt: 'Not an hour goes by when I don't think about George.'[50]

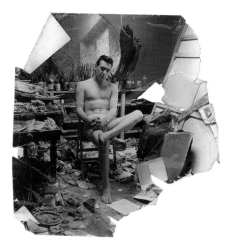

fig 111 George Dyer at the Reece Mews studio, c1965 photographed by John Deakin
Dublin City Gallery The Hugh Lane F104:34

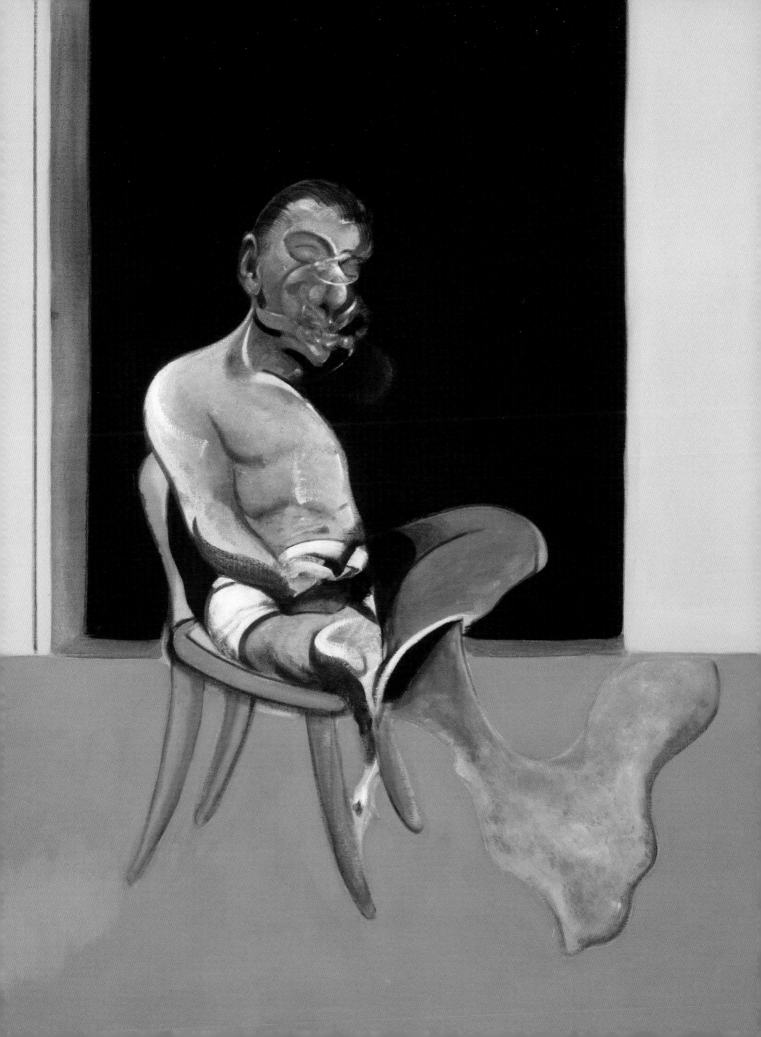

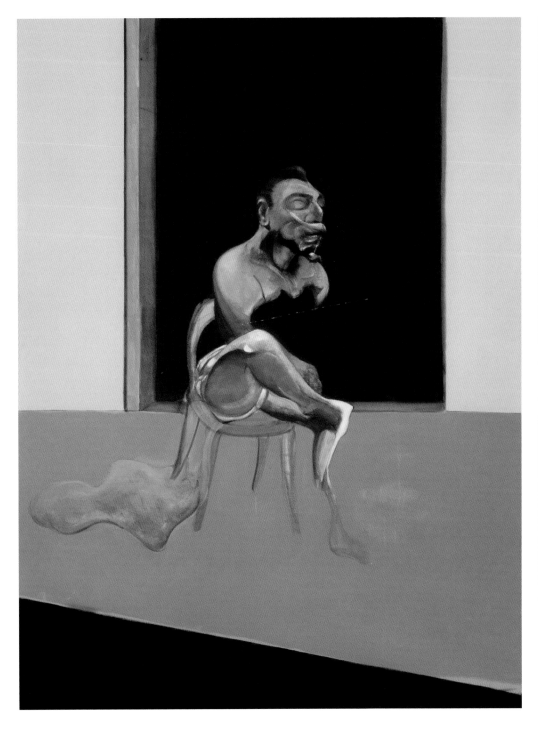

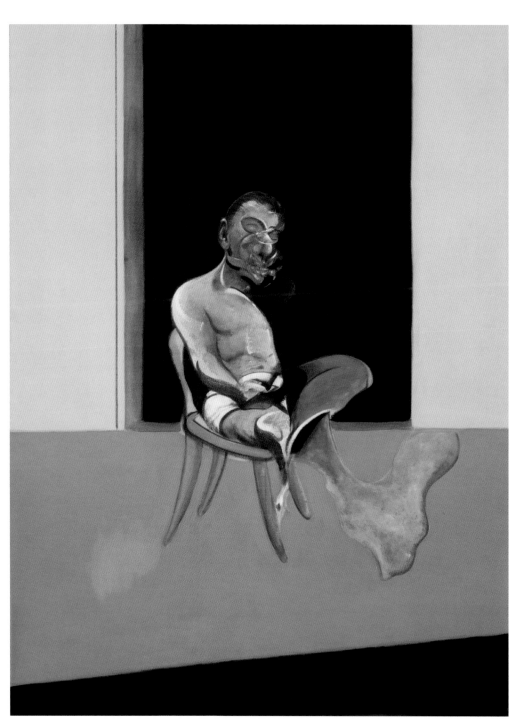

Self portrait
1973

oil on canvas
35.5 x 30.5 cm
Private collection
Courtesy Richard Nagy Ltd, London

Arguably, the radical distortion in Bacon's work was a direct response to photography and driven in part by a need to differentiate his paintings from his photographic sources. As Bacon himself noted: 'photography has altered completely this whole thing of figurative painting.'[51] In an interview with David Sylvester he explained that when painting self-portraits he looked both in the mirror and at photographs.[52] It is clear from the material found in his studio that the creases and crumples of the photographs he used influenced the distortions of the paintings, even functioning as a kind of drawing. Bacon held that his work occupied a space between representation and abstraction, and while he abhorred the latter, his work was not naturalistic or realistic in the traditional sense. Courting chance was a key strategy in Bacon's efforts to achieve this brinkmanship. He always claimed that the successful image came from a balance between critical faculties and accident.

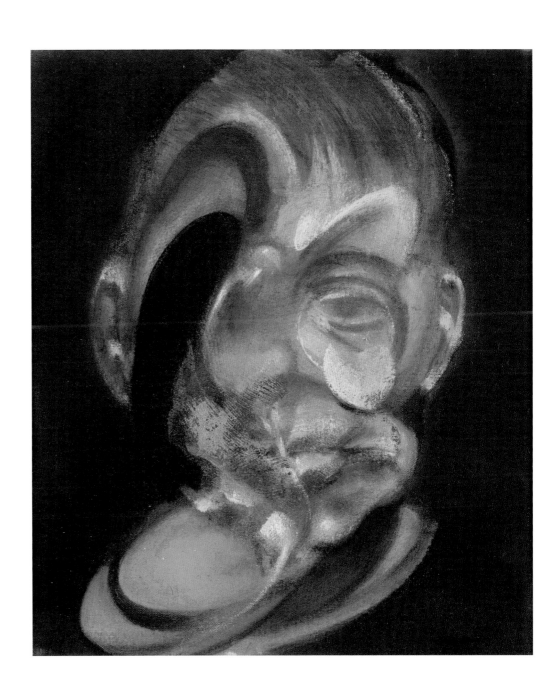

Portrait of a dwarf
(The dwarf)
1975

oil on canvas
158.5 x 58 cm
Private collection

The Dionysiac sometimes has the soul of a miniaturist ... Portrait of a dwarf, one of Bacon's most successful works in the last few years, is particularly significant for its seemingly paradoxical coexistence of these two elements. Eddy Batache, 1985[53]

Portrait of a dwarf (The dwarf) reflects Bacon's passion for Velázquez, who painted the dwarfs who customarily attended the seventeenth-century Spanish court. In a conversation with David Sylvester, Bacon noted that 'the court and the grand people of Spain at that period liked to have dwarfs around them, and that is probably because a dwarf enhanced their sense of reality'.[54] Velázquez's dwarfs are portrayed with dignity and Bacon's figure, with its sharply defined features and single deep black eye, echoes this.

By the 1960s Bacon had settled on standard dimensions for both his large and small canvases. *Portrait of a dwarf* was originally painted as a large-format canvas, as shown in the photo below which was found in Bacon's studio. However Bacon, who ruthlessly edited his own work, was seemingly dissatisfied with the convulsing figure at the left. Reinhard Hassert has related how Bacon cut that figure from the canvas at Reinhard's suggestion to preserve the dwarf, which they both liked. Because of this radical excision, the shape of the remaining canvas is unique among the artist's compositions. Bacon usually despatched canvases from his studio immediately but kept *Portrait of a dwarf* for a number of years and exhibited it as his own property at Galerie Claude Bernard, Paris, in 1977.

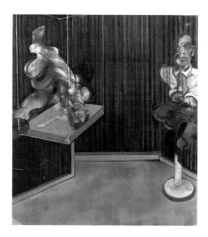

fig 112 Photograph of *Portrait of a dwarf* prior to completion.
Private collection
Dublin City Gallery The Hugh Lane F104:79

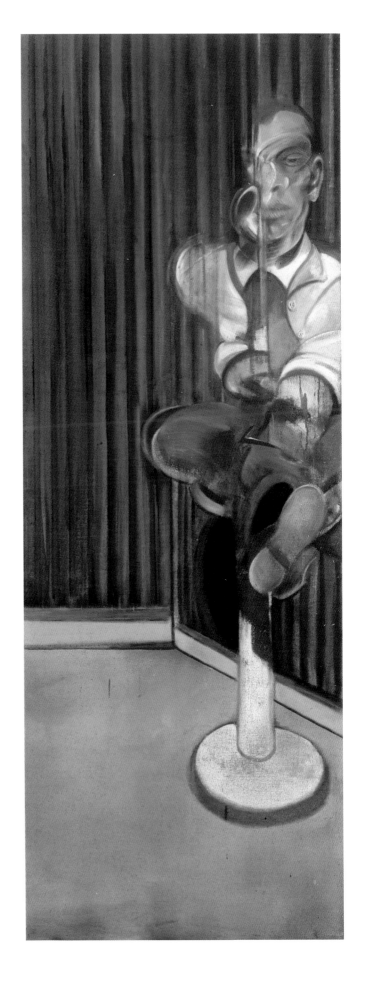

Three figures and a portrait
1975

oil and pastel on canvas
198.1 x 147.3 cm
Tate, London. Purchased 1977
T02112

This work is one of only a few paintings by Bacon showing more than two figures in a single panel. The figure in the foreground is one of the Eumenides – mythological creatures that relentlessly haunted the protagonist of Aeschylus's Greek tragedy *Oresteia*. In the background is a small portrait nailed to the wall: an image-within-an-image. The profile of the figure on the left resembles that of George Dyer in a photograph taken by John Deakin at Bacon's behest. While the figure wears a collar and tie, its naked, convulsing body appears skinless. The protruding spine references the nineteenth-century French artist Edgar Degas's drawing *After the bath, woman drying herself* c1890–95 (below), which Bacon described thus: 'you will find at the very top of the spine that the spine almost comes out of the skin altogether. And this gives it such a grip and a twist that you're more conscious of the vulnerability of the rest of the body ... '[55]

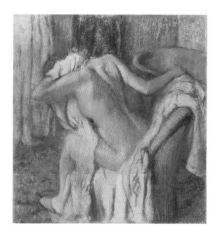

fig 113 Edgar Degas
After the bath, woman drying herself c1890–95

pastel on wove paper laid on millboard, 103.5 x 98.5 cm
The National Gallery, London. Purchased 1959

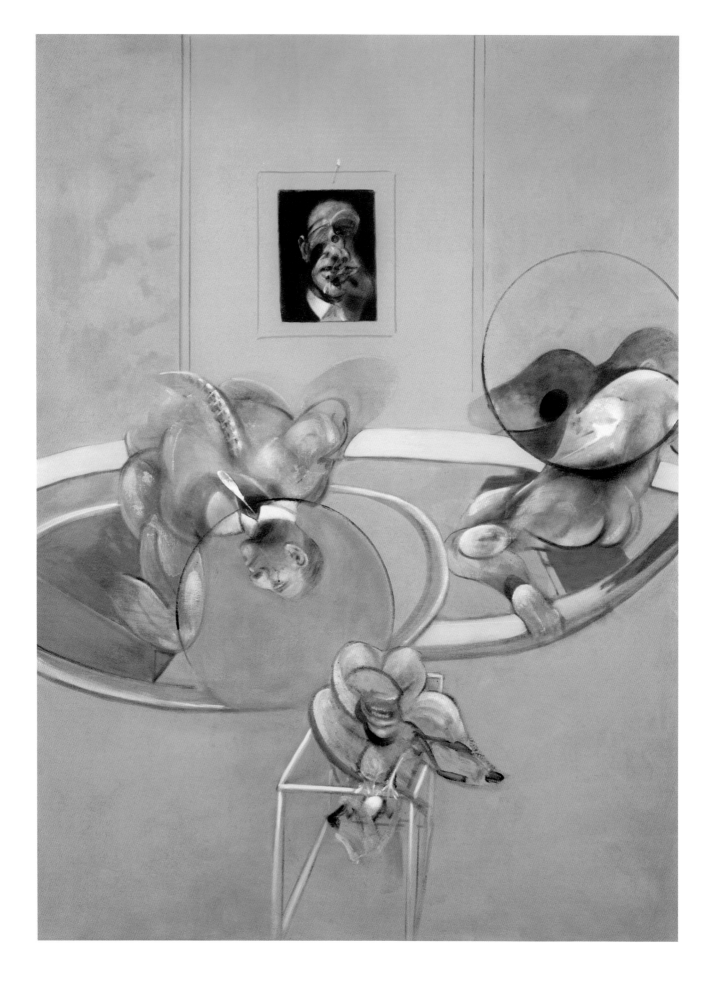

Studies from the human body
1975

oil and Letraset on canvas
198.1 x 147.5 cm
Private collection

Studies from the human body presents a compartmentalised space. Each figure in this composition is isolated – visually trapped in its own area. Set against black, the head of the figure on the right is circled with pale blue. This derives from a medical textbook, *Positioning in radiography*, that Bacon kept in his studio and which informed many other works.[56] The central figure is positioned against a square of pale blue and lies on a newspaper, the artist using Letraset to achieve the effect of newsprint. On the far left a figure is glimpsed from behind, reflected in a mirror.

In Bacon's work the mirror functions to place figures within the same visual field, yet inherently separate from one another. Here we see three figures on the same canvas but none of them 'see' the other. In addition, a figure reflected in a mirror is there without being there: we can see it but it is also corporeally absent. This sense of displacement tells us something about the act of looking that Bacon aims to elicit in his work.

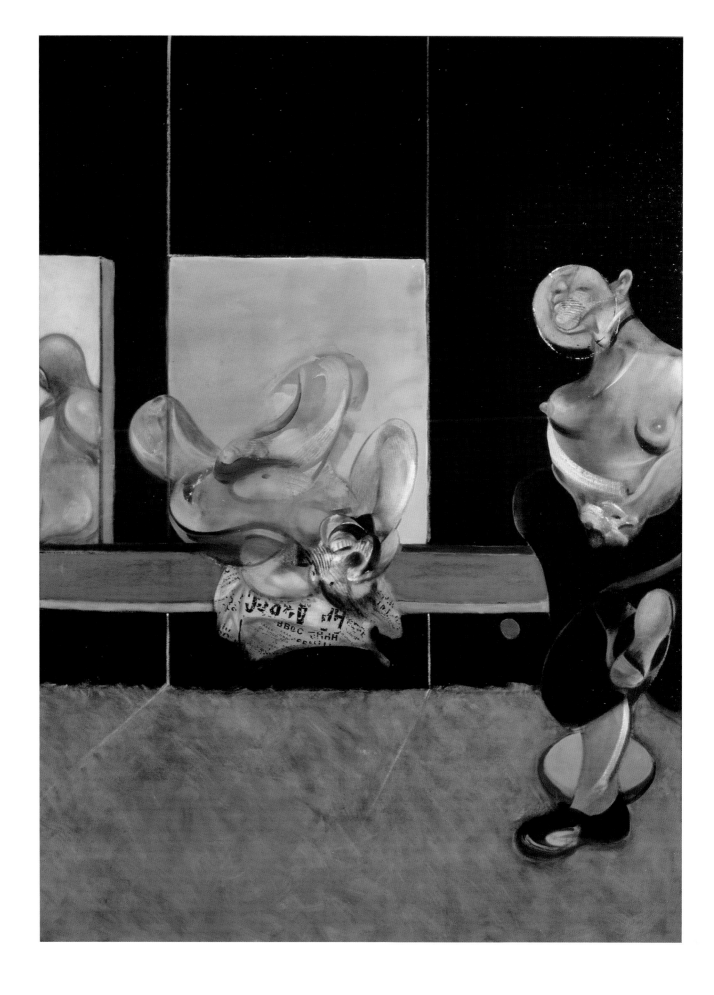

Portrait of Michel Leiris
1976

oil on canvas
35.5 x 30.5 cm
Louise and Michel Leiris Collection.
Pompidou Centre, Paris

'The portrait is a masterpiece of controlled distortion, and Leiris emerges from it with the force of a survivor.' Michael Peppiatt, 1996[57]

Bacon perceived both 'compassion and despair' in the French intellectual Michel Leiris (below).[58] Leiris was an ethnographer, critical theorist and poet associated with the Surrealists. Among his friends were the artist André Masson and the intellectual Georges Bataille. He was also the author of some of the most beautiful prose written about Bacon. The artist wrote 47 letters, postcards and telegrams to Leiris, including one that read: '[you are] the only one to have understood and to have put into words all sorts of things that I have tried to do.'[59]

Bacon made two portraits of Leiris in the late 1970s at the time when Leiris was translating David Sylvester's interviews with Bacon into French. The sweeping circular gestures forming the face are set against areas of textured paint created by pressing fabric against the wet surface. These marks convey a sense of interrupted movement and while they are not naturalistic, Bacon felt that 'the one I did which is less literally like him is in fact more poignantly like him'.[60]

fig 114 Michel Leiris, c1975–76. photographed by Michel 'Mischka' Soskine
Dublin City Gallery The Hugh Lane F11:8

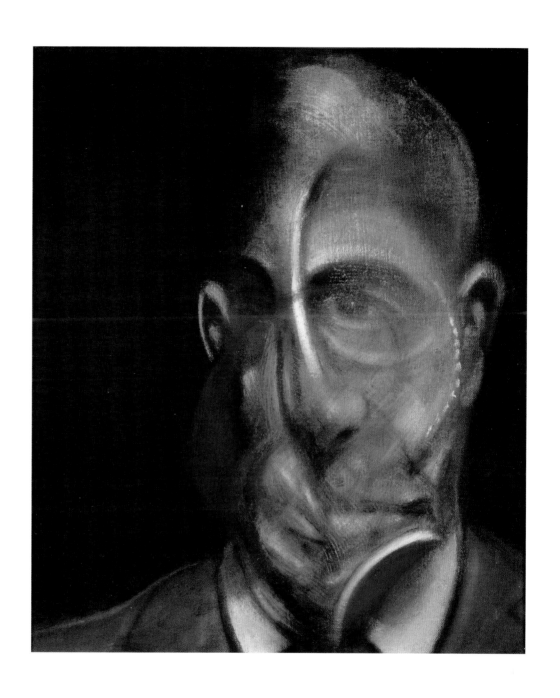

Study for self-portrait
1976

oil and pastel on canvas
198 x 147.5 cm
Art Gallery of New South Wales.
Purchased 1978

In this self-portrait Bacon depicts his body in tumult. Seated on a stool, he seems to twist around himself in a corkscrew motion that indicates awkwardness and anxiety. In many filmed interviews Bacon's unease (in part concealed by his demonstrative eccentricity) is palpable in postures such as this. The musculature of his figure is picked out with dashes of white-and-cream paint on his shoulder, knee and calf. Tilted towards the viewer, his head and shoulders are framed by a rectangular black void. Against a cool, flat acrylic ground, his body casts a shadow that has a material presence – like an object or an extension of Bacon's own flesh.

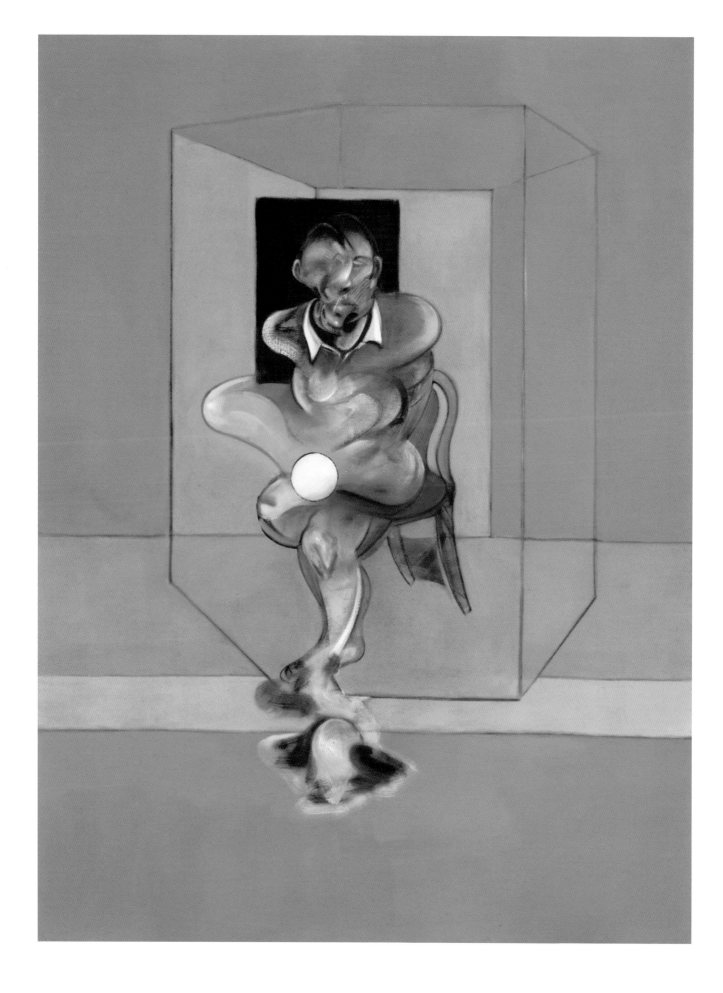

Seated figure
1978

oil on canvas
198 x 147.5 cm
Private collection
Courtesy Richard Nagy Ltd, London

Seated figure includes a late portrayal of Bacon's deceased lover George Dyer. Dyer's profile – which Bacon may have traced around from a photograph by John Deakin (below) – fills the bottom half of the canvas, while the figure above features some of the artist's key emblems, including the umbrella and nascent cricket pads. When asked about the cricket pads Bacon said that they strengthened the figure and made it more real.[61]
The 1970s were characterised by memorial portraits of Dyer, yet in the year after he painted this work, when he was asked by David Sylvester if he had done any paintings of his former lover, Bacon replied: '[it] seems more difficult to me – to do heads of people who are dead.'[62]

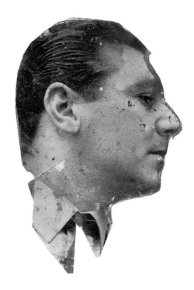

fig 115 Photograph by John Deakin of George Dyer c1965, cut by Bacon around the profile.
Dublin City Gallery The Hugh Lane
RM98F130:82

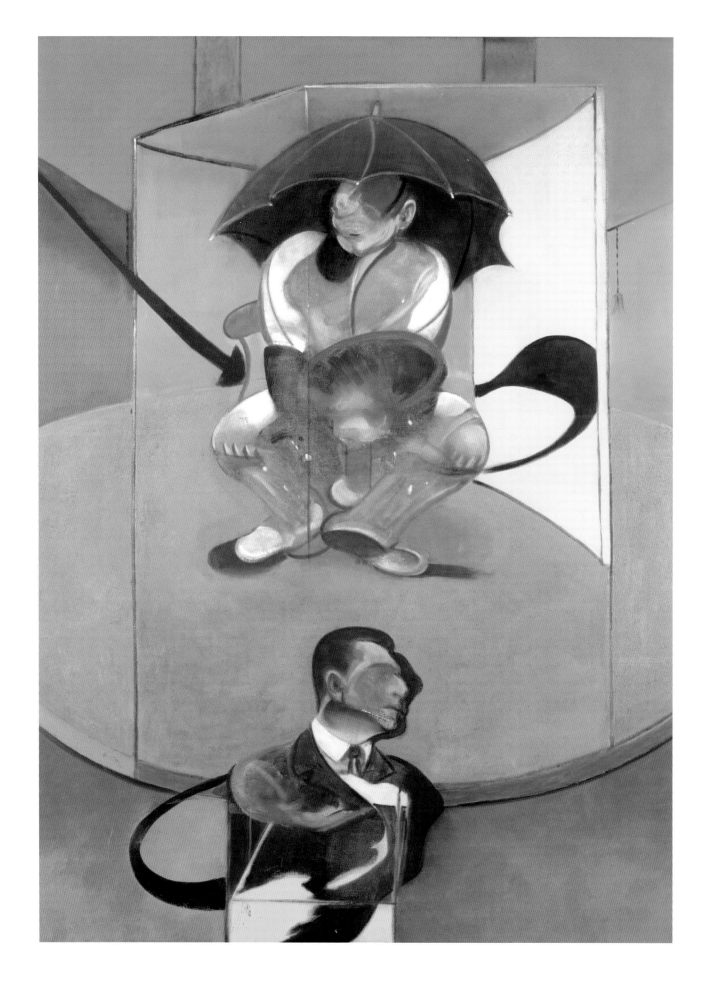

Study of Reinhard Hassert
1979

oil on canvas
35.5 x 30.5 cm
Private collection

Study of Eddy Batache
1979

oil on canvas
35.5 x 30.5 cm
Private collection

The prominent Sydney art-world figures Eddy Batache and Reinhard Hassert met Bacon in Paris in the 1970s and established a strong friendship which lasted until the artist's death in 1992. Batache is one of the few people to have observed Bacon at work.[63]

This double-portrait places Batache and Hassert alongside and yet distinct from one another. The format harks back to a portraiture style customary in the sixteenth century, traditionally depicting husbands and wives, or friends. Painted on separate canvases, the portraits were hung alongside one another with their heads turned slightly towards each other. In the late 1970s Bacon subtly played with this art-historical format to portray an enduring and intense relationship between two of his friends.

figs 116 & 117 Reinhard Hassert (left) and Eddy Batache in Bacon's Paris studio at rue de Birague, 1979. photographed by Raphaël Gaillarde, Gamma Agency

Dublin City Gallery The Hugh Lane
F1:45, F1:44

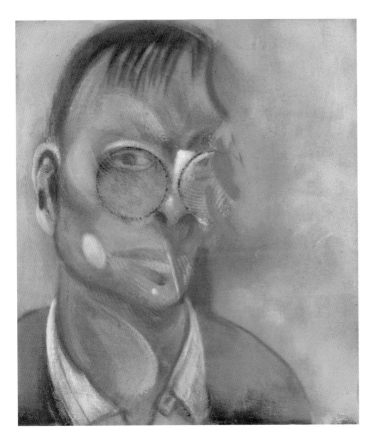 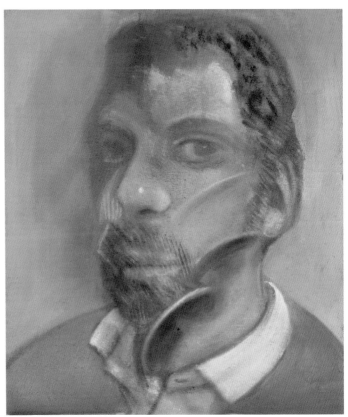

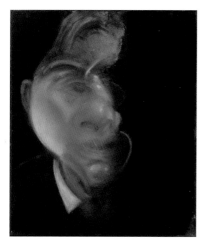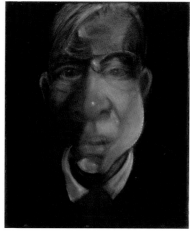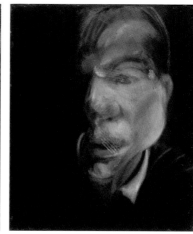

Three studies for a self-portrait
1979–80

oil on canvas
triptych, each 37.5 x 31.8 cm
Metropolitan Museum of Art, New York.
Jacques and Natasha Gelman Collection,
1998
1999.363.1a-c

Although he painted many self-portraits in his later life, Bacon downplayed their significance. When the interviewer Michel Archimbaud suggested that the self-portrait might be 'the essence of figure painting' Bacon countered: 'It's a model just like any other. The important thing is always to succeed in grasping something which is constantly changing, and the problem is the same whether it's a self-portrait or a portrait of someone else.'[64]

Nevertheless, Bacon also claimed that he had to know the subjects of his portraits intimately – a closeness that afforded him greater opportunity to observe the changes he sought to capture. This work is of a subject the artist knew well: his own face.

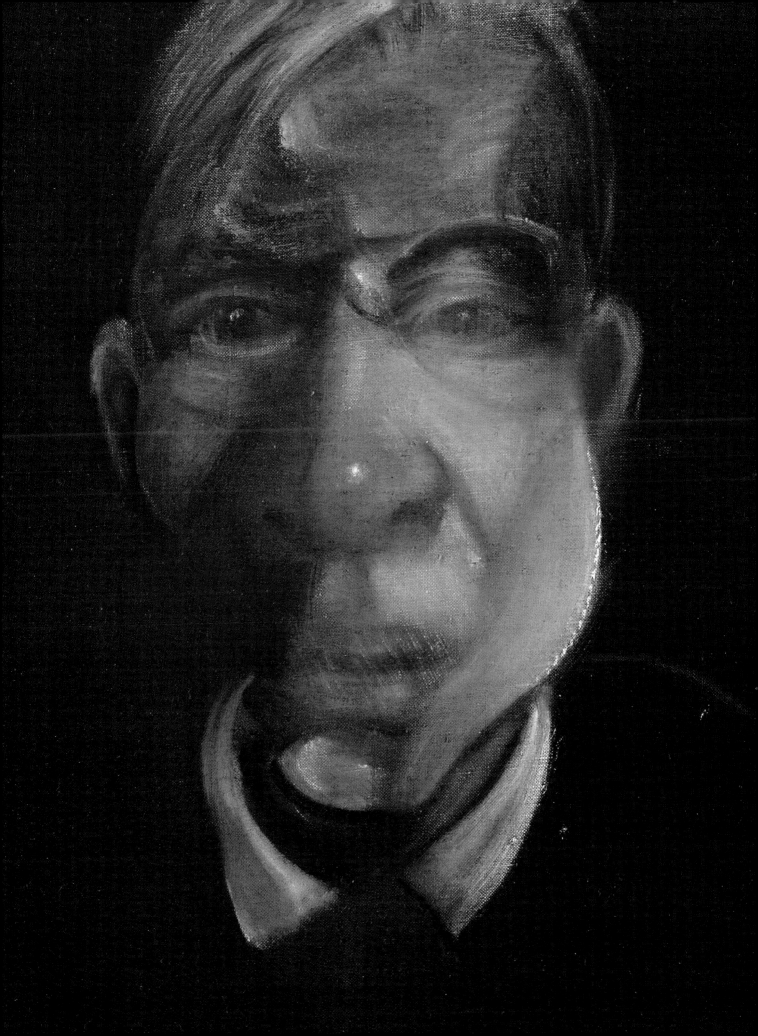

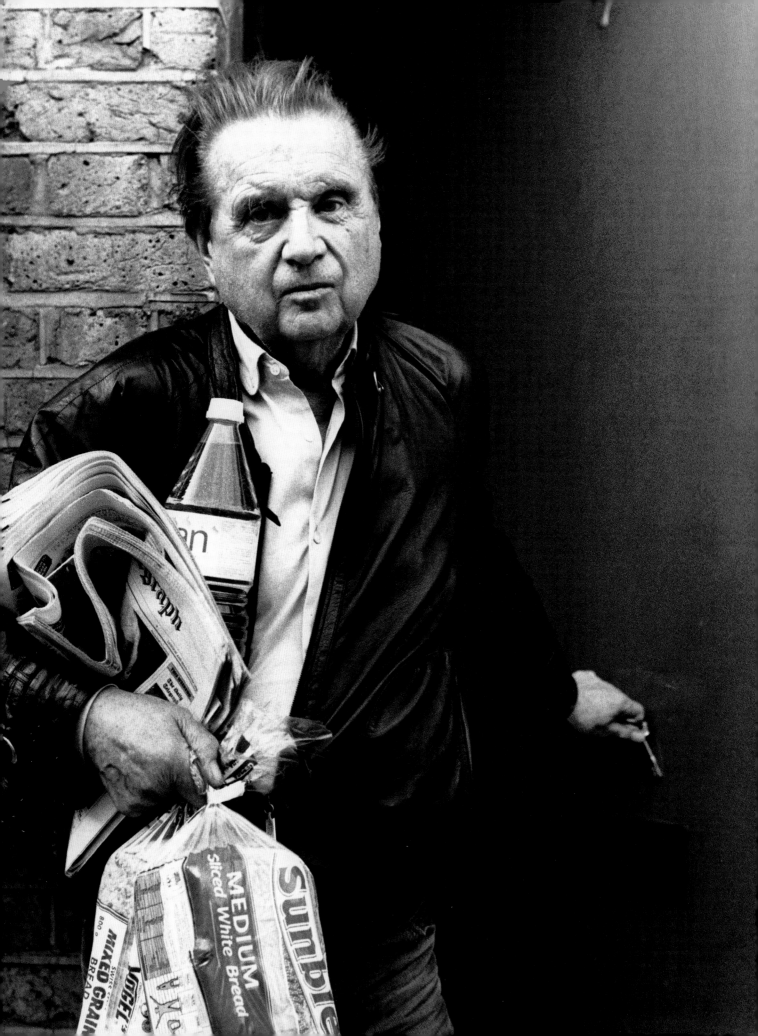

1980s

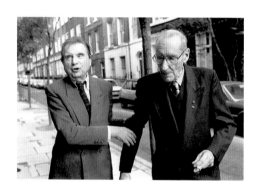

fig 118 Francis Bacon with
William Burroughs, 1989.
photographed by John Minahan
© John Minahan

page 202:

Neil Libbert
Francis Bacon 1989 (detail)

bromide print, 34.3 x 23.1 cm
National Portrait Gallery London.
Purchased, 2000
© Neil Libbert

By 1980, with the death of his long-time friend Sonia Orwell, most of Bacon's close companions were dead. Michael Leiris died in 1990 and Isabel Rawsthorne died shortly before Bacon in 1992. Apart from Lucian Freud, David Sylvester and another long-term friend, the writer William Burroughs (left), who outlived him, Bacon was the last survivor of a fascinating circle of larger-than-life people. In the 1980s he was sustained by his new stable relationship with John Edwards, although he did have at least one sexual liaison in these last years with a successful young Spanish business-man, José Capello, from Madrid. Bacon visited Capello in Spain in this decade and it was in Madrid that he died in 1992.

Bacon continued to work throughout the 1980s and completed major works, including some ambitious triptychs. He was by now an international figure of some importance, an accomplishment from which he seemed to gain little satisfaction. While he enjoyed being free of financial constraints he seemed to view the art world with a degree of disdain, although he was generally polite and often charming in public.

In 1981 the French philosopher Gilles Deleuze wrote an influential book on his work, *Francis Bacon: logique de la sensation* (*The logic of sensation*), and in 1982 Michel Leiris published *Francis Bacon: face et profil* (*Francis Bacon: full face and in profile*). In 1991, the year before he died, Bacon concluded a series of interviews with Michel Archimbaud who asked some original questions, particularly about music, although Bacon refuted any idea of musical inspiration or synaesthesia that others have at times hinted at in his work. Archimbaud's interviews add a few new elements to Bacon's own account of his work, although at times the artist reiterates, often word for word, what he said previously to both David Sylvester and Melvyn Bragg.

Bacon was now showing internationally on a regular basis, including in 1984 at Galerie Maeght Lelong in Paris and Marlborough Fine Art in New York. In 1985 he had a second retrospective exhibition at the Tate, which travelled in 1986 to Berlin and Stuttgart, with Bacon returning to Berlin for the first time since the 1930s. In 1988 he had a retrospective in Moscow and another in 1989 at the Hirshhorn Museum and Sculpture Garden, Smithsonian Institution, Washington DC, travelling to Los Angeles County Museum of Art and the Museum of Modern Art in New York.

In the 1980s Bacon made a number of self-portraits that are among his best works of this period. He also made *Second version of Triptych 1944* 1988, a late version of his 1944 triptych *Study for figures at the base of a crucifixion*. This full-size version of what he and his most astute critics claim to be his first significant painting is a technical and aesthetic revision, which he later gave to the Tate to replace the very fragile

1944 triptych. Of course this later work no more replaces the original than does *Second version of 'Painting 1946'*, his 1971 version of *Painting 1946* 1946, now in the Ludwig Museum in Köln.

Second version of 'Painting 1946' was painted in a fit of anger at the failure of New York's Museum of Modern Art to lend the original to his 1971 retrospective at the Grand Palais in Paris. Bacon often described *Painting 1946* as a composition he did not set out to paint. He had wanted to paint a bird alighting in a field, but as he applied the paint the image turned into a figure under an umbrella surrounded by carcasses. How on earth could he re-create this chance emergence of an image so many years later? The Tate's later reconfiguration of the 1944 triptych is most interesting in that it provides an aesthetic framework for evaluating Bacon's work of the 1980s compared to that of the 1940s. By this later time Bacon had achieved a degree of fluency that belies the lifelong courtship with chance that animated his earlier work. The paint structure is more even and lacks the drama of the thick strokes of paint of previous decades, and yet the images remain vibrant and the colour intense.

In March 1992 Bacon wrote to the artist Louis le Brocquy commenting favourably on Damien Hirst's work *A Thousand Years* 1990, which he had seen at the Saatchi Gallery in London: 'It is of a cow's head in one compartment and in the second part they breed the flies which swarm around the cow's head – it really works.' This was a very rare compliment as Bacon seldom acknowledged any artist after Marcel Duchamp. Perhaps Hirst's subject matter had something to do with it, but he seems to be saying that *A Thousand Years* works both formally and conceptually – and certainly the formal aspect was always uppermost for Bacon.

Perhaps Bacon's long flirtation with the idea of making sculpture found an expression in Hirst's cool installations of glass and stainless steel enclosing desecrated bodies. Bacon's failure to connect with Joseph Beuys, despite the efforts of Richard Hamilton, is an example of his disinclination to follow through on the Duchampian question of indexical realism into the present. Beuys is surely a crucial precursor for Hirst, although the former artist's aesthetic might have been too messy for the fastidious Bacon. Or perhaps Beuys was too close to Bacon in seniority – a potential challenger? Bacon tended to dismiss artists of his time whose reputation took on iconic status, such as the American abstract expressionist artist Jackson Pollock, who he famously described as an 'old lace-maker'.[65] AB

fig 119 Damien Hirst
A Thousand Years 1990

glass, steel, silicone rubber, painted MDF, insect-o-cutor, cow's head, blood, flies, maggots, metal dishes, cotton wool, sugar, water, 207.5 x 400 x 215 cm

© Damien Hirst and Science Ltd. All rights reserved, DACS/ Licensed by Viscopy

Self portrait
1980

oil on canvas
35.5 x 30.5 cm
Private collection

Bacon increasingly painted self-portraits as he got older and remarked to his friends Eddy Batache and Reinhard Hassert that this work was from his 'impressionist' period. This comment reflects the softness with which Bacon has rendered his own face. While earlier self-portraits, such as *Three studies for a self-portrait* 1979 (pp 200–01), have sharply defined edges and a dramatic chiaroscuro, this painting is gently blurred and softened.

As Bacon aged, his friends – many of whom he painted on a regular basis – began to die. The 1970s opened with the death of his lover George Dyer and ended with the deaths of his close friends Muriel Belcher in 1979 and Sonia Orwell in 1980, the year this portrait was made. Bacon commented to David Sylvester: 'I loathe my own face, but I go on painting it only because I haven't got any other people to do.'[66] Yet here Bacon appears as a much younger man; the loathing that he spoke about to David Sylvester has been replaced with a romantic quality that is uncharacteristic of his work at the time.

Figure in movement
1985

oil on canvas
198 x 147.5 cm
Private collection

In his later works Bacon began to depict cricket paraphernalia. *Figure in movement* is one of several images portraying men clad in cricket pads and little else. The figure here is isolated between planes of iridescent orange on an elevated field or tabletop. Other paintings by Bacon used cricket pads to draw attention to the figure's genitals. When asked about his references to cricket Bacon commented that he was aware of the game's importance to the British.[67] Yet his interest in sports of all kind shows his attraction to the virile male form in movement.

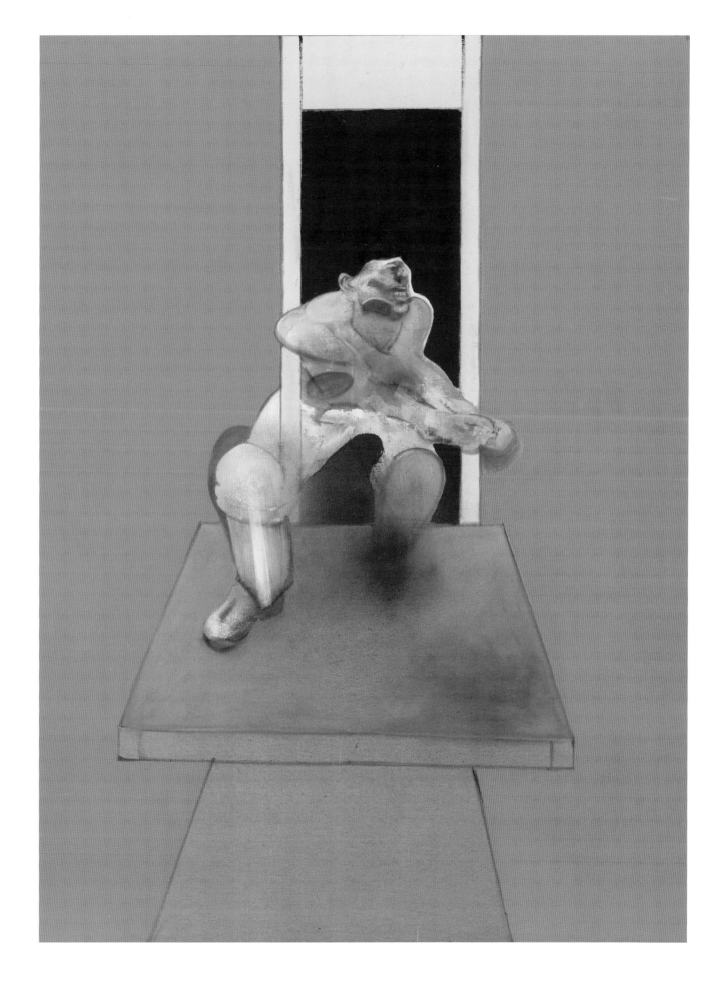

Triptych
1987

oil on canvas
each 198 x 147.5 cm
The Estate of Francis Bacon
Courtesy Faggionato Fine Art, London

The starting point for this work is Federico Garcia Lorca's 1935 poem 'Lament for Ignacio Sanchez Mejias' describing the death of a matador.[68] The left and central panels in this work show wounds, while in the right is the shadow of a bull with one of its horns soaked in blood, recalling a line from Lorca's poem: 'A thigh with a horn of desolation / at five in the afternoon'.[69] The scene is conveyed in the manner of medical imagery, drawing on the book *Positioning in radiography* that Bacon kept in his studio.[70] Bacon had a keen interest in bullfighting and made other images of the sport. He also included a bull in one famous portrayal of his friend Isabel Rawsthorne, *Portrait of Isabel Rawsthorne standing in a street in Soho* 1967. Bacon saw live bullfights during his travels to Spain (where he died in 1992) and kept many images of bullfighting in his studio, such as the page torn from a magazine below. Like Bacon's approach to painting, bullfighting is a sport that risks all.

fig 120 Page from Vincent JR Kehoe, *Wine, women, and toros: the Fiesta de Toros in the culture of Spain*, Hastings House, New York, 1961

Dublin City Gallery The Hugh Lane BC19

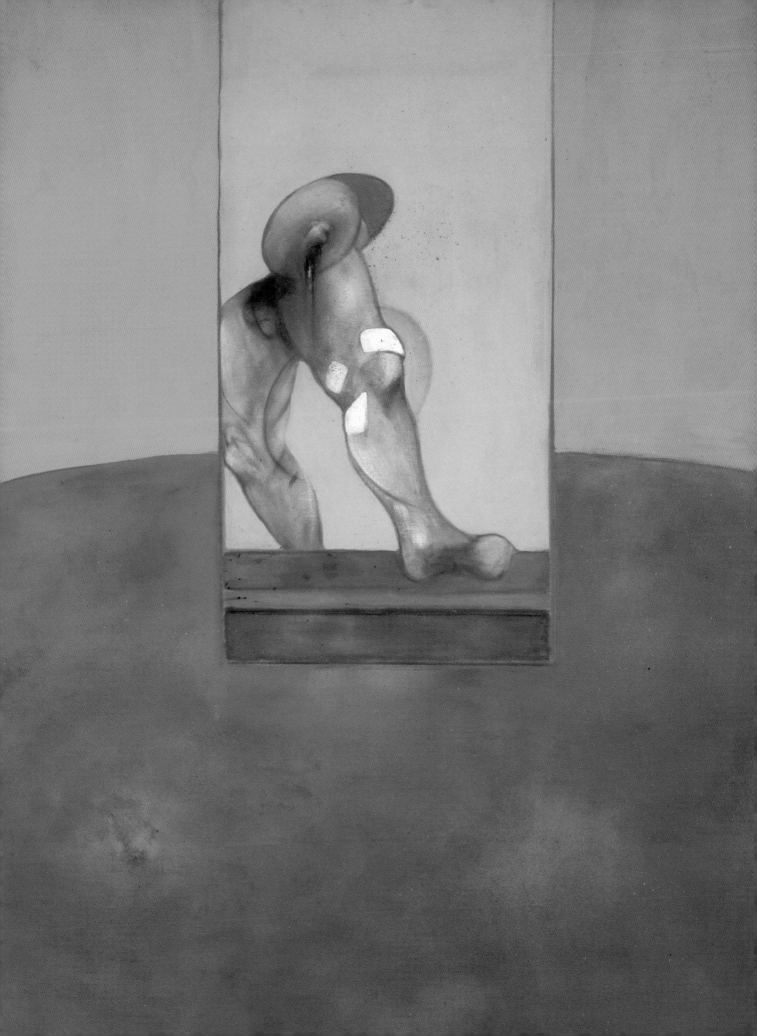

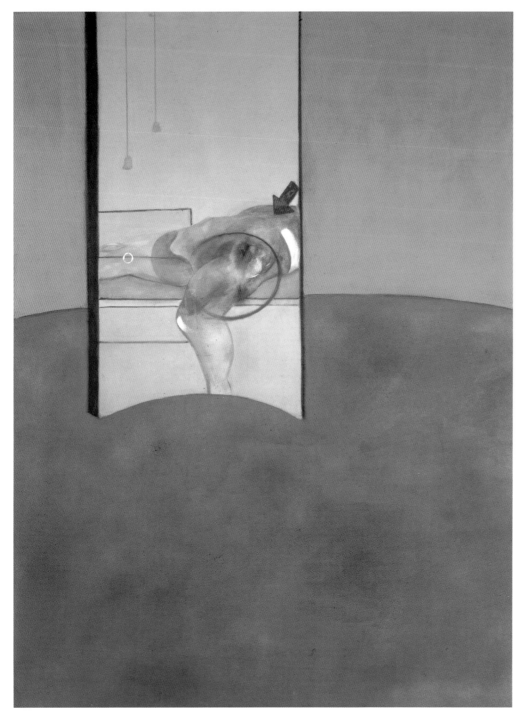

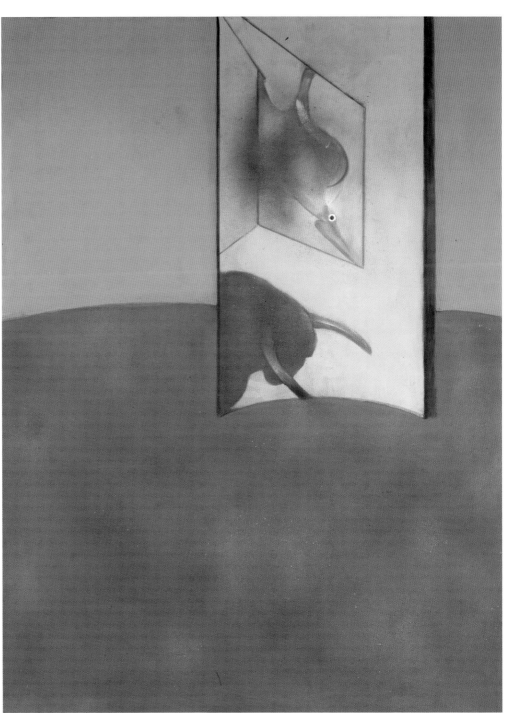

Portrait of John Edwards
1988

oil on canvas
198 x 147.5 cm
The Estate of Francis Bacon
Courtesy Faggionato Fine Art, London

John Edwards was Bacon's companion in later life: a friend, surrogate son, heir to Bacon's estate and the subject of several portraits. *Portrait of John Edwards* has its origins in photographs taken by Bacon in around 1980 showing Edwards framed by a darkened bookshelf (below left) that resembles the square black background in this painting. Margarita Cappock has suggested that the painting is an amalgam of these images of Edwards and an earlier photograph of George Dyer taken by John Deakin. Specifically, the lower body is taken from Deakin's photographs of Dyer in his underwear in Bacon's Reece Mews studio (below right), while the head and shoulders belong to Edwards.[71] This image embodies the sense of calm that came over Bacon's work in the last decade of his life.

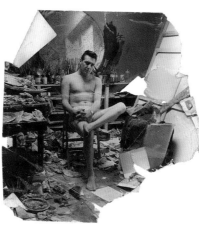

fig 121 John Edwards photographed by Francis Bacon at 21–22 Stanhope Gardens, London, c1983.
Dublin City Gallery The Hugh Lane BC23

fig 122 George Dyer at the Reece Mews studio, c1965. photographed by John Deakin.
Dublin City Gallery The Hugh Lane F104:34

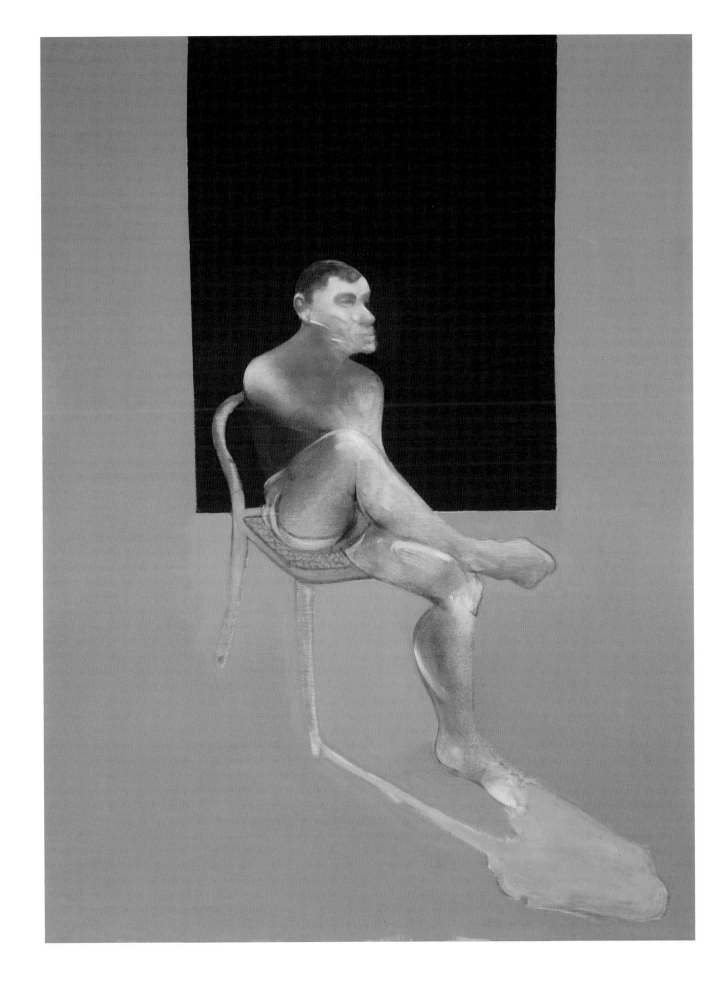

**Study from the human body
after Muybridge**
1988

oil on canvas
198 x 147.5 cm
Private collection

This is one of the last paintings by Bacon before his death in 1992 to be included in this exhibition. It is a fitting tribute to one of his enduring inspirations: the pioneering nineteenth-century British photographer Eadweard Muybridge. As always, Bacon has transformed the photographic image through painterly gesture. The shadow has a central role in the composition, seeming to crawl away from the figure like liquid flesh escaping the confines of the body. As the writer Rachel Tant has pointed out, while Bacon's late compositions were more serene, the shadows in his work of this last decade have 'all the colour gradations of bruising'.[72]

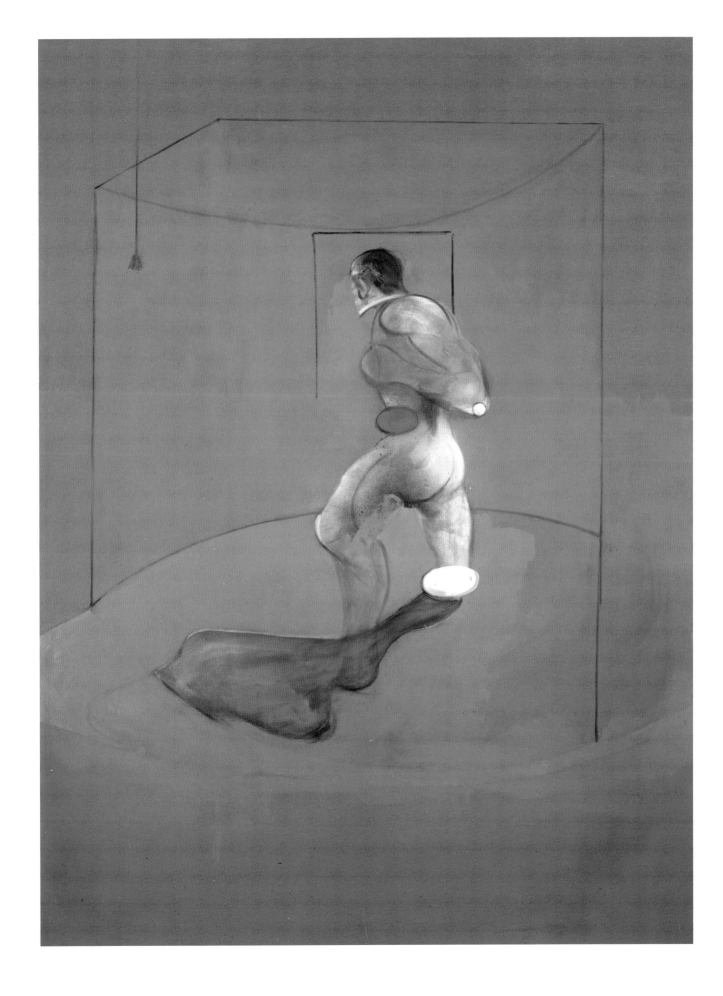

BUT HOW CAN THIS THING BE MADE SO THAT YOU CATCH THE MYSTERY OF APPEARANCE WITHIN THE MYSTERY OF THE MAKING?

FRANCIS BACON

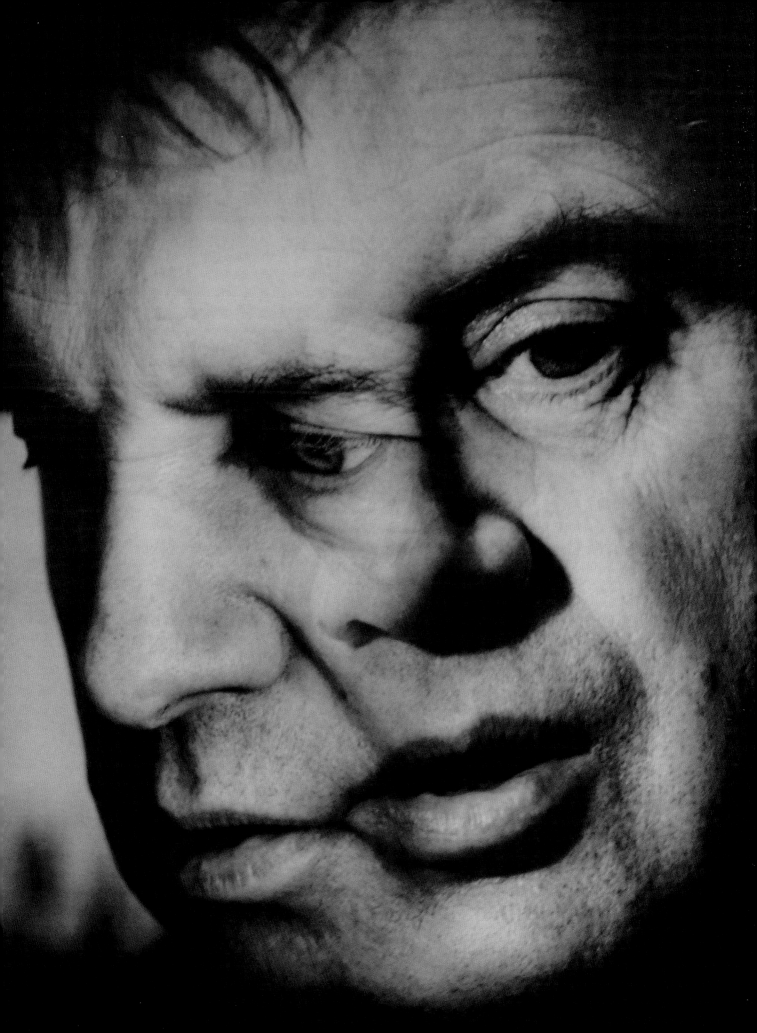

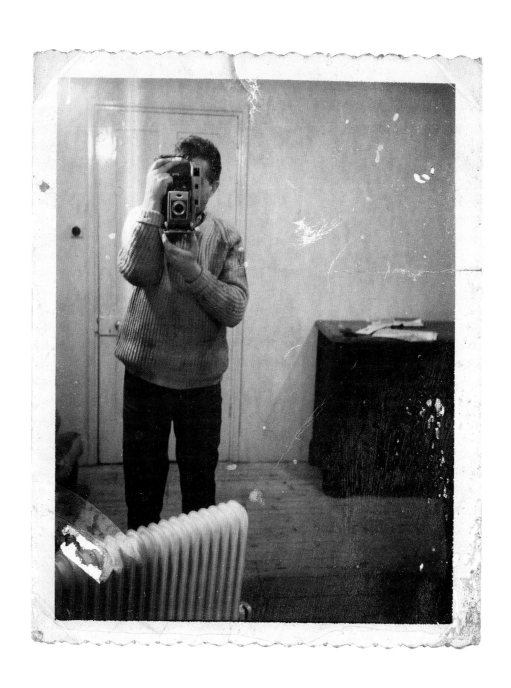

Francis Bacon
Self-portrait 1970
Polaroid photograph
The Estate of Francis Bacon

opposite:

Francis Bacon
Three studies for a self-portrait
1979–80 (detail)
see pp 200–01

previous page:

Jorge Lewinski
Francis Bacon 1967
bromide print on card mount

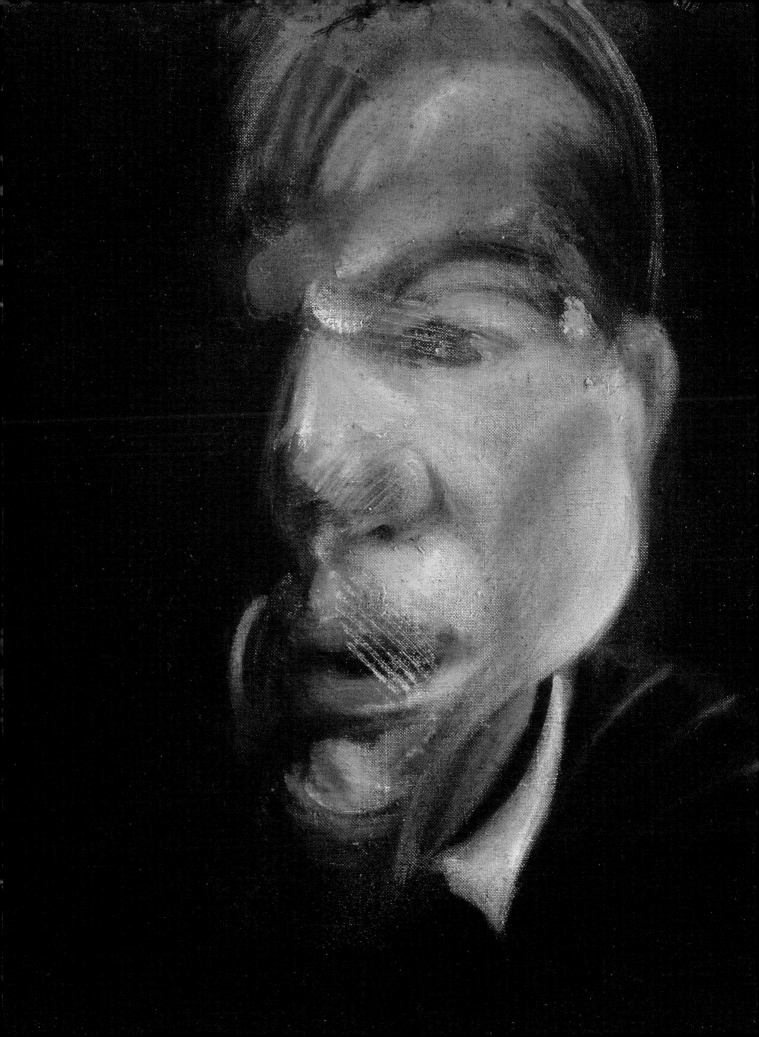

NOTES

FRANCIS BACON
FIVE DECADES

1. Ernst van Alphen, *Francis Bacon and the loss of self*, Reaktion Books, London, 1992.

2. Michel Archimbaud, *Francis Bacon in conversation with Michel Archimbaud*, Phaidon, London, 1993, p 151.

3. This is an expression Bacon used repeatedly in interviews.

4. David Sylvester, *Interviews with Francis Bacon*, Thames & Hudson, London, 1980, p 17.

5. Bacon often referred to the equivalence of paint and subject, with possibly the first published example found in the catalogue *Matthew Smith: paintings 1909–1952*, Tate Gallery, London, 1953, p 12, where Bacon wrote of Smith's painting: '… attempting to make idea and technique inseparable … a complete interlocking of image and paint, so that the image is the paint and vice versa.'

6. Archimbaud 1993, p 86.

7. The American art historian James Elkins makes reference to this in his book *Pictures of the body: pain and metamorphosis*, Stanford University Press, California, 1999, pp 120–21, where he writes: 'Arguably, Francis Bacon has been most successful in thinking his way toward a kind of fluid body that is at once inside and outside …'

8. John Russell, *Francis Bacon*, Thames & Hudson, London, 1993, p 100.

9. David Sylvester, *Interviews with Francis Bacon*, Thames & Hudson, London, 1987, p 46.

10. See Anthony Bond & Joanna Woodall, *Self portrait: Renaissance to contemporary*, Art Gallery of New South Wales, Sydney & National Portrait Gallery, London, 2005, pp 32, 99, 156, 171.

11. Sylvester 1987, p 58.

12. Sylvester 1987, p 121.

13. I refer to Bacon's interest in Duchamp a number of times in this text. Sometimes, as in this case, it is simply to point out a parallel idea that may be coincidental. However, it is important to note that Bacon did admire Duchamp and had several books on him in his studio, as well as pages about him torn from journals and books.

14. Bacon relates this differently at different times. In his interview with Sylvester 1980, p 87, he suggests it is just a matter of technical safety, of putting greater distance between the viewer and the work, and requiring them to look harder. Sylvester persisted with the idea that there was a similarity between Bacon's use of glass and Duchamp's work. Subsequently, in his book *Looking back at Francis Bacon*, Thames & Hudson, New York, 2000, pp 22, 24, Sylvester discusses his repeated attempts to develop this idea in his conversations with Bacon. Bacon admitted that he liked to create a distance between the viewer and the work, but did not accept that the reflections of the viewer were important to him; rather, they were just something viewers had to put up with.

15. Sylvester 1987, p 192.

16. Quoted in Sylvester 1987, p 22.

17. Gilles Deleuze, *Francis Bacon: the logic of sensation* (1981), trans Daniel W Smith, University of Minnesota Press, Minneapolis, 2003.

18. In art history the term *mise en abyme* refers to an image within an image; it also refers to the infinite regression of opposed mirrors.

19. Van Alphen, 1992, p 30.

20. There has been a great deal written about this painting, most notably by the French philosopher Michel Foucault in the opening chapter of his 1970 book *The order of things*. A contrary view has been put forward by the Australian academic Donald Brook who used optical coordinates to prove that the image in the mirror must be a reflection of the painting. Correspondence between the author and Brook, 23 February 2006.

21. See Bond & Woodall 2005.

22. Ian Burn, *Looking at seeing and reading*, exhibition catalogue, Ivan Dougherty Gallery, Sydney, 1993.

23. In interviews Bacon repeatedly distinguishes between the gesture that conveys the feelings of the artist as in itself being of importance, and the business of conveying onto a spectator's nervous system something of what he finds to be the sensation of the real.

24. Archimbaud 1993, p 78.

25. One recent attempt to make sense of aspects of this is Susan Best's book *Visualising feeling: affect and the feminine avant-garde*, IB Tauris, London, 2011.

26. Yves Klein Archives, Paris, 1954. Quoted in Nicolas Charlet, *Yves Klein*, Vilo Adam Biro, Paris, 2000, p 170.

27. *Francis Bacon: a film by David Hinton*, DVD video, presented by Melvyn Bragg, a London Weekend Television co-production with RM ARTS, London, licensed by ArtHaus Musik GMBH, 1985.

28. As discussed by Rosalind Krauss in her essay 'Allusion and illusion in Donald Judd', *Artforum*, no 9, May 1966, p 24.

29. Bacon wrote about this at some length in a letter to Sonia Orwell, 13 December 1954, George Orwell Archive, University College London.

30. Martin Hammer and Chris Stephens reproduced a number of such potential source images in their article '"Seeing the story of one's time": appropriations from Nazi photography in the work of Francis Bacon', *Visual Culture in Britain* (special Francis Bacon issue), November 2009, pp 317–53.

31. Roland Barthes, *Camera lucida: reflections on photography*, Hill & Wang, New York, 1981.

32. Martin Harrison, *In camera. Francis Bacon: photography, film and the practice of painting*, Thames & Hudson, London, 2005. See also Martin Harrison & Rebecca Daniels, *Francis Bacon: Incunabula*, Thames & Hudson, London, 2008 and Katherina Günther, *Francis Bacon: metamorphoses*, The Estate of Francis Bacon, London, 2011.

33. See also Margarita Cappock, *Francis Bacon's studio*, Merrell, London, 2005.

34. Sylvester 1987, p 179.

35. Sylvester 1987, p 179.

36. This idea was first used by Bacon in his statement for *The new decade: 22 European painters and sculptors*, exhibition catalogue, Museum of Modern Art, New York, 1955, p 63.

37. Transcript from original letter from Bacon to Michel Leiris, c1981.

38. Archimbaud 1993, p 163.

39. *Francis Bacon: a film by David Hinton*, 1985.

AUSTRALIAN CONNECTIONS

1. Fred Johns, author of *Who's who in the Commonwealth*, included a chapter on Lady Charlotte in *A journalist's jottings*, The Hassell Press, Adelaide, 1922, pp 60–65.

2. John Richardson in conversation with Martin Harrison, New York, April 2010.

3. Franck Maubert, 'Bacon L'ecorche solitaire', *Paris Match*, 14 May 1992, p 92.

4. Megan Martin, 'A man of unerring taste and colour sense: Adrian Feint and interior decoration', in Richard Heathcote (ed), *Adrian Feint: cornucopia*, Wakefield Press, South Australia, 2009, p 1.

5. Heather Johnson, *Roy de Maistre: the English years 1930–1968*, Craftsman House, Sydney, 1995, p 24.

6. Susie Darnton in conversation with Martin Harrison, Godalming, UK, April 2007.

7. Several of de Maistre's paintings, traditionally identified as depicting Bacon's studios, are in fact of his own studio.

8. Johnson 1995, p 21.

9. John Rothenstein, *Modern English painters. Volume three: Hennell to Hockney*, Macdonald & Co, London & Sydney, 1984, p 152.

10. Johnson 1995, p 21.

11. Rebecca Daniels would like to thank John MacDermot for this information, email correspondence, 14 February 2012.

12. MacDermot's room is illustrated in the Burdekin House catalogue. Brenda MacDermot's paintings lessons took place in Sydney. See Johnson 1995, p 11.

13. Rebecca Daniels would like to thank John MacDermot for this information.

14. Johnson 1995, p 39.

15. Andrew Sinclair, *Francis Bacon: his life and violent times*, Sinclair-Stevenson, London, 1993, p 63.

16. Rebecca Daniels would like to thank John Richardson for this information.

17. David Marr, *Patrick White: a life*, Vintage, London, 1991, p 169.

18. Marr 1991, p 169.

19. Marr 1991, p 169.

20. A press-cutting book relating to the exhibition is in the Agnew's Archive. Rebecca Daniels would like to thank Christopher Kingzett for permission to view this material.

21. Marr 1991, p 169.

22. Private collection, England.

23. Marr 1991, p 169.

24. De Maistre painted a *Madonna and child* in 1944, which may offer a clue to the date of the image underneath the Bacon head.

25. John Rothenstein, *Brave day, hideous night: autobiography 1939–1965 (II)*, Hamish Hamilton, London, 1966, p 105.

26. John Rothenstein, *Modern English painters. Volume 2: Innes to Moore*, Arrow Books, London, 1960, pp 250–51.

27. John Rothenstein, *Time's thievish progress: autobiography III*, Cassell & Company Ltd, London, 1970, p 85.

28. Rothenstein and Ronald Alley also embarked on a Bacon catalogue raisonné in 1962; it was published in 1964.

29. Michel Archimbaud, *Francis Bacon in conversation with Michel Archimbaud*, Phaidon, London, 2004, p 25.

30. De Maistre's painting was transferred to Westminster Cathedral in May 2007.

31. Rothenstein 1960, p 237.

32. Johnson 1995, p 22.

33. Barry Pearce, *Sidney Nolan 1917–1922*, Art Gallery of New South Wales, Sydney, 2007, p 243.

34. The Redfern Gallery was controlled by the New Zealander, Rex Nan Kivell, who appointed the Australian, Harry Tatlock Miller, as a director after the Second World War. Tatlock Miller had known Nolan since the 1930s when he lived in Melbourne and he positively reviewed Nolan's Queensland paintings when they were exhibited at the David Jones Art Gallery in Sydney in 1949. Jane Clark, *Sidney Nolan: Nolan landscapes and legends*, Cambridge University Press, Melbourne, 1987, pp 95–96.

35. The uncatalogued archive of Robert Melville is held at the Tate, Archive TGA948 Robert Melville. The archive reveals that Melville wrote most prolifically on surrealism, Nolan and Bacon.

36. Sir Colin Anderson owned *The death of Captain Fraser* which was exhibited in *Twelve Australian artists* at New Burlington Galleries, London, in 1953 (no 30). Anderson undoubtedly discovered Nolan through his close friend, Kenneth Clark.

37. The Nolan date is given as c1957 in Pearce 2007, p 28; this is probably correct, for Nolan had a major retrospective at the Whitechapel Art Gallery in June–July 1957.

38. David Sylvester, 'Art from abroad', *The Listener*, 12 May 1955, p 854. Clark 1987, p 71.

39. Alleyne Zander, 'Sidney Nolan', *Studio*, vol 150, no 750, September 1955, p 86.

40. Robert Melville, *Ned Kelly: 27 paintings by Sidney Nolan*, Thames & Hudson, London, 1964.

41. Bacon's studio contained many books on murders and assassinations. See Rebecca Daniels, 'Francis Bacon and Walter Sickert: "images which unlock other images"', in Martin Harrison (ed), *Francis Bacon: new studies, centenary essays*, Steidl, Göttingen, 2009, pp 57–89.

42. Sinclair, 1993, p 27.

43. TG Rosenthal, *Sidney Nolan*, Thames & Hudson, London, 2002, p 97.

44. Rosenthal 2002, p 96.

45. Bacon originally produced seven works in this series but destroyed two. The place of the destroyed works in this sequence is not known.

46. On the back of a letter from Alan Rawsthorne, 21 October 1963, Alley has scribbled, 'come back to London after Christmas 1955. Thinks 3,2,1.' Letter held in the papers of Ronald Alley, Tate Archive, Ronald Alley Papers, TGA8414/Correspondence.

47. Notes from a conversation with Robert Sainsbury (not identified in the notes but established through the context of the conversation). Alley notes for catalogue raisonné, Tate Archive, Ronald Alley Papers, TGA8414.2/Notes.

48. Bacon often painted works quickly for exhibition; his van Gogh series is a prime example. Works that had not arrived at the gallery in time were often ex-catalogue. In fact, he had borrowed the Blake works back from Schurmann, to whom he had given them, as he had not finished enough works for the show.

49. Notes held in the Tate Archive, Ronald Alley Papers, TGA8414.2/Notes.

50. Pearce 2007, p 36.

51. *Narrative of the capture, sufferings, and miraculous escape of Mrs Eliza Fraser*, Charles and Webb, New York, 1837. Photograph from the Mitchell Library, Sydney, pp 5–24. TGA948 Robert Melville uncatalogued collection.

52. Mrs Fraser eventually returned to London and told her story for sixpence admission in Hyde Park.

53. Clark 1987, p 89.

54. Clark 1987, p 89.

55. Pearce 2007, pp 36, 64. Pearce notes the link with Blake's work and observes that it was available in reproduction in Australia by 1947 and that Nolan could therefore have seen it. It is possible that Bacon also had Blake's stooping *Nebuchadnezzar* in mind when painting his *Figure study II* 1945–46.

56. Jinx Nolan, email to Rebecca Daniels, 22 February 2012.

57. It is possible that Bacon also met Nolan that evening. Bryan Robertson, 'The London years', in Barry Pearce, *Brett Whiteley: art and life 1939–1992*, Thames & Hudson, Australia, 2004, pp 8–15, provides an invaluable account of Whiteley in London.

58. This was part of an article that looked at three private collectors posing with their possessions; Dublin City Gallery The Hugh Lane, RM98F104:85.

59. David Sylvester, *Interviews with Francis Bacon*, Thames & Hudson, London, 1997, pp 46–47.

60. Postcard from Whiteley to Edwards, 29 November 1984, MB Art Foundation, Monaco.

BACON'S STUDIO

1. David Sylvester, *Brutality of fact: interviews with Francis Bacon*, Thames & Hudson, London, 1987, p 190.

2. Sylvester 1987, p 30.

3. Martin Harrison, 'Point of reference', *Francis Bacon: paintings from the Estate 1980–91*, Faggionato Fine Arts, London, 1999, p 21.

4. Sylvester 1987, p 166.

5. Martin Harrison, *In camera. Francis Bacon: photography, film and the practice of painting*, Thames & Hudson, London, 2005, p 56.

6. Martin Harrison, *Francis Bacon: incunabula*, Thames & Hudson, London, 2008, p 212.

7. Harrison 2005, p 10.

8. Martin Harrison & David Sylvester, *Francis Bacon: caged/uncaged*, exhibition catalogue, Fundação Serralves, Museu de Arte Contemporânea de Serralves, Oporto, 2003, p 37.

9. David Sylvester, *Looking back at Francis Bacon*, Thames & Hudson, London, 2000, p 72.

10. Sylvester 1987, p 114.

11. Harrison 2005, p 10.

MAKING SENSE OF AFFECT

1. Gilles Deleuze & Felix Guattari, *Kafka: toward a minor literature*, trans Dana Polan, University of Minnesota Press, Minneapolis, 1986.

2. Gilles Deleuze, *Francis Bacon: the logic of sensation*, trans Daniel W Smith, University of Minnesota Press, Minneapolis, 2003.

3. David Sylvester, *Brutality of fact: interviews with Francis Bacon*, Thames & Hudson, London, 1987, p 22.

4. Michel Archimbaud, *Francis Bacon in conversation with Michel Archimbaud*, Phaidon, London, 1993, p 81.

5. Hugh Davies & Sally Yard, *Francis Bacon*, Abbeville Press, New York, 1986, p 110.

6. John Rajchman, 'Another view of abstraction', *Journal of Philosophy and the Arts*, no 5, 1995, pp 17–18.

7. Rajchman 1995, p 19.

8. Sylvester 1987, p 30.

9. Davies & Yard 1986, p 44, note 59.

10. Michel Leiris, *Francis Bacon: full face and in profile*, Phaidon, Oxford, 1983, p 45.

11. For a more elaborate analysis of the motifs of the mirror and the lamp in Bacon's work see Ernst van Alphen, *Francis Bacon and the loss of self*, Reaktion Books, London, 1992.

12. See also Deleuze 2002, pp 31–39.

13. Gilles Deleuze, 'Francis Bacon: the logic of sensation', *Flash Art*, no 112, May 1983, p 16.

FIVE DECADES

INTRODUCTION TO A CHRONOLOGY

1. Matthew Gale & Chris Stephens (eds), *Francis Bacon*, Tate Publishing, London, 2008.

2. Bacon talked about this several times, including to David Sylvester in *Interviews with Francis Bacon*, Thames & Hudson, London, 1987, pp 71–72.

3. Sylvester 1987, pp 81–82.

4. Michel Archimbaud, *Francis Bacon in conversation with Michel Archimbaud*, Phaidon, London, 1993, p 20.

5. Sylvester 1987, p 23.

1940s

6. Following the 2009 retrospective of Bacon's work at Tate Britain, which toured to the Prado in Madrid and the Metropolitan Museum of Art in New York, *Three studies for figures at the base of a crucifixion* was deemed too fragile to travel.

7. See Sam Hunter's photographs reproduced in this catalogue (pp 46, 85).

8. Sylvester 1987, p 44.

9. Archimbaud 1993, p 32.

10. *Bacon's arena*, DVD video, Adam Low (dir), a BBC Arena co-production with The Estate of Francis Bacon, London, screened March 2005, special edition, 2009.

11. *Bacon's arena* 2009.

12. Sylvester 1987, p 192.

13. Jean-Paul Sartre, *Being and nothingness: an essay on phenomenological ontology*, trans Hazel E Barnes, Routledge, London, p 16.

14. Martin Hammer & Chris Stephens, '"Seeing the story of one's time": appropriations from Nazi photography in the work of Francis Bacon', *Visual Culture in Britain* (special Francis Bacon issue), November 2009, pp 317–53.

15. Armin Zweite, 'Bacon's scream: observations on some of the artist's paintings', in Armin Zweite & Maria Muller (eds), *Francis Bacon: the violence of the real*, Thames & Hudson, London, 2006, p 79.

16. Zweite 2006, p 79.

17. Gilles Deleuze, *Francis Bacon: the logic of sensation*, trans Daniel W Smith, University of Minnesota Press, Minneapolis, 2003.

18. Martin Harrison, *In camera. Francis Bacon: photography, film and the practice of painting*, Thames & Hudson, London, 2005, p 105.

19. Harrison 2005, p 208.

20. Chris Stephens, 'Animal', in Gale & Stephens 2008, p 95.

21. Quoted in David Alan Mellor, 'Film, fantasy, history in Francis Bacon', in Gale & Stephens 2008, p 55.

1950s

22. Harrison 2005, p 14.

23. David Sylvester, *Looking back at Francis Bacon*, Thames & Hudson, London, 2000, p 235.

24. David Sylvester, *David Sylvester on Francis Bacon*, nd, francis-bacon.com/world/?c=David-Sylvester (accessed May 2012)

25. Rebecca Daniels, 'Francis Bacon and Walter Sickert: "images which unlock other images"', in Martin Harrison (ed), *Francis Bacon: new studies, centenary essays*, Steidl, Göttingen, 2009, pp 64, 66.

26. Daniels 2009, p 66.

27. Sylvester, francis-bacon.com/world/?c=David-Sylvester (accessed May 2012)

28. Michael Peppiatt, *Francis Bacon in the 1950s*, Yale University Press, New Haven, 2006, p 26.

29. Harrison 2005, pp 126, 132.

30. Sylvester 2000, p 243.

31. Michael Peppiatt, *Francis Bacon: anatomy of an enigma*, Skyhorse Publishing, New York, 2009, pp 223–24.

32. Sylvester 1987, p 200.

33. Sylvester 1987, p 46.

34. Harrison 2005, p 208.

35. Frank Laukotter & Maria Muller, 'Commentaries', in Zweite & Muller 2006, p 133.

36. Peppiatt 2009, p 205.

1960s

37. Transcript of original letter from Bacon to Michel Leiris, c1981.

38. Harrison 2005, p 121.

39. Tim Hilton, 'Life on a broad canvas', *Guardian*, 8 January 1999, guardian.co.uk/news/1999/jan/08/guardianobituaries2 (accessed May 2012)

40. Sylvester 1987, p 40.

41. TS Eliot, *The dry salvages* (1941) in *The complete poems and plays*, Faber & Faber, London, 1969, p 187. Bacon scholar Martin Harrison suggested that this was Bacon's favourite line from Eliot (Harrison 2005, p 232).

42. Chris Stephens, 'Portrait', in Gale & Stephens 2008, p 181.

43. Dawn Ades, 'Web of images', in *Francis Bacon*, Tate Gallery/Thames & Hudson, London, 1985, p 14.

44. Sylvester 1987, p 86.

1970s

45. John Russell, *Francis Bacon*, Thames & Hudson, London, 1971. A revised edition was published in 1993.

46. Russell 1993, p 151.

47. Sylvester 2000, p 131.

48. Martin Harrison, 'Bacon's paintings', in Gale & Stephens 2008, pp 42–43.

49. Margarita Cappock, *Francis Bacon's studio*, Merrell, London, 2005, p 185.

50. Michael Peppiatt in Matthew Gale, 'Memorial', in Gale & Stephens 2008, p 205.

51. Sylvester 1987, p 28.

52. Sylvester 1987, p 142.

53. Eddy Batache, 'Francis Bacon and the last convulsions of humanism', *Art & Australia*, vol 23, no 2, summer 1985, pp 222–26.

54. Sylvester 2000, p 242.

55. Sylvester 1987, pp 46–47.

56. KC Clark, *Positioning in radiography*, Ilford Ltd, London, 1964.

57. Peppiatt 2009, p 325.

58. Peppiatt 2008, p 325.

59. Peppiatt 2008, p 323.

60. Sylvester 1987, p 146.

61. Sylvester 2000, p 235.

62. Sylvester 1987, p 144.

63. Batache 1985, p 223.

64. Archimbaud 1993, p 147.

1980s

65. Peppiatt 2009, p 223.

66. Sylvester 1987, pp 130–33.

67. Cappock 2005, p 124.

68. Chris Stephens, 'Epic', in Gale & Stephens 2008, p 218.

69. Federico Garcia Lorca, 'Lament for Ignacio Sanchez Mejias', in *Federico Garcia Lorca: selected poems*, trans Alan S Trueblood, Penguin, London, 1997, p 263.

70. Clark 1964.

71. Cappock 2005, p 40.

72. Rachel Tant, 'Late', in Gale & Stephens 2008, p 233.

SELECT BIBLIOGRAPHY

Ades, Dawn et al. *Francis Bacon*, Tate Publishing and Thames & Hudson, London, 1983

Archimbaud, Michel. *Francis Bacon in conversation with Michel Archimbaud*, Phaidon, London, 1993, 2004

Cappock, Margarita. *Francis Bacon's studio*, Merrell, London, 2005

Clark, Jane. *Sidney Nolan: Nolan landscapes and legends*, Cambridge University Press, Melbourne, 1987

Deleuze, Gilles. *Francis Bacon: the logic of sensation*, trans Daniel W Smith, University of Minnesota Press, Minneapolis, 2003

Farson, Daniel. *The gilded gutter life of Francis Bacon*, Century, London, 1993

Gale, Matthew & Chris Stephens (eds). *Francis Bacon*, Tate Publishing, London, 2008

Harrison, Martin. *In camera. Francis Bacon: photography, film and the practice of painting*, Thames & Hudson, London, 2005

Harrison, Martin (ed). *Francis Bacon: new studies, centenary essays*, Steidl, Göttingen, 2009

Johnson, Heather. *Roy de Maistre: the English years 1930–1968*, Craftsman House, Sydney, 1995

Marr, David. *Patrick White: a life*, Vintage, London, 1991

Melville, Robert. *Ned Kelly: 27 paintings by Sidney Nolan*, Thames & Hudson, London, 1964

Pearce, Barry. *Brett Whiteley: art and life 1939–1992*, Thames & Hudson, Melbourne, 2004

Pearce, Barry. *Sidney Nolan 1917–1922*, Art Gallery of New South Wales, Sydney, 2007

Peppiatt, Michael. *Francis Bacon in the 1950s*, Yale University Press, New Haven, 2006

Peppiatt, Michael. *Francis Bacon: anatomy of an enigma*, Skyhorse Publishing, New York, 2009

Rosenthal, TG. *Sidney Nolan*, Thames & Hudson, London, 2002

Rothenstein, John. *Brave day, hideous night: autobiography 1939–1965* (I), Hamish Hamilton, London, 1966

Rothenstein, John. *Time's thievish progress: autobiography III*, Cassell & Company Ltd, London, 1970

Russell, John. *Francis Bacon*, Thames & Hudson, London, 1971, 1993

Sinclair, Andrew. *Francis Bacon: his life and violent times*, Sinclair-Stevenson, London, 1993

Sylvester, David. *Interviews with Francis Bacon*, Thames & Hudson, London, 1975, 1980, 1987, 1997

Sylvester, David. *The brutality of fact: interviews with Francis Bacon*, Thames & Hudson, London, 1982, 1987

Sylvester, David. *Looking back at Francis Bacon*, Thames & Hudson, London, 2000

Van Alphen, Ernst. *Francis Bacon and the loss of self*, Reaktion Books, London, 1992

Videos

Bacon's arena, DVD video, Adam Low (dir), a BBC Arena co-production with The Estate of Francis Bacon, London, screened March 2005, special edition, 2009

Francis Bacon: a film by David Hinton, DVD video, presented by Melvyn Bragg, a London Weekend Television co-production with RM ARTS, London, licensed by ArtHaus Musik GMBH, 1985

Website

Francis Bacon Estate: francis-bacon.com

following pages:

Francis Bacon
Studies from the human body 1975 (detail)
see p 191

page 228:

Arnold Newman
Francis Bacon 1975
National Portrait Gallery, London NPG P150(3)

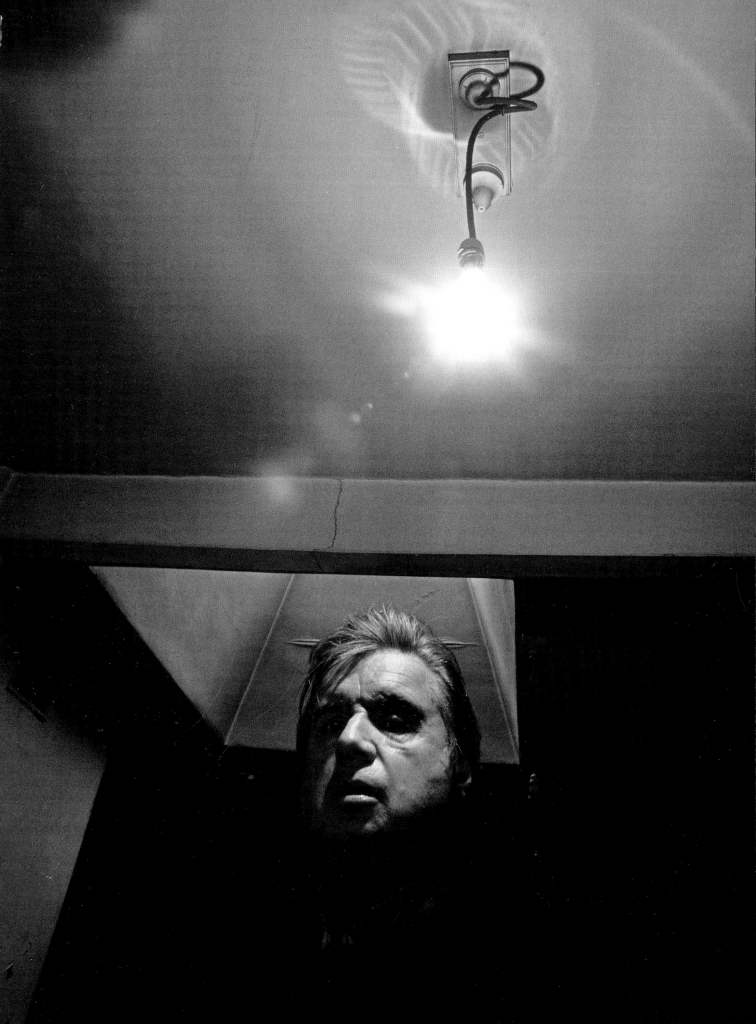

ART IS ALMOST LIKE A LONG AFFAIR WITH OBJECTS AND IMAGES AND SENSATIONS, AND WHAT YOU CAN CALL THE PASSIONS.

FRANCIS BACON

LIST OF WORKS

Crucifixion 1933
oil on canvas
60.5 x 47 cm
Courtesy Murderme

**Study for a figure at the
base of a crucifixion** 1943–44
oil and pastel on board
94 x 74 cm
Courtesy Murderme

Figure in a landscape 1945
oil on canvas
144.8 x 128.3 cm
Tate, London. Purchased 1950 N05941

Figure study I 1945–46
oil on canvas
123 x 105.5 cm
Scottish National Gallery of Modern Art,
Edinburgh. Accepted by HM Government
in lieu of Inheritance Tax and allocated to
the Scottish National Gallery of Modern Art,
1998

Figure study II 1945–46
oil on canvas
145 x 129 cm
Kirklees Museums & Galleries.
Presented by the Contemporary Art Society
to Batley Art Gallery

Head I 1947–48
oil and tempera on board
100.3 x 74.9 cm
Metropolitan Museum of Art, New York.
Bequest of Richard S Zeisler, 2007 2007.247.1

Head II 1949
oil on canvas
80 x 63.6 cm
Ulster Museum, Belfast. Donated by the
Contemporary Art Society, London, 1959.
National Museums Northern Ireland

Study for a portrait 1949
oil on canvas
149.4 x 130.6 cm
Museum of Contemporary Art Chicago.
Gift of Joseph and Jory Shapiro 1976.44

Study from the human body 1949
oil on canvas
147 x 134.2 cm
National Gallery of Victoria, Melbourne.
Purchased 1953

Untitled (study after Velázquez) 1950
oil on canvas
198 x 137 cm
The Estate of Francis Bacon
Courtesy Faggionato Fine Art, London

Untitled (crouching nude) c1950
oil on canvas
196.2 x 135.2 cm
The Estate of Francis Bacon
Courtesy Faggionato Fine Art, London

Untitled (figure) 1950–51
oil on canvas
198 x 137 cm
The Estate of Francis Bacon
Courtesy Faggionato Fine Art, London

**Pope I – study after Pope Innocent X
by Velázquez** 1951
oil on canvas
198 x 137 cm
Aberdeen Art Gallery & Museums Collections

Portrait of Lucian Freud 1951
oil on canvas
198 x 137 cm
Whitworth Art Gallery,
University of Manchester

Untitled (crouching figures) c1952
oil on canvas
147.3 x 132.2 cm
The Estate of Francis Bacon
Courtesy Faggionato Fine Art, London

Study for crouching nude 1952
oil and sand on canvas
198 x 137.2 cm
Detroit Institute of Arts, Detroit.
Gift of Dr Wilhelm R Valentiner

Study of a nude 1952–53
oil on canvas
61 x 51 cm
Robert and Lisa Sainsbury Collection,
University of East Anglia UEA 29

Study of a baboon 1953
oil on canvas
198.3 x 137.3 cm
Museum of Modern Art, New York.
James Thrall Soby Bequest, 1979 1198.1979

The end of the line 1953
oil on canvas
152.5 x 117 cm
Collection of Samuel and Ronnie Heyman,
New York

Untitled (half length figure in sea)
c1953–54
oil on canvas
198 x 136.5 cm
Courtesy Murderme

Untitled (sea) c1954
oil on canvas
155 x 117.5 cm
The Estate of Francis Bacon
Courtesy Faggionato Fine Art, London

Figure with meat 1954
oil on canvas
129.9 x 121.9 cm
Art Institute of Chicago.
Harriott A Fox Fund 1956.1201

Study for a running dog 1954
oil on canvas
152.7 x 116.7 cm
National Gallery of Art, Washington.
Given in memory of Charles Edward Rhetts
by his wife and children, 1976 1976.7.1

Owls 1956
oil on canvas
60.96 x 50.8 cm
Private collection.
Courtesy Dr Rebecca Daniels

Study for figure no 4 1956
oil on canvas
152.4 x 116.8 cm
Art Gallery of South Australia, Adelaide.
Gift of the Contemporary Art Society,
London, 1959

Figure in landscape 1956–57
oil on canvas
152.5 x 118 cm
Birmingham Museums and Art Gallery, UK

Study for a portrait of van Gogh IV
1957
oil on canvas
152.4 x 116.8 cm
Tate, London. Presented by the
Contemporary Art Society, 1958 T00226

Study for self portrait 1963
oil on canvas
165.2 x 142.6 cm
Amgueddfa Cymru – National Museum
Wales. Purchased 1978

**From Muybridge 'The human
figure in motion: woman emptying
a bowl of water / paralytic child
walking on all fours'** 1965
oil on canvas
198 x 147.5 cm
Stedelijk Museum Amsterdam.
Purchased 1980

**Portrait of Henrietta Moraes
on a blue couch** 1965
oil on canvas
198 x 147.5 cm
City of Manchester Art Gallery, UK

Portrait of Isabel Rawsthorne 1966
oil on canvas
81.3 x 68.6 cm
Tate, London. Purchased 1966 T00879

Untitled (dog) c1967
oil on canvas
30.5 x 35.6 cm
Private collection.
Courtesy Richard Nagy Ltd, London

Lying figure 1969
oil on canvas
198 x 147.5 cm
Fondation Beyeler, Riehen/Basel

Three studies for portrait of Henrietta Moraes 1969
oil on canvas
triptych, each 35.5 x 30.5 cm
Private collection

Three studies of George Dyer 1969
oil on canvas
triptych, each 36 x 30.5 cm
Louisiana Museum of Modern Art, Denmark.
Donation: Ny Carlsbergfondet

Studies of the human body 1970
oil on canvas
triptych, each 198 x 147.5 cm
Private collection.
Courtesy Ordovas

Three studies of the male back, triptych 1970
oil on canvas
each 198 x 147.5 cm
Kunsthaus Zürich, Vereinigung
Zürcher Kunstfreunde

Triptych 1970
oil on canvas
each 198 x 147.5 cm
National Gallery of Australia, Canberra.
Purchased 1973

Triptych – August 1972 1972
oil on canvas
each 198 x 147.5 cm
Tate, London. Purchased 1980 T03073

Self portrait 1973
oil on canvas
35.5 x 30.5 cm
Private collection.
Courtesy Richard Nagy Ltd, London

Portrait of a dwarf (The dwarf) 1975
oil on canvas
158.5 x 58 cm
Private collection

Three figures and a portrait 1975
oil and pastel on canvas
198.1 x 147.3 cm
Tate, London. Purchased 1977 T02112

Studies from the human body 1975
oil and Letraset on canvas
198.1 x 147.5 cm
Private collection

Portrait of Michel Leiris 1976
oil on canvas
35.5 x 30.5 cm
Louise and Michel Leiris Collection.
Pompidou Centre, Paris

Study for self-portrait 1976
oil and pastel on canvas
198 x 147.5 cm
Art Gallery of New South Wales.
Purchased 1978

Seated figure 1978
oil on canvas
198 x 147.5 cm
Private collection
Courtesy Richard Nagy Ltd, London

Study of Eddy Batache 1979
oil on canvas
35.5 x 30.5 cm
Private collection

Study of Reinhard Hassert 1979
oil on canvas
35.5 x 30.5 cm
Private collection

Three studies for a self-portrait 1979–80
oil on canvas
triptych, each 37.5 x 31.8 cm
Metropolitan Museum of Art, New York.
Jacques and Natasha Gelman Collection,
1998 1999.363.1a-c

Self portrait 1980
oil on canvas
35.5 x 30.5 cm
Private collection

Figure in movement 1985
oil on canvas
198 x 147.5 cm
Private collection

Triptych 1987
oil on canvas
each 198 x 147.5 cm
The Estate of Francis Bacon
Courtesy Faggionato Fine Art, London

Portrait of John Edwards 1988
oil on canvas
198 x 147.5 cm
The Estate of Francis Bacon
Courtesy Faggionato Fine Art, London

Study from the human body after Muybridge 1988
oil on canvas
198 x 147.5 cm
Private collection

Brett Whiteley
Francis Bacon c1984–89
ink drawing on paper
22.5 x 20.5 cm
Private collection

ACKNOWLEDGMENTS

Firstly, my thanks to the former director of the Art Gallery of New South Wales, Edmund Capon, for his early support for this project. My thanks also to the Gallery's new director, Michael Brand, who has helped to bring *Francis Bacon: five decades* to fruition. The Gallery's deputy director and head of exhibitions, Anne Flanagan, provided invaluable support throughout and I am grateful for her willingness to negotiate the tough decisions. Assistant curator Macushla Robinson was my right hand and guide in all aspects of this project and has written all of the artwork entries in this publication as well as the exhibition's didactic panels.

The exhibition, this book and associated public programs, have been made possible by the committed teamwork of staff at the Art Gallery of New South Wales. I thank Erica Drew and Jacqueline Strecker for so enthusiastically managing this complex exhibition. I am deeply grateful to registrar Charlotte Cox for her patience and attention to detail, and to senior registrar Charlotte Davy for her thoughtful advice. Thanks also go to Lisa Franey for assistance with loan letters.

Designer Analiese Cairis has, as always, gone above and beyond the call of duty and reflected the beauty of Bacon's work in the publication. My thanks also to Julie Donaldson, who oversaw the entire publication process, and Claire Armstrong, who edited the book with attention to detail and sympathy to the different voices that make up the whole. Donna Brett and Megan Young were diligent in researching images and negotiating their reproduction.

I am grateful to our exhibitions designer Tanguy Le Moing for developing the look and feel of the show. The Gallery's installation crew have been excellent, as has lighting designer Simm Steel, who always manages to bring out the best in every work. I am grateful to Francesca Ford and Kirsten Tilgals for their enthusiastic work on the website and video channel; to Michelle Andringa for clearing exhibition film footage; and to Jenni Carter for supervising photography.

I am grateful to Sheona White and Josephine Touma for putting together a wonderful series of public programs for this exhibition. Robert Herbert's fantastic film program invokes the claustrophobia and darker side of British society in the 1950s and 60s. Craig Brush at the Art Gallery Society has put together a wonderful series of lectures to accompany the show and, as always, I am grateful to Jill Sykes for supporting the exhibition through the Gallery's *Look* magazine. The Power Institute at the University of Sydney has kindly supported the exhibition symposium and its director Mark Ledbury has been an intelligent sounding board for ideas and angles on my research.

Kirsten Downie, Claire Macready, Sangeeta Chandra and Svetlana Mironov have managed the public face of the exhibition, developing a marketing campaign that is sympathetic to the ideas behind the show. Claire Martin has wrangled the press to bring the exhibition to a broad audience, and Penny Cooper has managed corporate support.

The Estate of Francis Bacon has provided inestimable support with loans and information. The executor of the Estate, Brian Clarke, along with Elizabeth Beatty and Christophe Dejean, have been more than helpful, and this exhibition is indebted to them for their support, for procuring loans and for offering a broader understanding of Bacon's work. My thanks also to Gerard Faggionato and Anna Pryer from Faggionato Fine Arts in London for their ongoing assistance with information and loans.

Martin Harrison, authenticator at the Estate, and Rebecca Daniels, researcher for Bacon's catalogue raisonné, have provided immeasurable assistance in locating works, passing on letters and, of course, writing for this publication. I am deeply grateful to the other contributors to this book – Ernst van Alphen and Margarita Cappock – for their insightful and very different interpretations of Bacon's work and archive. In addition to writing for the publication, Margarita assembled the studio/archival material for this show, which has enriched the exhibition immeasurably. I am also indebted to Bacon scholar Dawn Ades for her valuable insights into the relationship between Bacon and Marcel Duchamp. Michael Peppiatt, Bacon's biographer, was generous in offering his advice on the exhibition as a whole.

This exhibition would not have been possible without the generosity of our many lenders: Ann Goldstein, director, Stedelijk Museum, Amsterdam; John Edwards, head of collections, Aberdeen Art Gallery, Scotland; Glen D Lowry, director, Museum of Modern Art, New York; Simon Groom, director, and Keith Hartly, curator, Scottish National Gallery of Modern Art, Edinburgh; Gary Tinterow, former director, and Thomas P Campbell, current director, Metropolitan Museum of Art, New York; Alfred Pacquement, director, and Cecile Debray-Amar, curator, Pompidou Centre, Paris; Nicholas Serota, director, Tate, London; Chris Stephens, curator of modern British art and head of displays, Tate Britain; Matthew Gale, curator and head of displays, Tate Modern; Christoph Becker, director, and Christian Klemm, head of collections, Kunsthaus Zürich, Switzerland; Ron Radford, director, National Gallery of Australia, Canberra; Robert Hall, director, Huddersfield Art Gallery, UK; Madeleine Grynsztejn, director, Museum of Contemporary Art, Chicago; Maria Balshaw, Director, Whitworth Art Gallery, University of Manchester and Manchester City Art Gallery; James Cuno, director and president, and James Rondeau, curator, Art Institute of Chicago; Harry Cooper, curator of modern and contemporary art, National Gallery of Art, Washington; Anne Stewart and Martyn Anglesea, curators of fine art, Ulster Museum, Belfast; Tim Cooke, director, National Museums Northern Ireland; Barbara Dawson, director, Margarita Cappock, head of collections, Joanna Shepherd, head of conservation, Jessica O'Donnell, curator of education and research, and Elizabeth Wilms, collections assistant, Dublin City Gallery The Hugh Lane; Nick Mitzevich, director, Art Gallery of South Australia, Adelaide; Paul Greenhalgh, director, Sainsbury Centre for Visual Arts, University of East Anglia, UK; Gerard Vaughan, former director, and Tony Elwood, director, National Gallery of Victoria, Melbourne; Poul Erik Tøjner, director, Louisiana Museum of Modern Art, Denmark; Rita McLean, head of museum and heritage services, Birmingham Museums and Art Gallery, UK; Samuel Keller, director, and Philippe Buttner, curator, Fondation Beyeler, Riehen/Basel; David Anderson, director general, Oliver Fairclough, curator, and Adam Webster, head conservator, Amgueddfa Cymru – National Museum of Wales, Cardiff; Graham WJ Beal, director, Detroit Institute of Arts, Detroit; and Kate Davies at Murderme.

My thanks to the private lenders to this exhibition who wish to remain anonymous. I am also deeply grateful to Richard Nagy, Pilar Ordovas, Gregoire Billault, John Erle-Drax, and Oliver Barker and his assistant Cathriona Powell, for advice and support in procuring loans. I am indebted to Robin Vousden, Tim Taylor and Simon Lee for their generous advice and help in locating works. I am also grateful to Ivor Braka for his enthusiasm and marvellous anecdotes. Eddy Batache and Reinhard Hassert have been very helpful, providing insight into Bacon's working methods, his time in Paris and his correspondence

And, finally, my thanks to Anne Graham for her ongoing support and patience.

Anthony Bond

CONTRIBUTORS

Anthony Bond is curatorial director at the Art Gallery of New South Wales. His many projects at the Gallery include the exhibitions and accompanying publications for *The British show* (1984–85); *Boundary rider, the 9th Biennale of Sydney* (1992–93); *Body* (1997); *Self-portrait: Renaissance to contemporary* (for the National Portrait Gallery, London and Art Gallery of New South Wales, 2005–06); and *Anselm Kiefer: aperiatur terra* (for White Cube, London and Art Gallery of New South Wales, 2007). He was also curator of *Trace*, the inaugural Liverpool Biennial, UK (1999), and *Mike Parr: Cartesian corpse* at the Tasmanian Museum and Art Gallery, Hobart (2009).

Margarita Cappock is head of collections at Dublin City Gallery The Hugh Lane. She joined the gallery in 1999 as project manager of the Francis Bacon Studio and Archive, where she coordinated the documentation and reconstruction of Bacon's 7 Reece Mews, London studio and its contents. She is the author of *Francis Bacon's studio* (2005), editor of the guide to Dublin City Gallery The Hugh Lane (2005) and has written for *The Burlington Magazine*, *Irish Arts Review* and other academic journals and exhibition catalogues.

Rebecca Daniels is the researcher on the forthcoming *Francis Bacon: the catalogue raisonné* and co-author, with Martin Harrison, of *Francis Bacon: incunabula* (2008). She has published on Bacon in *The Burlington Magazine*, *Apollo* and *The British Art Journal* as well as various books, art journals and exhibition catalogues. She also co-edited *Ruskin and Architecture* (2003).

Martin Harrison is the editor of the forthcoming *Francis Bacon: the catalogue raisonné*. He is the author of *In camera. Francis Bacon: photography, film and the practice of painting* (2005) and co-author, with Rebecca Daniels, of *Francis Bacon: incunabula* (2008). In 2009 he edited *Francis Bacon: new studies, centenary essays* and was co-curator, with Barbara Dawson, of the exhibition *Francis Bacon: a terrible beauty*.

Ernst Van Alphen is professor of literary studies at Leiden University, the Netherlands. His publications include *Francis Bacon and the loss of self* (1992), *Caught by history: Holocaust effects in contemporary art, literature, and theory* (1997), *Armando: shaping memory* (2000) and *Art in mind: how contemporary images shape thought* (2005). He also edited *The rhetoric of sincerity* (2009).

Macushla Robinson is a curatorial assistant at the Art Gallery of New South Wales. She is the assistant curator on the *Francis Bacon: five decades* exhibition and the author of the artwork entries in this book. She has written catalogue essays including 'The future now' for the *John Kaldor Family Collection* (2011) published by the Art Gallery of New South Wales, as well as art criticism for journals including *Art and Australia*, *Imprint* and *artonview*.

LENDERS

Public collections
Aberdeen Art Gallery and Museums Collections
Art Gallery of South Australia, Adelaide
The Art Institute of Chicago
Birmingham Museums and Art Gallery
Centre national d'art et de culture Georges Pompidou, Paris
Detroit Institute of Arts, Detroit
Dublin City Gallery The Hugh Lane
Huddersfield Art Gallery
Kunsthaus Zurich, Switzerland
Louisiana Museum of Modern Art, Denmark
Manchester City Art Gallery
Metropolitan Museum of Art, New York
Museum of Contemporary Art, Chicago
Museum of Modern Art, New York
National Gallery of Art, Washington
National Gallery of Australia, Canberra
National Gallery of Victoria, Melbourne
Amgueddfa Cymru – National Museum Wales, Cardiff
National Museums Northern Ireland, Belfast
Sainsbury Centre for Visual Arts, East Anglia
Scottish National Gallery of Modern Art, Edinburgh
Stichting Stedelijk Museum, Amsterdam
Tate Britain, London
Whitworth Art Gallery, University of Manchester

Private galleries/collections
Foundation Beyeler
The Francis Bacon Estate
Murderme Collection
And ten private lenders who wish to remain anonymous.

Unless noted otherwise, all works by Francis Bacon
and archival ephemera from Bacon's studio are
© The Estate of Francis Bacon. DACS/Licensed by Viscopy.

Photo credits

The works

p 42 Jenni Carter, AGNSW
p 87 Prudence Cuming Associates Ltd/Bridgeman Art
 Library
p 89 Prudence Cuming Associates Ltd
pp 90–91 © Tate, London, 2012
p 95 Bridgeman Art Library
p 97 © Metropolitan Museum of Art/Art Resource/
 Scala, Florence
p 101 Nathan Keay © MCA Chicago
p 109 Courtesy The Estate of Francis Bacon
p 111 Courtesy The Estate of Francis Bacon
p 113 Courtesy The Estate of Francis Bacon
p 115 Bridgeman Art Library
p 119 Courtesy The Estate of Francis Bacon
p 123 James Austin
p 125 © digital image, Museum of Modern Art,
 New York/Scala, Florence
p 127 Prudence Cuming Associates Ltd
p 129 Beth Phillips
p 131 Courtesy The Estate of Francis Bacon
p 135 National Gallery of Art, Washington
p 141 © Birmingham Museums
p 143 © Tate, London, 2012
p 149 © National Museum of Wales
p 151 Bridgeman Art Library
p 153 Manchester City Galleries
p 155 © Tate, London, 2012
p 159 Peter Schibli, Basel/Bridgeman Art Library
pp 160–61 Peter Schälchi, Zurich
pp 169–71 Bridgeman Art Library
pp 181–83 © Tate, London, 2012
p 185 Prudence Cuming Associates Ltd
p 189 © Tate, London, 2012
p 191 Peter Schälchi, Zurich
p 193 © Centre Pompidou, Dist RMN/CNAC,
 Bertrand Prévost
p 195 Jenni Carter, AGNSW
p 197 Bridgeman Art Library
pp 200–01 © Metropolitan Museum of Art/
 Art Resources/Scala, Florence
p 207 Jenni Carter, AGNSW
p 209 Prudence Cuming Associates Ltd
pp 211–13 Courtesy The Estate of Francis Bacon
p 215 Courtesy The Estate of Francis Bacon
p 217 Prudence Cuming Associates Ltd

Photographic portraits

pp 4–5 © Centre Pompidou, MNAM-CCI, Dist.
 RMN/Philippe Migeat;
p 32 courtesy Martin Harrison;
p 82 © Henri Cartier-Bresson/Magnum Photos/
 Snapper Media
p 164 Jorge Lewinski/TopFoto/Austral;
p 219 Jorge Lewinski/TopFoto/Austral;
p 220 Courtesy The Estate of Francis Bacon;
p 228 Arnold Newman/Getty Images

Supplementary illustrations

fig 1 Giraudon/Bridgeman Art Library
fig 2 Giraudon/Bridgeman Art Library
fig 3 Alinari/Bridgeman Art Library
fig 4 Christopher Snee, AGNSW
fig 8 Giraudon/Bridgeman Art Library
fig 9 © Boltin Picture Library/Bridgeman Art Library
fig 10 courtesy Ullstein Bild
fig 12 Wolfgang Fuhrmannek
fig 16 Courtesy Menzies Art Brands
fig 17 Brenton McGeachie, AGNSW
fig 18 Courtesy Sotheby's, London
fig 19 Courtesy Martin Harrison
fig 21 © Tate, London, 2012
fig 23 Bridgeman Art Library
fig 24 © Tate, London, 2012
fig 69 Bridgeman Art Library
fig 71 bpk/Nationalgalerie, SMB. Jörg P Anders
fig 72 Bridgeman Art Library
fig 73 Bridgeman Art Library
fig 74 Giraudon/Bridgeman Art Library TBC
fig 75 Courtesy The Estate of Francis Bacon
fig 76 Courtesy The Estate of Francis Bacon
fig 78 Bridgeman Art Library
fig 82 Alinari/Bridgeman Art Library
fig 83 Illustrated in Hitler in seiner Heimat,
 Zeitgeschichte-Verlag, Berlin, 1938. Bayerische
 Staatsbibliothek München/Fotoarchiv Hoffmann
fig 84 Giraudon/The Bridgeman Art Library
fig 89 Courtesy The Estate of Francis Bacon
fig 91 Alinari/Bridgeman Art Library
fig 92 From Franz Kafka, Letters to Ottla and the family,
 Schocken Books, New York, 1982
fig 93 The Stapleton collection/Bridgeman Art Library
figs 101a & b The Stapleton collection/
 The Bridgeman Art Library
fig 107 From Francis Bacon 1909–1992: small portrait
 studies, exhibition catalogue, Marlborough Fine
 Art (London) Ltd, London, 1993
fig 108 © Eddy Batache
fig 109 Bridgeman Art Library
fig 113 © The National Gallery, London
fig 119 Roger Wooldridge

Quotes

p 1 Bacon's arena, DVD video, Adam Low (dir),
 special edition, 2009
p 12 Interview with Melvyn Bragg in Francis Bacon:
 a film by David Hinton, DVD video, 1985
p 76 Francis Bacon: a film by David Hinton, 1985
p 218 David Sylvester, Interviews with Francis Bacon,
 Thames & Hudson, London, 1987, p 82
p 229 Bacon's arena, special edition 2009
p 240 Bacon's arena, special edition 2009
back cover David Sylvester, Looking back at Francis Bacon,
 Thames & Hudson, London, 2000, p 186

opposite:

Francis Bacon
Study for self-portrait 1976 (detail)
see p 195

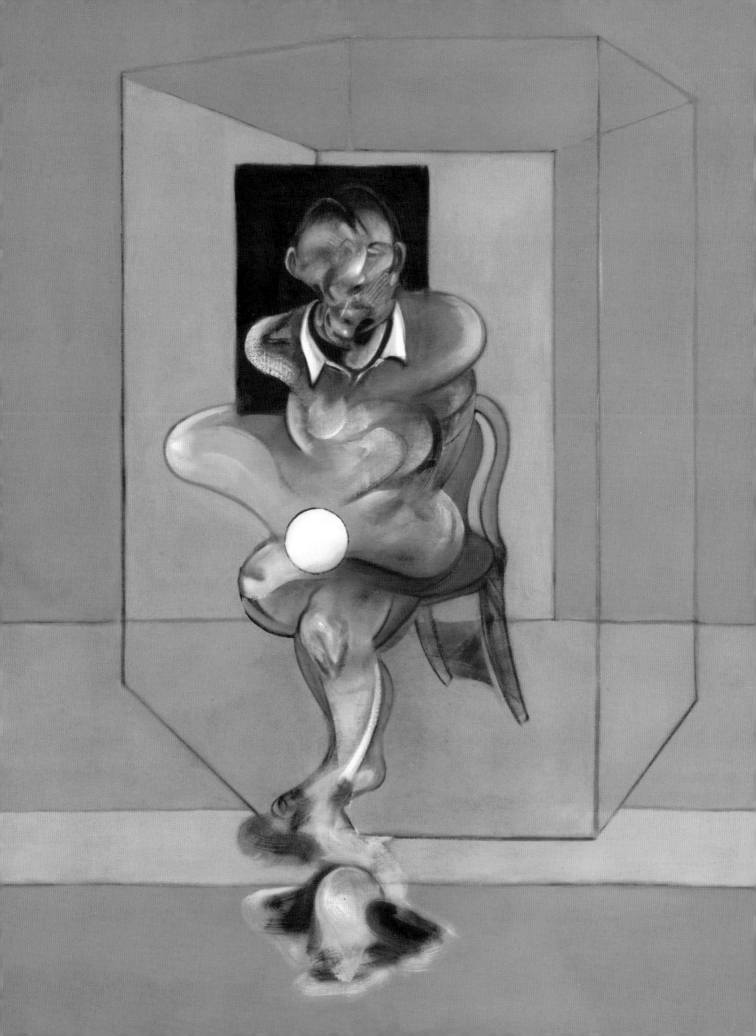

INDEX

Published by Art Gallery of New South Wales
Art Gallery Road, The Domain
Sydney 2000, Australia
artgallery.nsw.gov.au

in association with the exhibition
Francis Bacon: five decades
Art Gallery of New South Wales
17 November 2012 – 24 February 2013

© 2012 Art Gallery of New South Wales
All rights reserved. No part of this publication
may be reproduced or transmitted in any form
or by any means, electronic or mechanical,
including photocopying, recording or any other
information storage and retrieval system, without
prior permission in writing from the publisher.

The Art Gallery of New South Wales thanks
the copyright owners for granting permission
to reproduce works illustrated in this
publication. Every effort has been made to
contact the copyright owners and any omissions
will be corrected in future editions provided
the publisher has been notified in writing.

Art Gallery of New South Wales
Cataloguing-in-publication
Bacon, Francis 1909–92
Francis Bacon: five decades / edited by Anthony
Bond; with essays by Anthony Bond … [et al]

ISBN 9781741740783 (pb)

Includes bibliographic references and index
1. Bacon, Francis, 1909–92–Exhibitions. I. Bond,
Anthony, 1944–
II. Art Gallery of New South Wales. III. Title

Prestel ISBN 9783791347585 (hc)

Paperback distributed in Australia,
UK and Europe by Thames & Hudson
181A High Holborn, London WC1V7QX
tel: 44 20 7845 5000
sales@thameshudson.co.uk / thameshudson.co.uk

Hardcover distributed in North America by
Prestel Publishing
900 Broadway, Suite 603, New York, NY 10003
tel: 212 995 2720
sales@prestel-usa.com / prestel.com

The Art Gallery of New South Wales is a
statutory body of the NSW State Government

Managing editor: Julie Donaldson
Text editor: Claire Armstrong
picture research/rights & permissions:
 Donna Brett & Megan Young
Proofreading: Ella Martin
Index: Sherrey Quinn

Design: Analiese Cairis
Production: Cara Hickman & Penny Sanderson
Prepress: Spitting Image, Sydney
Printing: 1010 International Printing, China

This project has been made possible
with the support of:

Strategic partners

Principal sponsor

Official airline

Official hotel

S O F I T E L
LUXURY HOTELS

Media partners

 702 ABC
Sydney

Supported by

PRESIDENT'S
COUNCIL

JCDecaux

CITY OF SYDNEY

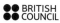
smh.com.au

Cultural partners

●● BRITISH
●● COUNCIL

SYDNEY
FESTIVAL
2013

cover: *Portrait of Michel Leiris* 1976 (detail) see p 193
opposite: *Untitled (study after Velázquez)* 1950
(detail) see p 109
endpapers: Photographs by Perry Ogden of Bacon's
studio at 7 Reece Mews, South Kensington, after
the artist's death, 1998 (details). Dublin City Gallery
The Hugh Lane 1963:14

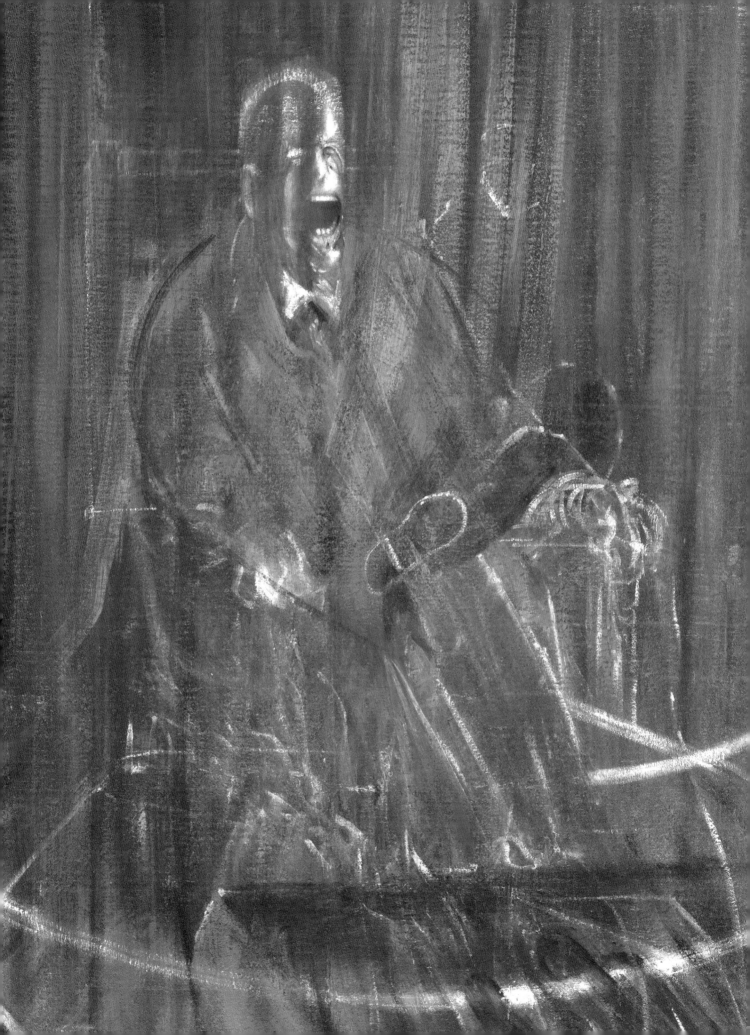

... PAINTING UNLOCKS ALL KINDS OF VALVES OF SENSATION WITHIN ME WHICH RETURNS ME TO LIFE MORE VIOLENTLY.

FRANCIS BACON